THE GUM BICHROMATE BOOK

Second Edition

Non-Silver Methods for Photographic Printmaking

DAVID SCOPICK

Focal Press
Boston London

Focal Press is an imprint of Butterworth-Heinemann.

Cover illustration by David Scopick, untitled, 1991, 21 × 32.5cm. Collection: Artist.
Illustrations in text by Jason Stephens and Michael Côté

Library of Congress Cataloguing-in-Publication Data
Scopick, David
 The gum bichromate book : non-silver methods for photographic printmaking / by David Scopick.—2nd ed.

 p. cm.
 Includes bibliographical references and index.
 ISBN 0-240-80073-7 (pbk. : alk. paper)
 1. Photography—Printing processes—Gum bichromate. I. Title.
TR445.S36 1991
773'.5—dc20 91-2985
 CIP

British Library Cataloguing in Publication Data
Scopick, David
 The gum bichromate book: non-silver methods for photographic printmaking 2nd ed.
 1. Photography. Printing
 I. Title
 773.5

 ISBN 0-240-80073-7

Butterworth-Heinemann
80 Montvale Avenue
Stoneham, MA 02180

10 9 8 7 6 5 4 3 2 1

Printed in the United States of America

THE
GUM BICHROMATE
BOOK

Second Edition

CONTENTS

PREFACE

The popularity of gum bichromate printing has not diminished since the first edition of *The Gum Bichromate Book*.[1] A multitude of other processes exist in academic catalogues internationally, yet an endless list of photographers have the desire to gum print. Statements such as "Gum dichromate is probably the technique most responsible for the current revival of the historical process"[2] or "It is easy to understand that the gum process is largely responsible for the current strong revival of interest in the so-called 'historical' or 'obsolete' processes"[3] prove the importance of gum printing in contemporary photography.

This text comes from my work in photography and from my interpretation of the gum bichromate process. There are many difficulties in deciphering the various early "treatises," including outdated material—"Whatman cold-pressed medium paper"—with vague references to quantities—a "thimbleful" of sensitizer—that make the process difficult to understand and incompatible with modern methods. The need for a contemporary manual is obvious.

The gum bichromate process does not use material regulated by the photographic industry. The photographer's personal taste and feelings can interpret each print with distinct, individual characteristics. The process is not difficult. It is extremely flexible and becomes confusing only because of the great number of inherent variables. It appeals to photographers who enjoy a process with many alternatives for printing. Workers can discover their unique talents for good images as they incorporate and modify new principles. Anyone working systematically, testing one element at a time, will find no difficulties. The resulting beauty is repayment for the necessary effort.

> The enemy of photography is the convention, the fixed rules of the "how-to-do." The salvation of photography comes from the experiment. The experimenter has no preconceived idea about photography. He does not believe that photography is only as it is known today, the exact repetition and rendering of the customary vision. He does not think that the photographic mistakes should be avoided since they are usually "mistakes" only from the routine angle of the historic development which can be achieved with photographic means with camera or without: all the reaction of the photosensitive media to chemicals, to light, heat, cold, pressure, etc.[4]

Gum printing and the other "pictorial" processes enjoyed popularity at the turn of this century, with the pictorial photographic movements in Europe and North America. The revival of these interesting and beautiful processes began in the late 1960s and retains an ever-increasing strength at the beginning of the 1990s. Many photographers today have never seen a gum print. Yet, they should not be discouraged from studying the process and can use the methods successfully.

This text contains the entire methodology of gum printing. This edition has many new aspects for the beginner and new ideas for the advanced printer. The formulas and methods are revised to include new

details and new approaches. It would be difficult to tell more, save in a different book expressly on the variations of the process.

My first text favored the traditional approach to gum printing—preference was given to visual terms and working methods, rather than sensitometric explanations. The philosophy remains, but sensitometric guidelines are needed in the second edition for the correct approach to new topics—halftone techniques, color separation, tricolor printing and masking, and so forth.

With methods such as color separation, the photographer can become obsessive, requiring strict adherence to the densitometer, voltage regulators, and masking. But exciting results are possible using a minimum of technology, allowing the process to be clarified and establishing future needs. This text does not try to present high-level or extensive complex theory in areas such as color separation or sensitometry.

> With the advent of extremely expensive electronic scanners, complicated masking, and the high degree of color technology, a myth seems to have arisen concerning the difficulties of making full color images.[5]

New to this edition is a chapter on the progression of photography that includes gum printing. Also new to the text is a chapter on Kwik-Print. Often referred to as a simplified gum bichromate process, Kwik-Print is the perfect introductory technique to anyone interested in gum printing.

Many of the features of the first edition have remained. A detailed Glossary offers further definitions of concepts and techniques. All the terms appearing in the Glossary are italicized the first time they appear in the text. Appendices have been expanded to include additional data on sensitometry, contrast control, print editioning, halftones, and chemical formulas. Full-color plates now supplement the text and illustrate the special qualities of gum printing.

Notes

1. Published by Light Impressions (Rochester, NY, 1978).

2. William Crawford, *The Keepers of Light* (Dobbs Ferry, NY: Morgan & Morgan, 1979), p. 199.

3. Luis R. Nadeau, *Gum Dichromate* (Fredericton, Canada: Atelier Luis Nadeau, 1987), p. 29.

4. Laslo Moholy-Nagy, *Vision in Motion* (Chicago: Theobald and Co., 1947), p. 197.

5. Philip Zimmerman, ed., *Options for Color Separation* (Rochester, NY: Visual Studies Workshop, 1980), foreword.

 # ACKNOWLEDGMENTS

With thanks to: The Ontario College of Art; Stephen Livick, photographer; F. William Scanlon and Gary Shennette of the Film and Photography Department of Ryerson's Polytechninal Institute; William Edwards of Light Impressions Corporation; John Stephens of Roxy Photography; Maia-Mari Sutnik of The Art Gallery of Ontario; Herzig Somerville Printers Ltd.; Seymour A. Rottenberg of Direct Reproduction Corporation (Kwik-Print); Martin Oudejans of Conestoga College; Andrew Stasik of The International Graphic Arts Foundation; Deli Sacilotto, printmaker; The George Eastman House; Ron Wood and Nic Ingvaldson of The Ontario College of Art; Jane Hinton, photographer; Stephen Bulger, photographer; Louis Palu, photographer; Graham Smith of Horizon Scan; Ed Doherty of BDH Chemicals.

THE GROWTH OF PHOTOGRAPHY

Outlining the evolution of an historic process is an ambitious endeavor. The history of photography shows that gum printing belongs to the elite of printing techniques, on a par with photogravure and platinum. A jewel among photographic processes that all the technology of the 1990s cannot diminish, it still retains a mystique that attracts zealous printers more than a century after its discovery.

Isolated experiments in optics, chemistry, and mechanics led to the invention of photography in 1839. The more significant events included the camera obscura (1558), the discovery of light sensitivity in silver nitrate (1725), and the discovery of hyposulphite as a fixing agent (1819). As Kraszna-Krausz stated, "the birth of Photography was like that of a prince. There were articles in the Press—some of them informative, some of them wildly exagerated, some of them just stupid."[1]

The information in this chapter highlights some of the major developments in the history of photography including gum printing (see Table 1.1).

DISCOVERIES AND MAJOR ADVANCES

Silver Nitrate In 1725, Johann Heinrich Schulze discovered the light sensitivity of silver nitrate. Others continued to experiment, especially Dr. William Lewis and Joseph Priestly, whose results led Thomas Wedgwood in 1802 to transfer images from glass to material soaked with silver nitrate. However, attempts to fix the image were unsuccessful.

Direct Positive Process Unknown successes by Hercules Florence in 1833 may have been similar to Hippolyte Bayard's largely ignored announcement in 1839 that he used silver chloride and potassium iodine, which would bleach to light. In 1948 Edwin H. Land introduced the Polaroid camera.

The author gratefully acknowledges the assistance of Stephen Bulger with this chapter. The dates and information outlined in this section are not extensively cross referenced and should be considered approximate. For details, refer to the Bibliography, "Growth of Photographic Processes."

TABLE 1.1 MAJOR EVENTS IN THE HISTORY OF PHOTOGRAPHY

	Camera Images	*Printing Techniques*	*Discoveries and Introduction*
1830	1802: Heliography 1839: Daguerreotype	1839: Salted paper	1829: Niepce meets Daguerre 1839: Herschel suggests his 1819 discovery of hyposulphite to fix the image
1840	1839: Bayard's direct positive 1841: Calotype (talbotype) 1847: Albumen negatives		1841: Sun and moon photographed
1850	1851: Wet collodion		1851: Bellows focusing 1853: Stereoscopy 1854: Portrait in electric light Cartes de visite
	1854: Ambrotype 1856: Tintypes	1855: Gum print	
1860			1857: First enlargements with Solarmicroscope 1858: Aerial photography 1860: Globe wide angle Camera tilts and swings Retouching 1861: Single-lens reflex patent Magnesium flash
		1864: Carbon process 1866: Woodburytype	1864: Photography in medical diagnosis 1866: Underwater photography 1869: Tricolor process
1870		1870: Collotype	
	1873: Gelatin dry plate		1874: Focal plane shutter Photography used in the detection of forgeries
1880		1880: Cyanotype Photogravure Platinum	
			1882: Folding camera
		1885: Letterpress half-tone Gelatin silver chloride printing out paper	
	1888: Celluloid roll film		1888: Kodak camera 1889: Actinometer
1890			1890: Photo finishing 1891: Telephoto lens
		1894: Gum prints become popular	
	1895: X-ray photography		1895: Cinematography View camera
1900			1898: Graflex 1900: Kodak Brownie 1901: Postcards
	1903: Panchromatic films 1904: Autochrome	1907: Bromoil process	
1910 1920			
			1925: Leica Flashbulb 1929: Flash synchronization

TABLE 1.1 (*continued*)

	Camera Images	Printing Techniques	Discoveries and Introduction
1930	1930: Safety film		
			1932: Weston meter
	1935: Kodachrome	1935: Dye transfer	
			1938: Built-in meter
			1939: Portable electronic flash
1940			
	1948: Polaroid		
1950			1955: Cibachrome
1960			1959: Zoomar 36–85mm f/2.8
1980			1982: Sony still video camera

EXPOSURE TIMES[2]: APERTURE OF f/16

1839	2400 seconds
1854	120 seconds
1856	30 seconds
1880	5 seconds
1910	1/10 second
1930	1/25 second
1960	1/250 second

Cameras The camera obscura (c. 1558) began as a darkened room that faithfully reproduced outside objects by light passing through a pinhole. This premise evolved into the box camera. The first publicly sold camera was designed by Daguerre in 1839. In 1844 Friedrich von Martens designed an arc-pivoted camera. In 1851 a bellows focusing system was sold by W. and W.H. Lewis of New York and by the 1860s cameras were offered with tilts and swings. In 1882 George Hare introduced a folding camera, which, with improvements by Frederick H. Sanderson in 1895, evolved into the view camera as it is known today. In 1888 George Eastman patented the Kodak and brought photography to the masses. Amateur cameras continued to improve from the Kodak Brownie of 1900 (see Figure 1.1) through 1963's Instamatic and its 1972 pocket version. In 1898 Fulmer and Schwing sold the Graflex based on Thomas Sutton's 1861 single-lens reflex patent. The Ermanox of 1924 enabled speeds of up to 1/1000 second but the 1925 Leica set the standard for 35mm.

Lenses The f/3.6 Petzval lens of 1841 was one of the first lenses to require focusing. In 1880, glass manufacture in Jena, Germany, improved, allowing significant design advances. The desire for exposure control led to the design of revolving apertures (see Figure 1.2). Anastigmats (resolving vertical and horizontal distortion) were made in the 1890s by Carl Zeiss and Carl Goertz with f/4.5. Charles C. Harrison designed the Globe wide angle in 1860 while the first telephoto lens was patented in 1891 by Thomas Rudolf Dallmeyer. Increased design technology and improved lens coating permitted the 1959 Zoomar 36-85 mm f/2.8 lens by Voigtlander to be made.

Shutters With the invention of faster plates, manual removal of a lens cap was no longer suitable. The sliding cap shutters of 1839 were replaced in the 1880s by flap shutters mounted on the lens; advance-

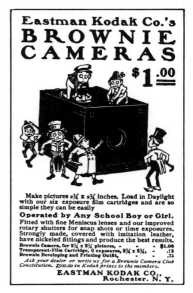

Figure 1.1 The Brownie was the result of Eastman's advertising to make thousands of children into amateur photographers with the familiar term "Brownie." *Source: A Century of Cameras,* Eaton S. Lothrop, Jr. (Dobbs Ferry, NY: Morgan & Morgan, Inc.) 1973, p. 93. From the collection of IMP/George Eastman House, reprinted with permission of Morgan & Morgan.

Figure 1.2 *(left)* Anthony's Single Combination Lens. An inexpensive lens that combined optical elements with a rotating aperature. *Source: Illustrated Catalogue of Photographic Equipment and Materials for Amateurs,* Eaton S. Lothrop, Jr. (Dobbs Ferry, NY: Morgan & Morgan, Inc.) 1980 reprint of the 1891 ed. published by E. and H.T. Anthony & Co., p. 47. Reprinted with permission of Morgan & Morgan.

Figure 1.3 *(right)* A diaphragm shutter. *Source: The Encyclopaedic Dictionary of Photography,* Walter E. Woodbury. (New York: Arno Press), 1979 reprint of the 1896 ed. published by The Scovill and Adams Co., New York, p. 445.

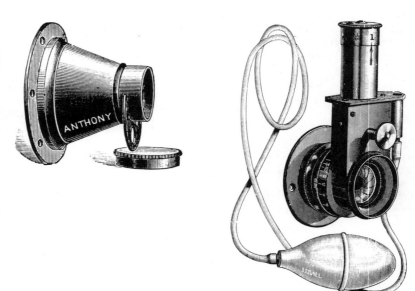

ments from this system led to the diaphragm shutter (see Figure 1.3). Around 1904 Friedrich Deckel of the Zeiss Company placed sets of blades within the camera controlling the size of aperture and length of exposure.

Enlargers Early daylight enlarging was done through a number of methods ranging from a simple fixed-focus enlarger to an entire darkroom, which used the space as an enlarging camera (see Figure 1.4). In 1857 David A. Woodward patented the "Solarmicroscope" or "magic lantern" which enlarged negatives. Advances followed after improvements were made with better optics and the better consistency of electric light.

Figure 1.4 The Eastman Enlarging Apparatus. The negative is placed in the window with ground glass behind it. Light is prevented from entering the printing room except through the camera lens, which projects the image onto a paper easel. *Source: Photographic Printing Methods,* Rev. W.H. Burbank. (New York: Arno Press) 1973 reprint of the 1891 ed. published by The Scovill and Adams Co., New York, p. 112.

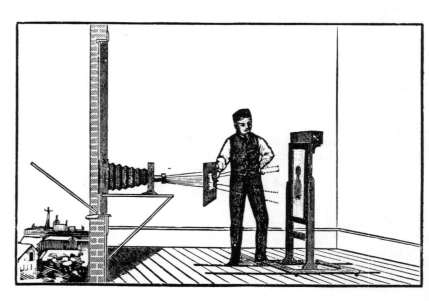

Meters Originally for use with silver-bromide plates, a slide-rule-type exposure calculator—the *actinometer*—was introduced in 1888 by Ferdinand Hurter and Charles Driffield (see Figure 1.5). This chemical meter was used until 1940 when it was supplanted by the photoelectric meter first issued by Weston in 1932. In 1938 some cameras are introduced with built-in meters.

Flash Early flash pictures (c. 1860, see Figure 1.6) required igniting magnesium until Dr. Paul Vierkötter patented the flashbulb (a magnesium wire encased in glass) in 1925. In 1929 batteries triggered foil-filled bulbs leading to flash synchronization. Portable electronic flash units were introduced by Edward Rolke Farber in 1939.

Color Color was first applied by hand to finished prints in the 1840s. By 1904 the Autochrome process of the Lumière brothers (using the three primary colors in dye form on a single silver-bromide plate) became the first truly successful—albeit costly—attempt. The breakthrough in subtractive principles came in 1935 with the invention of Kodachrome by Leopold Godowsky and Leopold Mannes. The film consisted of a triple emulsion of primary dyes that blocked out their complements. Successes in color printing came with separation techniques and reached a high point in 1934 with the Kodak *Dye Transfer* system, where three gelatin reliefs are dyed in yellow, magenta, and cyan and transferred in register to paper. Today most prints and negatives are chromogenic, where dyes form during processing or are dye-destructive, like *Cibachrome*, where all dyes are present and the ones not needed are bleached away.

Figure 1.5 1911. An actinometer with paper scale. Different types existed, the principle feature exposing p.o.p. until the desired effect indicates correct exposure of the invisible image. *Source: Encyclopedia of Photography*, Bernard E. Jones, ed. (New York: Arno Press) 1974 reprint of the 1911 Cassell's *Cyclopaedia of Photography*, London and New York, p. 8.

INITIAL METHODS

Heliography Heliography is widely recognized as the first successful photographic process. By 1827 Joseph Nicéphore Niepce was coating pewter plates with bitumin of Judea (which hardened under light) and exposing them in a camera obscura. Unexposed areas could be washed away with a mixture of oil of lavender and white petroleum. Due to eight-hour exposures and muddy results, the process survives solely as a milestone.

Daguerreotype This first practical photographic process came through the work of Louis Jacques Mandé Daguerre with the early help of Niepce (see Figure 1.7). The methods involved coating copper plates with highly polished silver sensitized with iodine fumes. The resulting silver iodine was then exposed to light in a box camera. Next, the plate was developed with mercury vapor and the image fixed with hyposulphite of soda upon the suggestion of Sir John Herschel. Officially introduced in 1839, this nonreproductive and expensive process remained popular until 1857.

Figure 1.6 A flash apparatus that uses magnesium powder blown through a flame. *Source: The Encyclopaedic Dictionary of Photography*, Walter E. Woodbury. (New York: Arno Press), 1979 reprint of the 1896 ed. published by The Scovill and Adams Co., New York, p. 206.

NEGATIVE PROCESSES

Calotype (Talbotype) The first successful negative to positive process was patented by William Henry Fox Talbot in 1841. Paper was sensitized with potassium iodide and silver nitrate and, after roughly 1 to

Figure 1.7 Adapted from "The Legend of the Daguerreotypist" by Champfleury, drawing by E. Morin.

2 minutes of exposure, it was developed in gallic acid and silver nitrate. The negative was then placed in contact with paper containing salt and silver nitrate which, when exposed, creates positives. Initial results were not sharp, but its ease of use and the improvements made in 1847 by Louis Désiré Blanquart-Evrard and in 1851 by Gustave Le Gray with waxed paper ensured its widespread use until 1857.

Albumen Negatives The transparent mixture of egg white with potassium iodide and sodium chloride that coated a plate of glass and could suspend silver nitrate was invented by Claude Félix Abel Niepce de Saint-Victor in 1847. It produced a textureless negative but was too slow for practical use.

Wet Collodion The wet collodion process was introduced in 1851 by Frederick Scott Archer. Plates of glass were coated with gun cotton dissolved in alcohol and ether, to be used as a base for potassium iodide and potassium bromide. Exposure was made while the plates were still wet, required 30 to 120 seconds, and necessitated portable darkrooms (see Figure 1.8). A daguerreotype imitation, the ambrotype (1854 by James Ambrose Cutting of Boston) made underexposed negatives backed with an opaque material or varnish to create a positive. In 1856 Hamilton L. Smith created a similar process using iron plates (tintypes), which became widely used because of their durability and low cost.

Gelatin Dry Plate In the search for a more consistent medium, experiments done in the 1870s (especially by Dr. Richard Leach Maddox) arrived at a practical dry plate in which glass was coated with a silver

Figure 1.8 A portable darkroom for the wet collodion process.

bromide emulsion. By 1873 John Burgess had introduced a ready-made emulsion for sale and in 1878 Charles Bennett ripened this emulsion for 1/25 second capabilities.

Celluloid Roll Film Soon after celluloid could be manufactured to a standard .01-inch thickness, John Carbutt successfully replaced glass with a celluloid dry plate. In 1888 early work on celluloid roll film was carried out by Hannibal Goodwin but it was the work of Henry M. Reichenbach for the Kodak camera in 1895 that lay the foundations for modern photography. His film was backed with paper for loading in daylight and closely resembles our present-day film. Color sensitivity of black-and-white film improved when Hermann Wilhelm Vogel added dyes to silver bromide emulsions and came up with the *orthochromatic* plates of 1873. In 1903 Adolphe Miethe developed *panchromatic* films, which were sensitive to all colors but required shooting through a yellow filter because of an oversensitivity to blue. The flammable nature of cellulose nitrate film was no longer a worry after the introduction in 1930 of safety film and especially after 1965 when nontearing polyester film was used.

PAPER PROCESSES

Salted Paper Print (1840–1855) Originally part of Talbot's calotype process, writing paper was soaked in a weak salt solution with silver nitrate brushed on, resulting in silver chloride. This printing-out paper (developed solely through exposure) was fixed with Herschel's thiosulphate and required contact printing. Although the results lacked detail, its accessibility attracted many.

Albumen (1850–1895) In a desire to coat paper to obtain better printing consistency, Louis Désiré Blanquart-Evrard used a solution of egg white and salt to soak the paper, thus creating a separate layer for the silver nitrate. The prints could be tinted and had a glossy surface, creating greater detail, but because of the extensive preparation involved, they were highly unstable.

Carbon Process (1860–1940) Wanting to avoid the fading quality of silver processes, experiments began with bichromates, the light-hardening nature of which was first discovered by Mungo Ponton in 1839. Paper coated with gelatin, potassium bichromate, and pigment (initially carbon black) was exposed and then washed in warm water to remove unexposed areas. Major advancements were made in the patent by Joseph Wilson Swan in 1864, although the process remained too time-consuming for large scale use. (See Figure 1.9 for an example of a carbon print.)

Gum Bichromate (1880–1920) This non-silver contact printing method uses paper coated with an emulsion containing gum arabic, bichromate sensitizer, and watercolor pigment (note that the more common designation for bichromate is now dichromate). Throughout their history, gum prints have always been handmade by the photographer. As with all bichromate processes, the exposed parts of the negative are hardened by light, permitting the unexposed areas to develop (dissolve) in water. The watercolor provides density to the midtones

Figure 1.9 Paul L. Anderson, *The Arcade,* plate 18 from "The Smith College Album," carbon print, 1935, 12.5 × 9.8cm. Collection: IMP/George Eastman House. Reprinted with permission of IMP/George Eastman House.

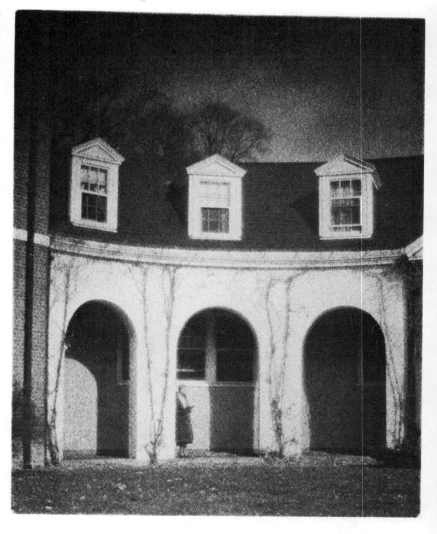

and shadows, the paper white forms the highlights. The process was popular with pictorial photographers, and still is prevalent today because of the manipulation available in handwork and color. (See Color Plate 1.)

Bromoil (1907–1955) The process evolved following E. J. Wall's suggestions in 1907 that it be used as an alternative to the earlier oil process. The oil process required a negative the same size as the finished print whereas bromoil prints can be made directly from bromide enlargements. Details were worked out by Welborne Piper and others, but the process did not reach its best known form until the 1920s. The conventional print is bleached, leaving a faint image, which takes up oil pigment applied with a brush (any color can be used). An extension of this process was the bromoil transfer, which transferred the inked image by pressure to another base. Bromoil rivaled—and somewhat displaced—gum printing in the pictorial scene as a result of its enlarging capabilities.

Cyanotype (1880–1920) First discovered by Herschel in 1842, *cyanotype* is an inexpensive process that uses paper coated with iron salts and potassium ferricyanide, which become darker shades of blue when exposed to light. The present day blueprint is a close relative.

Platinotype (1880–1930) This highly permanent process came through initial discoveries by Herschel on the light sensitivity of chloride of platinum. This ready-to-use paper produced beautiful, delicate tones, but was kept from widespread use due to its cost.

Gelatin Silver Chloride Printing-Out Papers (1885–1920) Significant advances for silver papers included the use of Barium sulphate (baryta) as an insulator between paper and emulsion, providing greater contrast and choice of surface characteristics, the subsequent selling of premixed emulsion, and the ability to sensitize large rolls of paper by machine.

Bromide Developing-Out Papers (1885 to Present)
Bromide developing-out papers are similar in nature to printing-out papers. The increased sensitivity attained with the addition of bromide filled the need brought about by enlarging from small negatives.

PHOTOMECHANICAL PROCESSES

Woodburytype (1866–1900) Walter Woodbury's permanent photomechanical process involved making a relief in bichromated gelatin, then a lead mold, into which pigmented gelatin was poured and then transferred to paper in a hand press.

Collotype (1870 to Present) Collotype process covers a very popular and versatile series of photomechanical processes that use bichromated gelatin on metal or glass plates that are treated with glycerin after exposure and used to transfer a variety of greasy inks onto paper surfaces (see Figure 1.10).

Photogravure (1880 to Present) Photogravure is a photomechanical process invented by Karl Klic in which a copper plate is coated with resin dust and covered with a bichromated gelatin tissue that becomes etched after exposure through a negative. The plate is then inked and pressed.

Letterpress Halftone (1885 to Present) First patented by Frederick Ives in 1881, the letterpress *halftone* rephotographs a *continuous tone image* through a screen, creating large dots in dark areas and small, widely spaced dots in light areas. The practical nature and subsequent widespread use of this process ushered in photojournalism.

Figure 1.10 A collotype preparation table for glass plate sensitizing and drying. *Source: The Encyclopaedic Dictionary of Photography,* Walter E. Woodbury. (New York: Arno Press) 1979 reprint of the 1898 ed. published by The Scovill and Adams Co., New York, p. 129.

THE HISTORY OF GUM BICHROMATE PRINTING
Gum bichromate printing prevailed at a time in photographic history when processes were changing rapidly. Photographers could suffer from an inferiority complex if they were not aware of the latest "stratagem."

Many of these processes are now found under the classification of obsolete in photographic dictionaries. They include methods of making positive prints by exploiting the various physical changes produced in a *bichromated colloid,* with the action of light. Certain organic colloids such as albumen and gum arabic, sensitized with a bichromate such as potassium or ammonium, change their physical character when exposed to light. Three principal changes can take place in the colloid: it can no longer absorb water and swell up, it can lose its surface tackiness, or, if previously soluble, it can become insoluble.

The principal processes based on the swelling of the colloid are bromoil and oil printing. In these, following contact exposure under a negative, the colloid bathes in water so that the unexposed areas swell. A greasy ink is then applied with a brush, rejected by the swollen areas, and accepted by the exposed unswollen colloid to form an image.

The dusting-on or powder process is based on the loss of tackiness. In this, a bichromated colloid such as gum arabic is exposed under a negative and "developed" by being lightly brushed over with a finely powdered pigment. Where the light has acted, the surface loses its tackiness and the pigment does not adhere. Thus an image is formed only on tacky, unexposed areas.

There are three principal processes based on the change in solubility of the colloid: carbon, carbro, and gum bichromate. Alphonse Louis Poitevin (1819–1892), a French chemist and photographic inventor, is credited with the discovery of the principle involving the action of light on chromated colloids in 1855.[3] John Pouncy (1820–1894), an Englishman, first took Poitevin's theory and developed the gum process around 1856.[4] Reeve and Sward summarize this discovery:

> Ultimately, three men were responsible for the research on which gum printing is based: Mongo Ponton, who discovered the light sensitivity of dichromates in 1838; Talbot, for noting that soluble colloids mixed with a dichromate lose their solubility; and Alphonse Louis Poitevin, who in 1855 added pigment to the colloid.[5]

Yet, the process did not reach full popularity until forty years later when Alfred Maskell of England and Robert Demachy of Paris used it. They called it the Photo Aquatint Process and between 1894 and 1900 worked extensively with the methods. They became its leading exponents, first with single and later *multiple printing.* From their endeavors, the process became popular over the next twenty years.

Another major figure in the history of gum printing is Arthur Baron Von Hubl. He was an Austrian officer who made valuable contributions to photomechanical processes, color photography, and color printing. His work entailed extensive studies on emulsions and *sensitometry* and in 1898, he invented multiple gum printing.[6] It was after Hubl's presentation that Demachy began his work in multiple gum printing.[7]

Gum printing seemed particularly suited to the new photographic genres then in vogue. Several new "pictorial" processes, or variations on old processes, were discovered and extended the range of manipulation available to photographers. This paralleled an increasing desire for processes that were more permanent. Two styles were gaining popularity.

The first involved direct manipulations of the negative such as distortion through abnormal exposure or development (e.g., overexposure causing reversal of the highlights, which altered the way volumes and spaces looked). Changes the most apparent to the untrained eye were

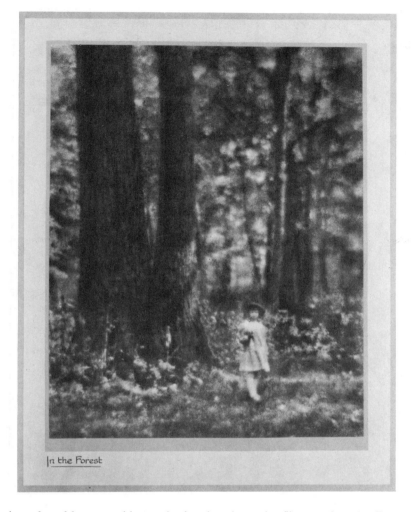

In the Forest

Figure 1.11 Charles Macnamara, *In the Forest,* oil pigment print, c. 1911, 29.3 × 22.7cm. Collection: Judith and Martin Hunter, courtesy of the Art Gallery of Ontario, Toronto.

introduced by scratching or by handwork on the film, as done by Frank Eugene. The second involved changes introduced at the point of making the print, as is the case with gum printing. Such techniques in handwork and color evoked styles that the secessionist photographers found attractive in painting and the related graphic arts. They all required stepping beyond the conventional means of producing photographs. (See Figure 1.11.)

Because of this philosophical and visual kinship to the traditional fine arts of the period, photographs made during that time are called "pictorial," "high art," or "salon" photographs. The freedom offered by the fact that parts of the image could be removed or altered caused the process to be severely criticized. Some critics declared that gum prints were not photographs. Yet, it is well documented that photography was practiced by numerous late nineteenth-century artists.[8] Among the most noteworthy was Edgar Degas (1834–1917), who adopted the impressionist compositional device of the close-up borrowed from photography. Many artists also left painting for photography; Edward Steichen, Gertrude Kasebier, and Alvin Langdon Coburn are among the better known (see Figure 1.12, next page).

Figure 1.12 Gertrude Kasebier, *The Swing,* gum bichromate print, 1909, 33.4 × 25cm. Collection: IMP/George Eastman House. Reprinted with permission of IMP/George Eastman House.

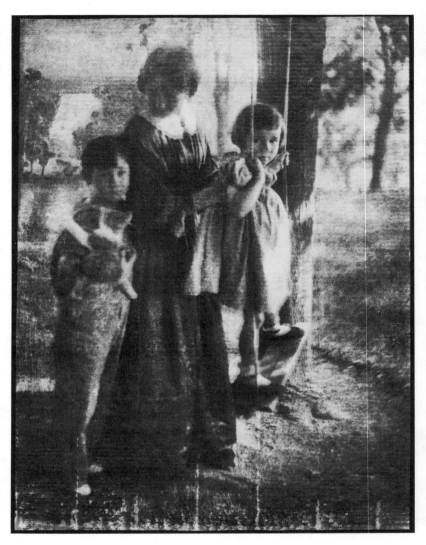

NOTES

1. A. Kraszna-Krausz, ed., *Victorian Photography* (London: Focal Press, 1942), p. 7.

2. From Arnold Gassan, *A Chronology of Photography* (Athens, OH: Handbook Co., 1972), pp. 125–126.

3. For a copy of Poitevin's French and English patents, see Luis R. Nadeau, *Gum Dichromate* (Federicton, Canada: Atelier Luis Nadeau, 1987), pp. 7–9.

4. Discrepancy on this date varies between 1856 and 1859. W. J. Warren in *The Gum Bichromate Process* (London: Iliffe Books, c. 1899), p. 11, states 1859. A. Kraszna-Krausz (ed.) in *The Focal Encyclopedia of Photography,* Vol. 2 (Boston: Focal Press, 1965), p. 1165, states 1857. Bernard E. Jones (ed.) in the *Encyclopedia of Photography* (New York: Arno Press, 1974), p. 425, states 1856. Nadeau disagrees on Pouncy as the originator of prints from photographic negative, claiming in fact that Poitevin was first (*Gum Dichromate,* p. 9, footnote 15).

5. Catherine Reeve, and Marilyn Sward, *The New Photography* (Englewood Cliffs, NJ: Prentice-Hall, 1984), p. 68.

6. A. Kraszna-Krausz, *Focal Encyclopedia,* p. 757. Nadeau credits Poitevin as the originator of multiple gum printing based on his original French patent (the English patent is not identical), stating that "Yet another unknown aspect of Poitevin's patent is that it covers the idea of multiple printing using different colors, as well as the idea of using several coats of different colors prior to the exposure." (*Gum Dichromate,* p. 7).

7. Leyland Whipple, "The Gum Bichromate Printing Process" (Rochester, NY: IMP/George Eastman House, Cat. 81.4 W574 #9998, 1964), p. 4.

8. For a full account of the relationship between art and photography, see Marina Vaizey, *The Artist as Photographer* (London: Sidgwick and Jackson, 1982).

2
KWIK-PRINT

Kwik-Print is the ideal introduction to gum bichromate printing. Kwik-Print was introduced in the 1940s as a graphic art proofing medium labeled "Kwik-Proof." Today it is called "the modern version of gum printing."[1] (See Color Plate 2.)

Kwik-Print is perfect for anyone interested in gum printing since it uses the principles of a simplified gum bichromate process. All the chemicals are prepared, including gum, pigment, and sensitizer dilutions and handling is identical to gum printing. Consequently, Kwik-Print provides a "gumlike" print, without the necessity of obtaining and mixing the chemical solutions. Consider the following information:

1. Kwik-Print and gum require the same basic equipment—the light source, registration, and so on, are identical.

2. The novice can test it as an initiatiation to gum printing. A familiarization with the principles of pigment printing can be enjoyed while organizing items such as chemical scales that will be used in gum printing.

3. Kwik-Print is the ideal medium for proofing negatives and practicing *color separation*. Pigments are available in process colors (refer to Color Plate 6 and Step 15 in Chapter 4).

4. Kwik-Print is intended for printing halftones, but it is sufficiently flat for continuous tone negatives to be used. The color is vivid, similar to *gouache colors* used in pigment printing. In fact, organic pigments, not dyes, are the color agent used in Kwik-Print, and the permanence is comparable to Dye Transfer and Cibachrome.[2]

Kwik-Print is distributed exclusively by Light Impressions Corporation.* Contact them for a catalogue listing the materials and pertinent information needed to start working with Kwik-Print.

EQUIPMENT AND MATERIALS

Information in this section is limited to items necessary for Kwik-Print only. Equipment also required for gum printing is mentioned, but not in

*Light Impressions specializes in mail order of archival supplies, photography books, framing, and specialty items such as Kwik-Print. Contact them for specific catalogues and information sheets pertaining to the types of products of interest to you at 439 Monroe Ave., Rochester, NY 14607. Tel.: 1-800-828-6216.

detail. For further information, refer to the Equipment and Materials section of Chapter 4.

Enlarger and Standard Darkroom Equipment

* red safelight filter for the production of enlarged negatives
* contact printing frame
* light box
* small measuring graduate

Film and Chemicals for Enlarged Negatives

* duplicating film
* bromide paper developer

Printing Paper

* artist's intaglio paper or Kwik-Print Base Sheets

It should be noted that originally, a range of specially made printing sheets were available from the manufacturer of Kwik-Print, Direct Reproductions. Their advantage was the ability to speed-dry by blotting or using a hot-air fan. Currently, only "Super White" is available. (These are polyester sheets and do not permit the possibility of vacuum forming* that earlier vinyl sheets had.)[3] Super White has a front which is easily identified by its matte surface compared to its high-gloss back.

An inexpensive alternative that approximates Kwik-Print Base Sheets is recommended by Laura Blacklow: Kimdura plastic-impregnated sheets.[4] Another choice could be photomechanical transfer (PMT) sheets such as those manufactured by Kodak. Use an airbrush for the best application since their extra smooth surface does not respond well to the brushing or buffing techniques used with Kwik-Print.

Kwik-Print is also an excellent formula for printing on fabric and stands up to repeated washing. It works best on synthetics as it is difficult to develop on organics. The color varies depending on the fabric being used.

Paper Size

* Base Sheets do not require sizing, but it is necessary to use a *size* when the look of an "artist's paper" is preferred (see Step 2 in Chapter 4 for information on sizing paper).

Brushes

* oil paint brush[†]
* watercolor brush
* airbrush (excellent for both Kwik-Print and gum, but optional)

*If a printer feels a specific interest in such work, as with most discontinued products, an order can be secured if the amount requested is sufficient.

[†]Brushes are only required if artist's paper will be printed. Kwik-Print sheets do not respond well to brush technique.

Care must be taken to ensure that there is adequate ventilation and that the proper mask is worn whenever using an airbrush. Otherwise the dichromate particles and vapor can be extremely dangerous.

Registration System

• registration pins and stationary or graphic arts punch

White Light Source

• any UV-emitting light source (a photoflood is a first good choice)

Color Pigments

Select from a list of 15:*

Lemon Yellow	Opaque White	Magenta
Pale Yellow	Light Emerald	Crimson
Pale Blue	Dark Brown	Pink
Medium Blue	Geranium Red	Black
Ultramarine Blue	Flesh Tint	Gray

Kwik-Print is available in an impressive spectrum of colors that can be mixed to any desired effect. The pigments are manufactured using a "water dispersed" method, unlike the method of "mixing" with water.[5] Colors have a tendency to settle and must be mixed before printing to avoid air bubbles. Order process colors—Magenta, Lemon Yellow, and Medium Blue—as a starting palette since these may be desired to proof tricolor gum separations. Clear and Process Black are also suggested for the starting kit. Clear is just a sensitizer without pigment. Add it to the basic pigments to increase their transparency or to thin pigments for airbrush application. Pigments have approximately a one-year shelf life.[6] This can be extended if proper storage is provided and pigments are kept in a dark and cool place.

Developing Aids

• As in gum printing, development with Kwik-Print is a wash-out process using plain water. Aqua ammonia (14%)* is available, to be used in a very dilute form—about 7ml per liter of water to clear the highlights. Household ammonia can be substituted—about 100ml per liter of water for a comparable solution. If clearing is difficult and background stain remains, brightener is also available.* Use it moderately, being careful not to remove too much color.

Kwik-Print Wipes

• Kwik-Print non-lint wipes* are available in rolls for applying the *emulsion* although the best technique for applying the emulsion is an airbrush.

*Can be special ordered from Light Impressions (tel.: 1-800-828-6216).

PRINTING WITH KWIK-PRINT

Whenever working with Kwik-Print, take precautions when handling the various solutions. If skin contact occurs, wash with water. For eye contact, wash with water and get medical attention. If any chemical is swallowed, induce vomiting and call a physician. Wear gloves while handling solutions. The aqua ammonia is a strong ammonia solution and precautions should be taken when mixing, and vapors avoided. Do not mix ammonia with acids, chlorine bleach, or other chemicals. Follow the same precautions using an airbrush.

Negative Preparation Kwik-Print is a contact print process and needs a full-scale negative. This does not require a large format camera and can be produced from your existing negatives. Either halftone or continuous tone techniques are suitable and can be easily made. For full details, refer to Step 1 in Chapter 4 and Appendix C.

Emulsion Application Anticipation of multiple printing requires selecting a *registration* system before proceeding (see Steps 6, 14, and 15 in Chapter 4).

The original "Kwik-Proof" information sheets gave two coating methods:

1. Standard method: for best color quality, coat, expose, and develop each color separately. Color Sequence: black, blue, red, yellow.

2. Speed method: omit development between colors and develop only after the final color is exposed. Color sequence: yellow, red, blue, black.[7]

Use the first sequence, printing the dark colors first, for high-contrast or halftone work. But Swedlund observes (and I agree) that it is preferred to reverse color order when working with continuous tone negatives.[8] This is further confirmed by current data from Light Impressions that states,

> Magenta is not recommended for the first application due to its higher pigment content which can make washing more difficult. Proceed with additional colors. If possible, do not use yellow last, as this may create a mottling effect on the print."[9]

Apply the emulsion by hand, using light buffing with the wipes, until the excess color is removed, and the surface is left dry and free of streaks (see Figure 2.1). The wiping technique is important on Kwik-Print sheets. Otherwise, the emulsion becomes too heavy or uneven. (This differs from other methods for the application of a gum emulsion.) Driers are coupled with the colors to speed the coating process.

It should also be noted that some pigment concentrations require "brush development." For "still development," aqua ammonia and brightener are often needed. (See Chapter 4, Step 10.)

Figure 2.1 Wiping technique for Kwik-Print on Kwik-Print Base Sheets.

Exposure Begin exposure immediately after drying. If some delay is necessary, it should not exceed 15 minutes. As with gum printing, this will reduce the risk of fogging and background staining.

One of the pleasing discoveries that will be made with both Kwik-Print and gum printing is the relative sensitivity of the emulsions. Exposures are very reasonable compared with many non-silver (or silver-based) experimental processes. The following represents the manufacturers' suggested guidelines:

	EXPOSURE (MINUTES)			
Light Source	*Black*	*Blue*	*Red*	*Yellow*
1000W-photoflood, or *carbon arc lamp* at 1m, or fluorescent at 15cm	2½	¾	1¼	1½
500W-photoflood	4	1	2	3
Original data, high-intensity UV	2	½	1	1½

The times given for "original data" are from an early Direct Reproductions information sheet. These shorter times are usually required, **even when using the 500W-photoflood.** Consideration should also be given to the fact that blue and red pigments are not successively more sensitive than yellow, as may be assumed from the information. The exposure is also being adjusted for "midtone" and "shadow" printings (see Step 11 in Chapter 4).

Continuous tone images require more exposure than halftones. The *latent image* following exposure is not visible, as with gum printing. A Stouffer Exposure Guide (see page 73) can be included as a test (usually it is written that the exposure should get a solid area in Step 4 of the Stouffer guide). This density provides a good indication for halftone work and would maintain full-shadow detail if you are using a continuous tone negative. But consider basing your test exposure on the highlights, which means a longer exposure than Step 4 would indicate. (See Appendix A for more details on the Stouffer Density Scale.) If the useful density range of the continuous tone negative is .9 to 1.1, then solid Step 8 or 9, which corresponds to a density of about 1.1 or 1.25, is a better exposure. Emphasize highlight detail, let the shadows fall, and print maximum black for a better result.

Printing also can be based entirely on visual observation:

1. Underexposure: Image detail is lost. The exposure has not hardened the color adequately to hold (this can be more of a problem in multiple printing).
2. Overexposure: The print will not clear, even with brightener.

Development Develop in plain water. The entire process for Kwik-Print requires less than 10 minutes, which would be inadequate for a gum print.

If the highlights do not clear after several minutes, rinse in a weak solution of aqua ammonia, diluted 7ml per liter, for 1 minute. Then, rinse the print in water and apply any desired brush manipulation to the surface (see still development and brush development in Step 10, Chapter 4). If the print is acceptable, give a 5-minute final wash.

If the image didn't clear sufficiently, even with the ammonia, use the brightener. Brightener is stronger than ammonia and is best diluted with water, approximately 25 to 50ml per liter. Allow the print to remain in the brightener for 10 to 20 seconds only and then wash for 5 minutes with water. The application of brightener is very delicate and requires careful handling.

Drying The simplest and safest way to dry the print is air-drying. Suspend finished prints using clothespins. Prints on Base Sheets can be blotted with newsprint or mechanically dried using a film drier (which would shrink most other papers) to speed drying.

Multiple Printing Like gum printing, Kwik-Print offers great flexibility with multiple printing. These methods quickly become involving, with limitless options for testing. Until you are more familiar with the options you can choose from when using the gum process, experiment by spontaneously applying additional coatings of the emulsion and test using varied exposure and development. If more advanced details are desired, refer to Step 11 in Chapter 4 and summarize the information of interest.

NOTES

1. Promotional literature from the distributor, Light Impressions, suggests this designation.

2. Charles and Elizabeth Swedlund, *Kwik-Print* (Rochester, NY: Light Impressions, 1985), p. 8, and Light Impressions distribution literature.

3. See Swedlund, *Kwik-Print,* pp. 19–22, for information on vacuum forming.

4. Laura Blacklow, *New Dimensions in Photo Imaging* (London: Focal Press, 1989), p. 43 suggests that Kimdura plastic-impregnated sheets can be ordered from Rourke-Eno Paper Company, 485 Wildwood Street, Woburn, MA 01817.

5. For an explanation of "dispersed" pigments, see Ralph Mayer, *The Artist's Handbook of Materials and Techniques* (New York: Viking Press and Macmillan, 1970), pp. 138–139.

6. Blacklow, *New Dimensions,* p. 109.

7. From Direct Reproduction distribution literature (c. 1965).

8. Swedlund, *Kwik-Print,* p. 32.

9. Light Impressions distribution literature.

INTRODUCTION TO GUM BICHROMATE

UNDERSTANDING GUM PRINTING

You will find many similarities between Kwik-Print and the summaries on gum printing in this chapter. Gum printing requires a negative the size of the desired print. This can be produced either in a camera or indirectly from a small-*format* negative by a suitable mechanical method. A selected paper is *preshrunk* and sized with a transparent, flexible coating, and sensitized with an emulsion of gum arabic, potassium dichromate, and watercolor pigment. The print is made by exposing the negative in contact with the sensitized paper.

Development takes place in plain water. The unexposed areas progressively dissolve, at which time the image can be readily manipulated. The development process can be done under normal light conditions so that modifications are directly visible. When development is complete, the print is air-dried, the image hardens and becomes permanent.

A good print can be obtained in one printing by using a negative with a short *density range* and a suitable emulsion. Still, the customary procedure is to resensitize the paper with a second coating and to reposition and reexpose the negative. Development and further manipulation follow and the process is repeated until a satisfactory print is obtained.

When the final printing has dried, a *clearing bath* and water wash make it permanent. Finished prints are archival. Only the watercolor is left on the surface and the image will last as long as the paper exists. (See Figure 3.1, pages 22–23, for a summary of the gum bichromate process.)

The superimposed layers of pigment create a subtle bas-relief with a distinct physical three-dimensional effect. All the unique characteristics of a watercolor painting are possible, the subtleties that transparent or opaque color, brush strokes, and paper selection bring. Because of personal variations inherent in the process, no two artists work alike.

As with Kwik-Print, the materials and chemicals required for gum printing are readily available and inexpensive. Complete cleanliness is easily maintained, since the emulsion of watercolor, dichromate sensitizer, and gum arabic is soluble in water.

1. Ingredients

a) Sensitizer
(dichromate)

POTA
DICH

b) Emulsion binder
(gum arabic)

M ARABIC

c) Pigment
(watercolor)

WATERCOLOR

2. Preparation

a) Mix sensitizer
with water.

MIXED
SENSITIZER

b) Mix watercolor
with liquid gum arabic.

GUM +
PIGMENT

3. Paper

a) Preshrink in water

WATER

b) Coat with a "size" of
gelatin and formaldehyde.

SIZING

Exposure light

4. Coat and expose

Mix and coat an emulsion
of sensitizer mixed with
equal amounts of
watercolor/gum solution.
Contact-print with
an enlarged negative.

Register negative on
paper using suitable
technique.

Figure 3.1 The gum bichromate process summary.

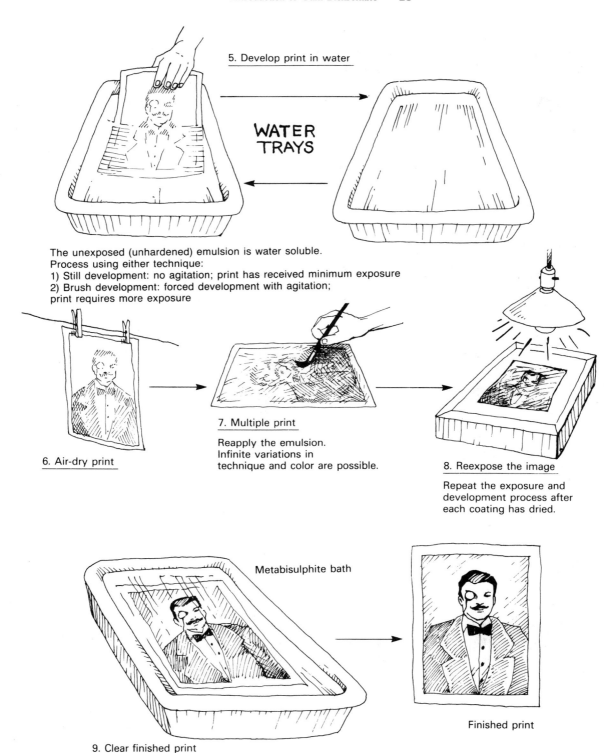

5. Develop print in water

WATER TRAYS

The unexposed (unhardened) emulsion is water soluble.
Process using either technique:
1) Still development: no agitation; print has received minimum exposure
2) Brush development: forced development with agitation;
print requires more exposure

6. Air-dry print

7. Multiple print

Reapply the emulsion.
Infinite variations in
technique and color are possible.

8. Reexpose the image

Repeat the exposure and
development process after
each coating has dried.

Metabisulphite bath

Finished print

9. Clear finished print

Figure 3.1 The gum bichromate process summary (continued).

GUM BICHROMATE FORMULAS SUMMARY

Negatives

- Make enlarged negatives from 35mm negatives using duplicating film processed in a dilute bromide paper developer such as Dektol 1:10 water.
- Develop to a density range of about 1.0.

Paper Preparation

- Preshrink paper in hot water for 1 hour. Hang to dry.
- Prepare size by mixing 30g of gelatin per 1000ml of cool water.
- Allow gelatin to absorb for 15 minutes, then heat the container until gelatin has dissolved.
- Soak paper in warm solution for 15 minutes.
- Hang to dry.
- Prepare hardener/preservative by mixing 25ml of 37% formaldehyde per 1000ml of water.
- Soak dried paper in it for 10 minutes.

Sensitizer

- To make your own sensitizer, use
 13g of potassium dichromate
 75ml of water (50°C)
 cool water (for 100ml total)

Gum Arabic

- Preferred choice is a premixed solution.
- To make your own solution, use
 2.5g of mercuric chloride (or substitute 15ml of a 37% solution of formaldehyde)
 1000ml of water (cool, distilled)
 300g of powdered gum arabic

Stock Pigment and Gum Solution

- With tubes, begin testing at 1g pigment per 3ml gum (for printing without testing, use 1g per 5ml gum).
- With powders, begin testing at 1g pigment per 6ml gum (for printing without testing, use 1g per 10ml gum).

Plasticizer

- Mix plasticizer into powder pigments after weighing.
- Use before mixing powders with gum arabic.
- Use a minimum from the following formula:
 40g white sugar in 20ml of hot, distilled water
 150ml of stock gum solution
 10 drops of photo-flo
 30ml of glycerol

Emulsion

- Prepare by mixing 1 part mixed potassium dichromate with 1 part prepared pigment and gum.

Print Stabilization

- Presoak the print in water.
- Follow with a soaking in a 1% solution of potassium metabisulphite, until any visible dichromate stain is removed, or about 2 minutes.

Color Separation Negatives

- For continuous tone, use a special separation film such as Kodak Super-XX Pan Film, processed in Kodak HC-110 developer, dilution B, 1:7 for a density range of .9 to 1.10. Prefer the red-filtered separation (cyan printer) with slightly less density than the other separations.
- For halftones, use a special panchromatic lith film such as Fuji Fujilith Panchro Film HP-100, processed in Kodalith Super-RT developer. Prefer the red-filtered separation (cyan printer) with slightly less density (a highlight dot of about 92% compared to 95% for the other separations).

Color Separation Pigments

- Use yellow, magenta, and cyan pigments, printed in the respective order. Mix pigments to maximum pigment concentrations.
- Try to reach proper densities in one exposure for each separation.

Color Separation Masking

- To print highlight, shadow, and color correction masks, use Kodak Pan Masking Film 4570 processed in HC-110, dilution B.
- Process highlight and shadow masks to a density of .3 to .5 and color correction masks to a density range of about 20% to 30% of the continuous tone.

GUM BICHROMATE EQUIPMENT AND MATERIALS SUMMARY

Enlarger and Standard Darkroom Equipment

- red safelight filter
- contact printing frame
- light box
- small measuring graduate
- glass dropping bottle
- plastic dropper jars
- chemical balance
- densitometer (optional—can be improvised, refer to Chapter 4)

Film and Chemicals for Enlarged Negatives

- duplicating film
- bromide paper developer

Printing Paper

- artist's intaglio paper

Paper Size

- gelatin
- formaldehyde

Brushes

- oil paint brush
- watercolor brush

Color Pigments

- watercolor in tubes or powders

Emulsion Binder

- gum arabic solution or powder
- mercuric chloride or formaldehyde (for powder only)
- distilled water (for powder only)

Sensitizer

- ammonium or potassium dichromate

Clearing Bath

- potassium metabisulphite

White Light Source

- any UV-emitting light source (e.g., a photoflood)

Color Separation Negatives

- Continuous tone or halftone separation film, developer, and separation filters

Color Separation Pigments

- yellow
- magenta
- cyan

Color Separation Masking

- Panchromatic masking film and developer

SYSTEMS FOR DESIGNING A NEGATIVE

A photographer must be cognizant of negative quality with any photographic process. Otherwise, the most skilled of printers can meet with disappointment. This section gives some options for making continuous tone and halftone techniques. Either system can be effective for Kwik-Print or gum printing. The continuous tone method is the definite choice for the purist. Yet, the halftone negative has advantages for a beginning and tricolor printer. The negative requirements for gum and Kwik-Print are very similar. Specifics for the production of halftones are outlined in Appendix C. Continuous tone negatives are discussed in Steps 1 and 14 of Chapter 4.

Considerations for Choosing a Halftone Negative

Halftone printing creates an image by illusion. In gum printing, this has the following effects:

1. The halftone printed from a tricolor separation is not visible, because of the necessary rotation of the screen. This mutes recognition of the dot in the same manner that it eliminates *moiré*. As Zimmermann noted, "When four layers of colored dots are printed over each other the dots always look finer than they would if just one was printed in black ink."[1]
2. The intrinsic nature of a gum print is to be a soft print. When printed with a halftone screen, the dots tend to "bleed" and create a diffused dot that is hardly discernable. (Extra smooth paper, such as Kwik-Print's Base Sheets, will have some halftone recognition.)
3. The pigmented dots hold better when exposed through the halftone and the unexposed areas wash more cleanly in the development process. (It follows that a continuous tone negative increases the difficulty in washing unexposed image areas.)

Sensitometry and Color Separation A knowledge of sensitometry is not required to practice gum printing or any other photographic process. The first edition of this book contained no sensitometric references, following the purist tradition in gum printing. This was also based on the observation that students often have little interest in the technology of photography—they feel they can succeed entirely with the visual principles of image making. Indeed, photographers can get impressive results by using visual skills. But there are important aspects to this system such as the fact that a magnifier with a minimum 5 power should be used whenever examining negatives. Also, a comparative study of all test results should be emphasized since we learn visual skill by witnessing change. Seeing great photographs does little to improve vision. Prefer examining two prints (or your test strips) with a slight variation, and you will acquire a lasting visual experience.

Color separation and other new techniques covered in this second edition have increased the need for sensitometric knowledge. The objective is to clarify the elements relevant for the gum process and to help readers without experience use it in the home darkroom. A homecrafted densitometer can be improvised, or the visual use of a transmission gray scale such as the Stouffer Density Scale or the Kodak Projection Print Scale, can be substituted. For more details, see "Densitometer" in the Equipment and Materials section of Chapter 4, Steps 1 and 14 also in Chapter 4, and Appendices A and C.

Two current books on the technique of photography are recommended, *The Practical Zone System* and *Sensitometry for Photographers.* In the former, Johnson states

> Notice the absence of logarithmic curves and scientific terminology in this book. This information is not essential to the system and often scares people away. For those who favor a scientific approach to their work a number of excellent, more detailed technical books on the zone system are listed. . . .[2]

In the latter, Eggleston states:

> With the superb cameras, materials and equipment available today, we can all produce photographs of good average quality. We may even achieve an optimum now and again, but only a competent photographer who understands and uses sensitometry can exploit high-quality equipment and materials to full advantage . . .[3]

Prefer to agree with both philosophies. Draw upon all sources of information to accomplish the objective. Discovery is useful in photographic education for the 1990s when the search for new images is intensified and much of photography can be represented as *minimal art.* (This visionary change seems to have been initially influenced by the way the *pop art* movement interacted with photography.)

Considerations for Choosing a Continuous Tone Negative
You have many options to achieve a good continuous tone negative. The highest quality negative for any process is an original. The gum print requires contact printing with a high-intensity light source, which suggests the introduction of a large-format camera. But there are alternate methods for enlarged negatives when using a small-format camera. The simplest and most direct technique is the use of *duplicating film.* (A product such as that manufactured by Fuji or Kodak is suitable.) Project an original small negative with an enlarger onto the duplicating film to produce a negative of any size. (When exposing film material by enlarging methods, always place black construction paper over the easel, below the film, to prevent *irradiation.*) This results in printing a negative from a negative. An intermediate positive is unnecessary.

Duplicating film is a subclassification of *lith film.* Lith film is normally extreme in contrast and development therefore requires modification to obtain a density range useful for gum printing (see Appendix A). Observe the following with duplicating film:

1. The film has a speed significantly slower than enlarging paper or other lith films.
2. Increases in exposure *reduce* negative density.
3. Decreases in developing time reduce negative contrast.

A second method to obtain a negative requires access to a commercially made transparency duplicator (see Figure 3.2).* The typical

*Two transparency duplicators currently available are the Beseler Dual Mode Slide Duplicator made in the United States and the Bowens Illumitran from England. To consider a purchase, discuss their differences with a dealer. Homecrafting a similar unit would not be difficult.

unit has a roll film camera mounted on a copy stand. Below, as an exposure platform, is an *electronic flash* covered with opal glass. You can make interpositives with a low-contrast emulsion such as Kodak's *Fine Grain Positive* and print them to the required size on ortho sheet film. You should *bracket exposures* when using a slide duplicator because of the critical demand of flash exposure.

A third method requires the use of a 10 × 13cm enlarger. Enlarge a small-format negative to a 10 × 13cm film positive, then print to the required size on ortho film. If you only have a small-format enlarger, contact-print and enlarge the original negative.

Any of these preceding negative options can be used with equal success in gum printing. They also provide a saving when compared to the time and expense required for a large format camera and film.

NOTES

1. Philip Zimmermann, ed., *Options for Color Separation* (Rochester, NY: Visual Studies Workshop, 1980), p. 6.

2. Chris Johnson, *The Practical Zone System* (Boston: Focal Press, 1986), pp. vii, viii.

3. Jack Eggleston, *Sensitometry for Photographers* (London: Focal Press, 1984), p. v.

Figure 3.2 A commercial copier can be used for intermediate positives.

CHAPTER 4

GUM BICHROMATE PRINTING

This chapter spans beginning to advanced gum printing. You begin with the supplies and then follow a series of "steps" that divide the process into 15 stages. This information has already been condensed in Chapter 3 (see Figure 3.1 and the Formulas and Equipment and Materials summaries). Begin quickly by finding the information to answer your questions from the summaries and try to get some immediate results. This will make understanding the details simpler and more fun!

EQUIPMENT AND MATERIALS

The quantities listed correspond to the minimum amounts commonly available from suppliers. Brand names, when suggested, are readily available. You can use them or other brands to determine their suitability to your needs. Manufacturers' data and chemical safety sheets should always be requested. A detailed explanation of chemicals is given in Appendix F.

Enlarger and Standard Darkroom Equipment A small-format enlarger is adequate, although there are certain restrictions when working with enlarged negatives, as outlined in Step 1. A 10 × 13cm enlarger is a good investment and extends the range of capabilities for special printing processes.

Print developing trays of adequate dimensions are needed. They should be one size larger than the negative, owing to the larger borders that are customary with gum printing. For example, a 20 × 25cm negative requires paper cut to 28 × 35cm.

Other items can offer convenience or better accuracy, but they are not essential. Sundries include timers, print easel, and so on. If you do not already have them, you can acquire them as the need arises.

Red Safelight Filter All film products for enlarged negatives are either orthochromatic or *blue-sensitive*. Unlike panchromatic emulsions, these can be handled under a red safelight. Be certain to follow the film manufacturer's data for correct distance and bulb. Test safelight filters periodically as fading occurs with use.

There are alternatives to using a commercial safelight:

1. The least expensive option consists of specially made "bare bulbs," available at electrical suppliers and photo stores (at a higher price).

Figure 4.1 *(left)* Spring-back contact frame. Be careful not to alter registration when securing paper and negative.

Figure 4.2 *(right)* A hinged glass contact printer. This is a simplified system that avoids registration difficulties.

They eliminate the need for a special safelight housing, reducing the cost to that of a basic socket.

2. If existing safelight housings are available, but require filters, these can be constructed from the plastic masking films discussed in Appendix B. This material is inexpensive and can be purchased in small quantities from art stores or art college supply stores. Ulano's "Rubylith" is an excellent red safelight material, in a double thickness. "Amberlith" is brighter and makes an excellent safelight for the gum emulsion (controlled amounts of "white light" also are acceptable).

Contact Printing Frame As with print developing trays, the frame should be several sizes larger than the negatives being printed. It must not interfere with accurate image registration, as errors can ultimately ruin a print on which extensive work has been done (see Figure 4.1). Only certain types are suitable. For example, glass hinged on the end reduces movement of the negative and paper (see Figure 4.2). If the frame has a sponge base, pressure can be inadequate for high-quality contact printing. Other types are available or you can begin printing with a makeshift frame such as a sheet of heavy glass, possibly weighed down or clamped on the corners. Note that frames with a plastic (instead of glass) contact plate are very susceptible to scratches and are costly to replace.

Superior to the contact frame is the vacuum table. Consideration can be given to the purchase or construction of a unit after familiarity with the process and the need for such a piece of equipment are established (see Figure 4.3).

Light Box A light box is necessary for examining the enlarged negatives, masking, opaquing, and other functions. Color-corrected units are available, yet unless precise tricolor printing is planned, they are not necessary. The price of a small portable light box has become reasonable, but you can easily construct your own (see Figure 4.4).

Small Measuring Graduate In addition to the usual darkroom measuring graduates, at least one supplementary graduate is needed (see Figure 4.5). It should be accurate to ±.5ml to a maximum of 25ml.

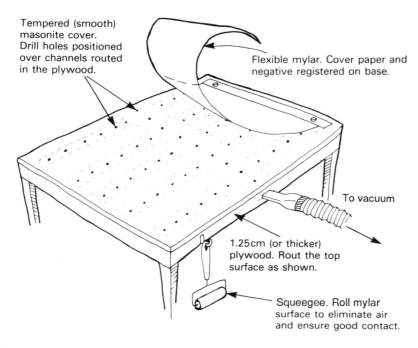

Tempered (smooth) masonite cover. Drill holes positioned over channels routed in the plywood.

Flexible mylar. Cover paper and negative registered on base.

To vacuum

1.25cm (or thicker) plywood. Rout the top surface as shown.

Squeegee. Roll mylar surface to eliminate air and ensure good contact.

Figure 4.3 Homecrafted vacuum table.

Glass Dropping Bottle Dispensing the sensitizer from a dropping bottle helps measure small amounts (see Figure 4.5). A burette, pipette, or syringe are suitable substitutes when used with a regular container.

Plastic Dropper Jars Plastic dropper jars are convenient for the preparation and use of the emulsion (see Figure 4.5). They should not be confused with the glass dropping bottle that requires a pressure-squeeze operation and has a small narrow dropper outlet. They store "stock solutions" of pigment and gum, eliminating the need to prepare a fresh mixture for each print. The number required increases with the color "palette," but about six in 150ml size should be sufficient to start with.

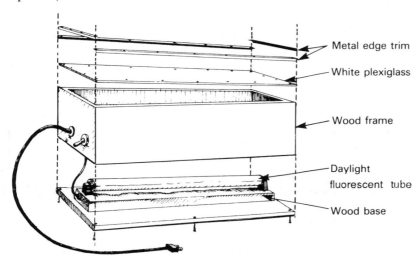

Metal edge trim

White plexiglass

Wood frame

Daylight fluorescent tube

Wood base

Figure 4.4 Homecrafted light table.

Figure 4.5 A measuring graduate, dropping bottle, and plastic dropper jar.

Figure 4.6 Chemical scale.

Chemical Scale Early texts referred to measuring pigments in inches squeezed from tubes and powder quantities taken by the "thimbleful." However, accurate measurement produces results that are more easily duplicated and decreases variables. It is best to acquire a chemical scale and use careful measurement with all photographic procedures (see Figure 4.6). A scale soon proves to be a useful investment.

A fair degree of refinement in the scale is desired. Select a triple-beam balance capable of measuring up to 500g, accurate to ±.05g. *Do not purchase scales that do not use the metric system*—their use is obsolete.

Film and Processing Chemicals for Enlarged Negatives

As explained in Chapter 3, you can make your existing negatives into a larger size by using a duplicating film (such as made by Kodak or Fuji). Obtain continuous tone results by processing in a bromide paper developer (such as Kodak's Dektol) or halftone results by using a lith developer. A stop, fix, washing aid, and photo-flo are also required. For information on the use and handling of these products, refer to any book outlining the fundamentals of photography.

Stationary or Graphic Arts Punch and Registration Pins

A simple and inexpensive system for multiple gum printing is pinhole registration (refer to Step 6). Working with more advanced methods such as color separation and masking can involve a variety of picture "elements." The image must be broken down and assembled with greater precision and with a method that is easy to repeat.

A practical alternative uses an ordinary two-hole stationary punch and registration pins purchased from a graphic arts supply store (see Figure 4.7), such as those made by Kodak or Stoesser (not to be confused with Stouffer). A nonadjustable punch prevents sliding of the surface. Compare the size of the hole to ensure that it matches the registration pins. Adhesive female tabs are available and can replace the need for perforating the film or paper. They are also helpful for registering unpunched films after printing. If a contact frame is used with the registration pins, a strip along the edge of the frame can be cut to accommodate the pins (see Figure 4.52). Better and more expensive systems can be purchased commercially, such as Kodak's punch registration system.

Densitometer

The use of a densitometer will simplify your work (see Appendix A and Appendix B for more information on densitometers and what to substitute for one). Today, light meters such as the "Gossen Master Six," have accessory attachments (Fiber Optics Probe) capable of *extremely* accurate sensitometric measurements. These are reasonable in cost provided one can afford the meter in the first place. However, if you like a bit of improvisation, the following text and illustration on how to make a homecrafted densitometer are very inspiring (see Figure 4.8). It also provides an excellent "mini course" on sensitometry!

While it is not expected that the average amateur will have access to a professional type densitometer, it should nevertheless be possible and it is certainly desirable for anyone to construct a simple instrument using one of the many popular types of photo-electric exposure meters.

The density meter to be described will not be dependable for ascertaining absolute density measurements, but it can be of very great value to a beginner in providing accurate comparison of the relative densities of his

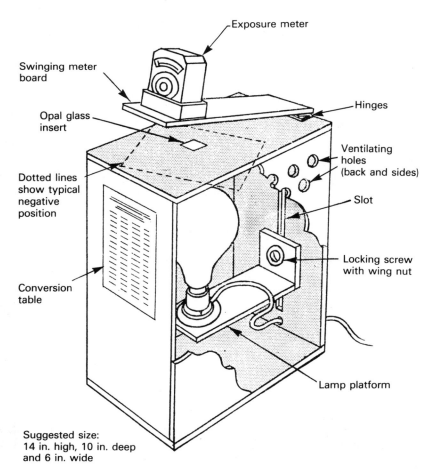

Figure 4.7 Registration tools including a paper punch, adhesive tabs, and options in registration pins. (Prefer the Stoesser pins.)

Kodak registration pin

Peel off adhesive cover

Stoesser registration pin

Exposure meter

Swinging meter board

Hinges

Opal glass insert

Ventilating holes (back and sides)

Dotted lines show typical negative position

Slot

Conversion table

Locking screw with wing nut

Suggested size: 14 in. high, 10 in. deep and 6 in. wide

Lamp platform

Figure 4.8 Densitometer with side cut away to show adjustable lamp. *Source: Making Colour Prints,* Jack H. Coote. (London: Focal Press), 1944.

colour separation negatives, something which the unaided eye can never be relied upon to do.

It will be clear from the accompanying drawing that basically the meter is nothing more than a wooden box containing a lamp which can be moved up or down and locked in any desired position. Since a high level of illumination will be necessary, adequate ventilation must be provided in the form of holes in the back and sides of the box.

The lid of the box must have a small hole (⅛th in. diam.) bored in the centre, and covering the hole is a small piece of opal glass, let into the lid so that the glass is flush with the surrounding wood.

Finally a hinged board is required to accommodate the particular exposure meter which will be used, and to swing up or down for the positioning or removal of negatives. Naturally a hole must also be cut in the hinged member in such a position that it will fall centrally over the small hole in the lid as well as being centrally placed below the window of the photo electric cell. When the exposure meter is placed in position, the diameter of this hole should be approximately a half an inch.

With the exposure meter in position, but no negative, the lamp is switched on and adjusted up and down until a full scale reading is obtained, which may be 100 or 50 or some other number of calibration units. It may in some cases be necessary to use a small photoflood bulb in the meter to obtain the full deflection. Then if a negative is placed over the measuring hole in the lid, and a second reading is taken, it will obviously be a lower number than before, and it is from this relation of full scale reading to the second reading that we can obtain a measure of density for any particular silver deposit.

Suppose for instance that the full scale or 'no density' reading is 100 units, and that with a particular deposit in position the second reading dropped to 20 units, then simple division of the no density reading into the second reading will result in a measure of the transmission of the deposit—in this case ⅕th; and conversely, division of the full scale reading by the lower reading will give the opacity—which is 5. From the opacity we can quickly obtain the density measurement as density is defined as the *logarithm of opacity*—log. 5 being 0.698 or for our purposes 0.7.

For the convenience of those who decide to make a density meter on the lines suggested, here is a simplified table of opacity—density conversions which might be usefully copied and attached to the meter.[1]

Opacity	Density	Opacity	Density	Opacity	Density
100	2.0	10	1.0	1.6	0.2
90	1.95	9	0.95	1.5	0.18
80	1.9	8	0.9	1.48	0.17
70	1.85	7	0.85	1.45	0.16
60	1.8	6	0.8	1.4	0.15
50	1.7	5	0.7	1.35	0.13
40	1.6	4	0.6	1.3	0.11
30	1.5	3	0.5	1.26	0.1
25	1.4	2.5	0.4	1.2	0.09
10	1.3	2	0.3	1.1	0.05
15	1.18	1.8	0.25		

For a more recent discussion on densitometers and other ways to construct one, refer to *Sensitometry for Photographers*.[2]

It should be noted that one advantage for the homecrafted densitometer is its suitability for halftone measurement due to the need of using a probe with a large opening. Interpreting large-scale negatives for gum printing further diminishes the demand for a narrow probe and precise appraisal. For more information on density readings, see Tables A.1 and A.5 in Appendix A.

Printing Paper: Artist's Intaglio Paper

It is possible to apply the gum emulsion to a variety of surfaces. The favored approach for beginners is the traditional method on paper.[3] The paper is repeatedly soaked in water and must be able to resist tearing and to retain an aesthetic appearance. *Intaglio* or etching paper is manufactured with these considerations in mind. Some watercolor papers also behave in an excellent manner, but not as consistently as etching papers.

The chemical purity—its pH value or acidity—determines how stable the paper will be. PH value is used to indicate the alkalinity (by a figure above 7) or acidity (by a figure below 7) of an aqueous solution. The purest papers are referred to as having a pH value of 7—the same neutral designation as water. The most permanent paper is made from linen rags, although a small amount of cotton is permissible. A chemically neutral container for storage will help avoid contamination.

The effects of texture can vary the image character and enhance the printing range. Coarse, rough papers diffuse the image with a loss of detail. Smooth papers, provided they offer an adequate grip for the layers of gum, increase sharpness and contrast. Unlike what happens with relief or intaglio printing, the paper's weight is not a factor since there is no press to exert extreme pressure. Nevertheless, a heavier paper resists shrinkage and handles better and is exquisite to work with. Observe the variation in weights and textures—some are almost cardboard like, but can perform the best when printing.

Two papers recommended for use are Arches and Rives BFK, both made in France.[4] Their appearance is classic and displays all the characteristics necessary for a good starting gum paper. Their established reputation also makes them available in most art stores. There are better choices as well. Some may be difficult to locate or too expensive, but an ongoing testing with different products can be enormously rewarding.

Because a lot of time is invested in printing for limited production, inexpensive papers are not recommended. They may prove misleading, even for test results. With the proper paper selection, there is a vast improvement in printing quality owing to sizing and handling characteristics.

At a more advanced stage, colored papers can be tried. Keep in mind that if you are printing from a negative on a dark paper, the image appears negative.

Paper Size: Gelatin (100g) and Formaldehyde (250ml, 37%)

Paper is a finely webbed mass of interlaced fibers. Because the structure is so absorbent, raw paper must be impregnated with sizing to permit the application of pigment. (Totally unsized papers are used for blotting or filtration purposes.) As a rule, sizing improves any raw paper. It fills up the pores, keeps the image on the surface, and sometimes increases the sensitivity.

Manufacturers add a sizing of weak gelatin solution or hydrous animal protein to the paper in the pulp stage. For gum printing, the manufactur-

er's sizing is so poor that it is not adequate for printing. Further sizing must be done before printing begins to keep the emulsion from staining the paper. The more common sizes are colloids, such as gelatin, arrow-root, or starch. To size paper you can let it float on the solution or brush the size over the surface of the paper. The use of gelatin as a paper size is the preferred method for gum printing, but the effort required may be discouraging for beginners. (The precise time-saving factors should be evaluated when using alternate methods, compared with methods detailed for gelatin and formaldehyde.) Paper can be coated with a mixture that has approximately 2 parts gesso and 5 to 8 parts water. (One part of acrylic matte varnish also can be added, but it is not essential.) This dilution depends on the thickness and on the method of application. If a heavy coat is brushed on, or the paper is submerged in the solution, the gesso should be thinned with water. Too heavy a size causes the emulsion to flake off during development; one even coat is sufficient. The paper's tendency to curl can be reduced by lightly moistening the back of the paper with water, using a sponge, before applying the size.

You can also prepare a size from a dilute solution of a latex-based glue such as Elmer's. The recommended dilution is 1:4 with water if used with tray application.[5] The most promising of the commercial sizes are called Hercon 40 and Aquapel.* Regular, grocery-store cornstarch can also be used. With a brand such as Argo, dilute a small amount (5–10g) in a little water until a paste is formed. Dilute it then further with 200 to 400ml of water, depending on the initial volume of starch used, and boil for 3 minutes.

I do not use the "quick sizes" for personal work. One of their disadvantages is that they change the aesthetics of the paper surface. Yet, they are of definite interest and benefit to students wishing a simplified method. They also are useful when presenting short workshops or demonstrating to introductory classes. Students who feel inspired by the process can progress to more detailed sizing.

What makes gelatin valuable as a paper size is the fact that a hot solution, when cooled, will set to a flexible gel without destroying the aesthetic look of the paper. Gelatin can be purchased from a grocery store. Prefer the better-known brands such as Knox (unflavored), that have proven reliable and will not cause yellowing of the paper. For even higher quality, obtain a commercial United States Pharmacopoeia grade. Bleached and refined, it maintains a higher purity and will form a clear "water-white" gel when mixed with water. Problems will not even occur in sunlight with highly refined gelatin.

Paper with a gelatin size softens when immersed in water and melts at about 32°C. Used alone, it does not withstand the high water temperatures necessary for gum printing. Such a problem and other ones, including fungus growth, can be avoided by hardening or "tanning" the gelatin. In contemporary gelatin-based negatives and prints, *hardeners* prevent frilling, blistering, and *reticulation.*

The usual hardening agents are chrome alum, potash alum, and formaldehyde. Formaldehyde is the most efficient for this process. Be-

*Available from Talas at 104 Fifth Avenue, New York, NY 10011 or check for papermaker suppliers in your area.

sides its superior hardening qualities, it can provide a more uniform coating than the alum hardeners.*

Mixing procedures for an alum hardener are described by Paul L. Anderson in Henney and Dudley's *Handbook of Photography*.[6] In practice, it proves less effective than formaldehyde. It causes an air bubble problem and its violet crystals can stain the paper.

Brushes: Oil Paint "Hog's Hair" Brush and Water-color "Sable Hair" Brush

Suitable brushes, available in art stores, are important for the successful, smooth application of the gum bichromate emulsion. For beginners, two brushes are required. In the gum process they are called the "spreader" (for applying the emulsion to the paper) and the "blender" (used to blend, smooth, and absorb excess emulsion). An experienced artist can tell the suitability of a brush by wetting and then shaping it with their fingers. However, a basic knowledge of the various qualities of brushes is enough and the exact degree of blend and absorbancy will be determined by experience.

Accounts of some early photographic processes stress that there should be no metal on the brush that could come into contact with the chemicals. However, it can be assumed that metal does not interfere with the emulsion used in gum printing.

It is important to get the best quality brush. Otherwise hairs can shed on the paper during the coating process. Both brushes are referred to as "Brights."[7] They are flat, sharp at the corners, with a thin bristle and a length about 1½ times their width. Fan shapes, popular for watercolor painting, are recommended by Maskell and Demachy,[8] but have not proven useful for any particular application (see Figure 4.9). The desirable width of the brush depends on the area of paper to be coated. For example, for a 20 × 25cm image size, brushes between 2 and 4cm wide should prove adequate.

The standard artist's oil painting brush is made of hog's hair and is useful as a spreader. Its degree of softness is not particularly important since it has no effect on the appearance of the coated surface. Artist's watercolor brushes made of sable with ox hair, squirrel hair, or ox hair alone, have the proper degree of absorbancy and spring to be used as blending brushes. Camel hair brushes sold in photography stores for lens cleaning, although similar in softness, are too mop-like for use as either spreader or blender.

Eventually, a greater selection of brushes is useful for manipulations in applying the emulsion and altering the image during development (refer to Step 10). Brushes are valuable, expensive tools and should be kept clean and stored safely. Any damage can easily render them useless. Also, note that even if an airbrush is available for emulsion application, brushes are necessary to get much of the handwork that is characteristic of gum printing.

Figure 4.9 A "Brights" style hog's hair spreader and fan shaped watercolor brush.

*Due to its highly toxic vapor, formaldehyde attacks the eyes, nose, and throat, causing intense irritation. It must be used with a fume hood, in an open air or well-ventilated room with proper vapor mask. Chrome alum and all chromium compounds are extremely dangerous. Chemical dust or contact with the skin while mixing must be avoided. When mixing, do so in open air or well-ventilated room with an appropriate particle mask. Always wear gloves and eye protection and wash residual dust away.

Color Pigments: Watercolor in Tubes or Powders

Any pigment—tempera, charcoal, watercolor, and so on—can be used for gum bichromate printing, provided it dissolves in water. Still, tube watercolor pigments are the preferred medium. In comparison to powder pigments, they are easy to handle, to store, and require no grinding. Mixing powders are unnecessary, especially if inconvenience matters more than saving money. There are only two points in favor of powders: they do not dry up as rapidly (which is of no consequence here since the pigments are stored in stock solutions with gum arabic) and secondly, it is possible to get a greater pigment density with certain pigments—more intense color. Experiment with a few of your favorite colors, comparing the results obtained from powders and tube pigment.

There is a great difference in quality among the watercolor pigments offered by various manufacturers. Only the pure, finely ground color will give satisfactory results. Windsor Newton is a recommended choice; many other brands are not adequately ground, nor do they have adequate density.

Many color effects can only be obtained by using a diversity of pigments. Yet, it is possible to obtain a wide range of colors even though the "palette" is limited. An understanding of the color properties in each pigment requires study and practice.

You only need six to eight pigments to start with. Some colors require mixing another color in to increase printing strength. Used alone they require so much pigment for a good density that they cannot coat well. Some pigments containing various chemicals, such as chromium, will react with the sensitizer causing bleaching and staining.[9] Because chemical composition varies from manufacturer to manufacturer for the same pigments and because there is a lack of chemical data available, it is difficult to recommend what colors to avoid. Begin by favoring earth colors, which are most highly recommended for gum printing. Use also some variety of the basics, such as lampblack, alizarin crimson, burnt umber, burnt sienna, cadmium pale yellow, prussian blue, and green. (Demachy's early gum prints were in reds and browns and his later works in black.)

White is not traditionally used in gum printing. The quality of transparent pigment allows the white of the paper to furnish the light areas of a picture. This is similar to the technique of pure watercolor painting that was perfected in England between the later eighteenth and early nineteenth centuries. But the possibilities of using white should not be ignored. All white pigments have opaque qualities and can be used to lighten colors and to add density to weaker pigments.

In practice, selecting the suitable color for each emulsion is difficult. Color charts available from manufacturers are unsuitable, as printing inks cannot accurately match the true pigment color. Prepare a personalized color chart, applying a stroke of each color to a piece of printing paper (see Figure 4.10). Make the wash range from opaque to transparent, and carefully label it for reference when printing.

Pigments also can be classified in relation to their physical characteristics. Those in standard tubes are transparent and those designated as *"gouache"* have opaque color qualities. Traditionally, transparent colors have always been used and are necessary for continuous tone images. Gouache pigment contains a white base that creates its opacity. It is useful in single printing and works fine, but with a different quality than transparent pigments. The strong solid colors of a gouache print can

Figure 4.10 Prepare a color chart with all pigments before mixing with gum arabic.

easily alter the unique subtle characteristics of gum printing. Such considerations are important in all forms of printmaking. Each image must be carefully considered to fit the process that will be used.

The pigment's degree of permanence is also important. Since the watercolor pigment is all that remains on an archival paper, it determines the life of each print. Many manufacturers provide this information on request. More information can be found in *The Artist's Handbook of Materials and Techniques,* which provides information on pigments, and from the Paint Standards Committee.[10]

Emulsion Binder: Gum Arabic Solution (2 Liters)

The gum solution functions as an emulsion binder. The emulsion consists of a gum solution combined with a sensitizer and watercolor pigment. It is applied to the paper, exposed, and developed in plain water. The only areas remaining are those exposed to and hardened by light. The importance of gum arabic in the emulsion lies in its ability to keep the emulsion soluble, allowing the unexposed image to dissolve below the tanned (exposed) surface layer. It also keeps the sensitizer on the surface and reduces staining.

Various other substances including gelatin, fish glue, starch, albumen, and ordinary animal mucilage have historically been used for the same purpose. But due to is superior solubility, gum arabic (acacia) is the best material to use to achieve the highest quality of gum print.

The best form in which to buy this chemical is in solution. It is usually available from graphic arts suppliers since it is commonly used by lithographers and college print departments. The strength of the solution prepared for their need is suitable for gum printing. Mixing the gum solution from a powder is possible, but inconvenient. The particles need to soak for two or three days to be absorbed in water. If you cannot find a premixed solution, purchase 500g of "Acacia." For mixing procedures, see Step 4. The difference in price between a premixed solution and making your own from powder is negligible.

For a beginner, 1 or 2 liters will provide enough for approximately 50 to 75 average-size prints. The strength is measured in *degree Baumé,* indicated on the label of the container. The recommended strength for gum printing ranges between 12° and 14° Baumé. It is possible to thin a heavy solution by diluting it with distilled water. The strength can be tested with a Baumé *hydrometer* and hydrometer jar. A gum solution thinner than 12° Baumé does not work well and requires the addition of more bulk powder.

Mercuric Chloride (25g, for powder only) A preservative is necessary to prevent the gum from decomposing caused by bacteria or fermentation (the solution becomes acidic and sours, usually giving off a pungent odor). Mercuric chloride is the chemical commonly used to prevent fermentation.* (Formaldehyde can also be used since you may already have it at hand for sizing.)

*Mercuric chloride is extremely poisonous. Do not consume, inhale, or place hands in solutions containing this or other mercury salts. Wear rubber gloves and a particle mask when mixing and wash dust away immediately.

Distilled Water (5 liters) Because of the chemical inconsistency of tap water, it is imperative to prepare the gum solution and sensitizer with distilled water.

Sensitizer: Potassium Dichromate (250g) The effect of the sensitizer is only due to the dichromate part of each chemical, called the dichromate ion.* A high concentration of these ions in solutions creates a greater sensitivity in the emulsion. There are three possible sensitizers: sodium, potassium, and ammonium.† Print quality is the same regardless of which one you use.

In a *saturated solution,* ammonium has the greatest ion concentration and the lowest point of *crystallization.* Since it possesses the greatest light sensitivity, ammonium dichromate has commonly been the preferred chemical for the preparation of the sensitizing solution.

Potassium became popular as the first sensitizer in the history of the gum process. It is the least sensitive of the three mentioned due to a lower concentration of its dichromate ions. However, we recommend it as a sensitizer because of its low "staining quality." When doing multiple printing, the printer must decide about each color following each exposure. The buildup of dichromate stain can make this difficult. Some staining will result from all the sensitizers, but is ultimately removed in a final clearing bath. (The price of potassium is comparable to that of ammonium.)

Sodium dichromate is *deliquescent.* It rapidly absorbs moisture from the air, interferes with accurate calculations and requires some dexterity in calculating its weight.

Clearing Bath: Potassium Metabisulphite (250g) Once the printing process has been completed, the image hardens by drying. A slight yellow stain, caused by traces of the chromic salts imprisoned in the printed emulsion, will be present. This will eventually damage the image unless it is "stabilized," or "cleared."

Several chemicals are suitable for this purpose, although each has a slightly different effect. Potassium metabisulphite is a good choice. It does not alter the image color, makes the dichromate extremely soluble and is the most soluble in water. Sodium metabisulphite and sodium bisulphite are also quite effective and do not seem to noticeably alter the image.‡ Still, they are not as soluble as potassium metabisulphite in water and thus require a long wash time. Potassium alum is also usable, but requires increased washing compared with either of the other clearing agents. It also seems to alter the image color, losing some of its soft delicate effect. As well, there are concerns with alum having an effect that "threatens print permanence."[11] Some texts recommend alum as they claim it hardens the image, but experience proves that the gum print does not require alum to be sufficiently hard.

*Again, note that dichromate is the current USP (United States Pharmacopeia) spelling of the older name, bichromate, but refers to the same chemical. This chemical can be requested using either designation.

†Ammonium dichromate and all chromium compounds are extremely dangerous. When mixing, do so in open air holding your breath or use an inexpensive surgical filter mask. Always wear eye protection and wash dust away immediately after use.

‡When handling metabisulphite, follow precautions similar to those for formaldehyde. A vapor mask and well-ventilated room are essential.

White Light Source: UV-Emitting Because the dichromate sensitizing ion used in the gum process is of such a low sensitivity, it is unsuitable for enlarging. A light source of adequate intensity must be adapted for use as a contact print process. Daylight—obviously used by early printers—is excellent. Today, though, lamps allow more control and are essential when natural daylight is not available. Almost any *white light* source made for photographic purposes or for the photomechanical trade is suitable to varying degrees. A 500W number 2 photoflood lamp is best for beginners. It operates at a *color temperature* of about 3,400° Kelvin.* Either clear or blue-colored bulbs are suitable. Some of the more significant advantages they offer are the fact that:

1. They provide reasonable exposure times.
2. They are inexpensive.
3. They have a long life span and the quality of light changes very little with use.
4. They can be used in regular household types of socket.

There are also some disadvantages:

1. They generate a high degree of heat. With long exposures, un-exposed areas become insoluble. A fan is necessary to gently circulate the air above the negative during exposure.
2. They require a reflector (which can be purchased at a low cost from a photo supply store) to contain and direct their emission.
3. They are not rich in the desired blue-violet portion of the spectrum. *Therefore they are not effective in exposing all pigments, particularly some pigments of greater density.* Most industrially made light sources are more useful.

Among the various other light sources available, sunlamps are rich in the necessary blue-violet waves, but require an annoying warm-up and cooling-off period with each use. If you are planning future work in specialized processes, consider the advantages of purchasing a commercial system, such as a *fluorescent* or *carbon arc lamp*.† Fluorescent blacklight tubes, such as those made by Sylvania, or even their daylight tubes, are a useful and economical light source offering the following:

1. They are easy to use if you want to design and construct a unit at a very practical cost.
2. They are very effective for other processes such as cyanotype and *Van Dyke* images that require enormous UV exposure.
3. They do not require a ventilation system.

You can create a candelabrum of several of these, arranged about 3cm away from the image (see Figure 4.11).

*Unfortunately, color temperature is not a proper indication of the suitability of a light source for gum work. More accurate would be the spectral distribution in the blue-violet wavelengths, to which the dichromate is most sensitive. Since that information is rarely available, it must be assumed that almost all light sources used for photography have some—if not the greatest portion of their emission—in the applicable part of the spectrum.
†Various centers for specialized photographic printing offer specialty exposure units. A current source for UV systems and vacuum tables is The Palladio Company, P.O. Box 28, Cambridge, MA 02140 Tel.: 1-800-628-9618.

Figure 4.11 A composite for a homecrafted exposure assembly.

Building a UV Printer

Materials Needed to Build Printer

- 1.25cm plywood
 - 1 piece 66cm × 46cm
 - 2 pieces 66cm × 10cm
 - 2 pieces 48cm × 10cm
- 2.54cm × 2.54cm Pine
 - 2 pieces 66cm
 - 2 pieces 40cm
- Fluorescents
 - 6 61cm UV tubes and lamp units with ballasts
- Glass
 - .575cm plate 66cm × 46cm
- Wiring
 - 8m 15 amp grounded wire
 - 1 large junction box
 - 24 marret wire fasteners
 - 1 on/off switch
 - 1 grounded plug

Figure 4.12 A simple exposure set-up. Check for even light distribution with an incident exposure meter.

No matter which system you choose, make sure that the light sources provide even illumination over the entire picture area. To start with or for small prints, one or two bulbs may be adequate. You can use an *incident light meter* to show the complete balance. Increase the distance of the lights to the print for a more even illumination (see Figure 4.12).

The author gratefully acknowledges Graham Smith of Horizon Scan for the guidelines and permission for "Building a UV Printer."

For specifics on crafting an exposure system, see Blacklow, pp. 34–41.

Having now completed your examination of the necessary supplies for gum printing, you can begin thinking about making gum prints. The following steps will outline all the stages, and you should be able to begin printing soon. Your experience with Kwik-Print, such as negative making and multiple printing colors, will make much of the reading easier and work more spontaneous.

This section concentrates on the preparation of continuous tone negatives. For halftone methods, refer to Appendix C. Both techniques also apply to the production of negatives for the Kwik-Print process.

STEP 1

Negative Preparation

Of paramount importance to the quality of the negative for any process is the subject matter itself. For gum printing, start with a selection of images that are not highly detailed. Quality that's satisfactory for a *pinhole camera* is excellent! The early texts stated that a gum print photographer should aim for charm of form as opposed to detail.

The salient aspects in the production of negatives are density and *contrast*. How to translate this into recommendations is difficult—one early text on gum printing suggested that the negative should print on a grade 2 bromide enlarging paper, but there are too many important variables such as paper manufacturer or type of enlarger that can drastically vary these guidelines.

Sensitometry provides a useful format for negative qualities and other printing concerns. But first, a discussion on the principles of negative making can provide a useful preliminary understanding to form a firm basis if a more technical methodology is not desired.

Gum bichromate is a short *tonal scale* process. Strive for full negative detail, with a contrast that would be termed "flat" for enlarging purposes. Avoid excessive negative density, to lessen the impact of a slow sensitizer.

As explained in Chapter 3, if an enlarged negative is being made from a small-format camera, duplicating film will likely be used. This film is orthochromatic and can be examined under a red safelight (the lighter side shows the emulsion). Most orthochromatic and duplicating lith films are intended for use in the graphic arts industry. When developed as directed by the manufacturer, they give high-contrast effects. A softer developer formula is necessary for gum print qualities. You can start with a bromide paper developer diluted 1:10 instead of the more standard dilution of 1:2.

The first test is the visual examination of the negative after development. A correct time is generally 2½ minutes at 20°C. Proper time can be determined by using a test strip procedure to see whether the developer requires further alteration, which is not difficult to assess. Be certain to observe the density and contrast changes closely in relation to exposure, development time, and dilution.

A useful density range is between .9 and 1.1. This is the same as prescribed for color separation gum work. Using the *three-point density control* (see Step 14), a D_{min} of .27 to .33 and a D_{max} of 1.27 to 1.33 should be achieved.[12] See also guidelines given in Appendix A to establish printing criteria based on your personal materials. Note that the information in Appendix A suggests that a suitable negative would print well with Ilford Multigrade 3 paper using approximately a 3½ filter and a condenser enlarger.

Negatives of extreme contrast present a problem. Whenever working with them, carry out manipulations such as dodging and burning while making the enlarged negative. Attempting corrections on the gum print itself are time-consuming and may lead to errors. Reference books and photographic product manufacturers offer extensive technical recommendations (see Appendix B) for guidelines on *flashing,* silver *masking,* masking using various polyester-backed films, *crocein scarlet dye,* and *reduction.* These methods are easy and should be helpful to control contrast without prior experience. *Diffusion sheets* are also useful for the same purpose, but with more limited results.

Also, bear in mind that you should use caution when examining wet films as they are very susceptible to stain. Have a tray of photo-flo at hand for immersion just prior to visual reading. This will prevent uneven drying that might ruin a suitable negative. After inspection, complete the required processing. If using duplicating film, remember that with development, although increases in exposure result in decreases in density, *increases in development also affect increases in density as well as contrast.*

STEP 2

Sizing Paper

Some preparation is necessary for paper to be suitable for gum printing. A gum print is developed in water. The paper dimensions will be reduced by about 15% the first time it is wet. To counter this instability and provide for multiple printing registration, it is necessary to shrink the paper before any printing takes place. It is also necessary to provide the paper with a protective coating or size. This will ensure that the emulsion, when later applied, will dry on the surface without penetrating and staining the support.

To help offset the amount of time required to size paper, prepare the largest quantity that you can possibly manage. Also, avoid tearing the paper into smaller pieces unless it is necessary to fit the soaking tray that will be used.

Begin by determining which are the front and back surfaces of the paper despite their similarity. Some papers can be used on both sides equally well, but many are finished only on one side. The reverse can contain a different grain, irregular spots, flaws, and blemishes, which do not show up until printing. Make the distinction by looking for the following characteristics before sizing (see Figure 4.13).

1. The most visible feature is usually the watermark. This is the manufacturer's identifying label, indelibly stamped in the substance of a sheet of paper during manufacture. It usually states the name of the company and/or particular brand of paper. View the paper by transmitted light and the watermark becomes visible. When read correctly, the paper is oriented to the front.
2. The front surface is often smoother and brighter.
3. A factory deckled edge always bevels up to the front surface.

Once that is determined, lightly mark the back with pencil (see Figure 4.14).

The next step is to shrink the paper. This involves thoroughly soaking it in water and allowing it to dry before any printing takes place. Give a soaking lasting between 30 minutes and an hour, using the hottest water temperature your hands feel comfortable working in. A shorter time and a lower temperature can be used, but these variables are based on each printer's criteria for a "full" development (e.g., the development pro-

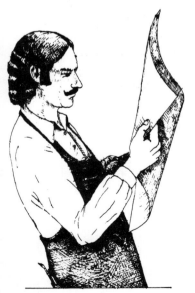

Figure 4.13 Examine the printing paper to find the front surface.

cedure for gum printing involves soaking the print in plain tap water). Much control is possible by varying the temperature and time factors. Because of the subjectivity involved in development, the presoaking time and temperature must not be less than those that will subsequently be used for development.

Fortunately, you do not have to check the sheets once the shrinking procedure has begun. Occasionally interleaf the sheets, pulling the bottom one free and laying it on top. Once sufficient time has elapsed, remove the paper from the water for drying.

Spring-type wooden clothespins strung on cord are the most practical drying arrangement (see Figure 4.15). Suspend the paper by the corners with the narrow end at the top and leave to hang until dry. If a large darkroom sink is available, position the drying line above it to catch the dripping water and sizing liquids and prevent contaminating the darkroom.

Once the paper has dried, sizing can follow immediately. Early texts suggest coating the front using a brush or sponge. However, preparing an adequate amount of size and fully submerging the paper in it is a less time-consuming and more thorough method.

To prepare the gelatin sizing solution, dissolve 30g of gelatin per 1000ml of cool water. Initially dissolving the gelatin in warm water causes lumps that prevent the gelatin from dissolving. Soak the gelatin for 15 minutes in the cool water and then heat the container until the gelatin is completely dissolved. Pour the hot gelatin into a large tray that has been rinsed with hot water just before use (to prevent cooling of the sizing solution) and insert the paper. Begin to agitate by removing one sheet at a time from the bottom of the tray and by reinserting it at the top. Bring the center of each sheet in contact with the solution first and then allow the sides to fall.

After a soaking of 15 minutes, lift the paper by drawing the front of each sheet separately over the edge of the tray, carefully removing air bells (see Figure 4.16). Existing bells on the back can be dabbed with a sponge once the paper has been suspended. Be careful when handling the dampened sheets. A buckle causes a permanent wrinkle. Hang the sheets to dry using clothespins, suspending them from the narrow edge.

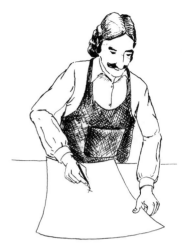

Figure 4.14 Mark the back surface with pencil.

Figure 4.15 Suspend the paper to dry with clothespins.

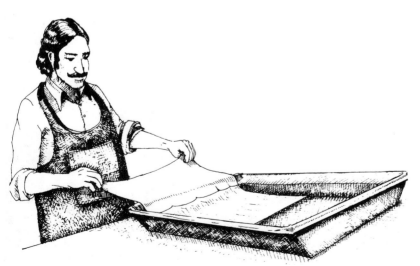

Figure 4.16 Draw the paper over the edge of the tray to remove air bubbles.

The gelatin can be stored in a refrigerator if more sizing is anticipated within the next few days. It will gel, but then will liquify when heated.

In a well-ventilated room and with a proper vapor mask on, prepare a hardening bath by mixing 25ml of a 37% solution of formaldehyde per 1000ml of water. Soak the paper in this solution for 10 minutes, interleaving the sheets regularly as described for the gelatin procedure. Remove and suspend each sheet to dry. The formaldehyde solution can be stored for later use.

There are variations to the suggested procedures. In the first edition, this writer recommended two coats of gelatin, each followed by a coat of formaldehyde. Continued work proves that this is often not essential and is time-consuming. One bath is adequate and the strength of gelatin can be increased, provided it does not become so thick as to cause uneven results (the weight of gelatin can be increased up to 60g per liter of water, but this should be attempted progressively, testing to observe how the pigments respond to the strength of sizing). *Not all pigments respond well to the same sizing.* Many heavier pigment concentrations will flake off during development if the print surface is oversized and does not provide a suitable grip for the emulsion. In other words, pigments from the same manufacturer can print well on one strength of sized paper, while others unexplainably do not! The strength of the formaldehyde should not be modified, as a greater concentration tends to make the paper susceptible to cracking.

Stephen Livick, an outstanding gum printer (see Color Plate 3), prefers a single coat of size with formaldehyde mixed with the gelatin, which has not been suggested in past references. He applies the size selectively onto the front surface image area only and thus maintains the appearance of no sizing on the margins of the paper.[13]

Store the sized paper in a container that does not contaminate its acid-free content.

STEP
3

Preparing Sensitizer

Formula: Sensitizer

- To make potassium dichromate sensitizer, use
 13g of crystals
 75ml of water (50°C)
 cool water (to make 100ml)
- To make ammonium dichromate sensitizer (see Figure 4.17), use
 27g of crystals
 75ml of water (50°C)
 cool water (to make 100ml)

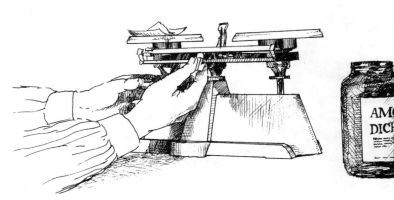

Figure 4.17 Weigh the sensitizer.

The saturation of dichromate in the formulas does not affect the quality of a print. It does alter the sensitivity or speed of the emulsion. The greater the volume of dichromate, the more sensitivity will increase. The given formulas are for a saturated solution and will therefore call for the shortest exposure. The dichromate required to make a saturated solution depends on the temperature of the solution. This formula becomes saturated at 16°C. When kept and used at about 20°C (photographic standard), it is constant in strength.

To eliminate variables, the sensitizing formula should remain the same. Should the prepared sensitizer chill during storage, crystals will form and separate out. Simply reheat the solution again until they are dissolved.

As recommended in the materials list, powdered gum arabic should only be selected if it is impossible to locate a premixed liquid form. The use of the following formula gives a dilution of 12.5° Baumé.

Preparing Gum Arabic Solution

Formula: Gum Arabic Solution

* To prepare gum arabic solution, use
 2.5g of mercuric chloride (or substitute 15ml of a 37% formaldehyde solution)
 1000ml of water (cool, distilled)
 300g of powdered gum arabic

At a strength between 12° and 14° Baumé, the gum solution does not set rapidly. This makes it possible to apply and blend the gum on the paper before it starts to dry. The strength of this dilution can be checked with a Baumé hydrometer and hydrometer jar. Since many hydrometers are calibrated in units of specific gravity, it is useful to know that 14° Baumé are equivalent to 1.10 on the specific gravity scale.

To mix the powder, use a wide-mouth mason jar (see Figure 4.18). Never mix gum arabic with hot water as this causes changes in the chemical composition and lowers its solubility.

The mercuric chloride acts as a preservative to prevent bacterial growth in the gum solution. A sour gum solution works, but differently (the progressive souring alters print consistency). A gum solution mixed with mercuric chloride has been known to stay fresh up to eighteen years.[14] Mercuric chloride readily dissolves in water and presents no special mixing difficulty. Simply stir it in the distilled water before dissolving the acacia (gum arabic) powder.

Gum arabic chunks can be used instead of powder. Speed their dissolving by first pestling the chunks in a mortar, adding small portions of water. Filter the mixed solution through a piece of fabric to ensure uniformity. Protect the solution from heat and sunlight.

Low-grade gum arabic is light tan in color compared to top-grade pharmaceutical gum that contains very little tanning. Tanning is responsible for the brown color and may vary from almost white to pale yellow.

Figure 4.18 A wide mouth mason jar.

The light-sensitive emulsion used in gum printing is a combination of gum arabic, watercolor pigment, and dichromate sensitizer. For more convenience and accuracy, prepare a stock solution of the pigment and gum to mix with the sensitizer when required.

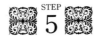

Preparing Stock Pigment and Gum Solution

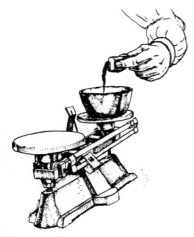

Figure 4.19 Weigh the pigment.

Figure 4.20 Measure the gum
solution.

Figure 4.21 Draw out the gum-
pigment mixture.

TUBE PIGMENTS

Figure out the amount of gum solution to add to the total amount of
pigment in each tube (mixing the entire contents of the tube of pigment
will save time. It also necessitates a larger quantity of gum solution,
reducing the drainage error that results from measuring small portions).
If you prefer to conduct the testing procedure to find the "correct"
pigment-to-gum ratio (outlined later in this section), begin the test with
the proportion of 1g of tube pigment blended with 3ml of gum solution for
all colors (see Figure 4.19). If you wish to begin immediately without
testing, prepare all stock solutions of 1g of tube pigment with 5ml of gum
solution. Note that the guidelines for pigment-to-gum ratios in this text
are heavier than commonly suggested. If testing or printing show the
need for a reduction in strength, it is easy to reduce density by adding
more gum solution. Adding more pigment to a weaker dilution is obvious-
ly less practical. It should be emphasized that several pigments do work
well (subject to manufacture), at the full strength suggested. *The difficul-
ty many printers have when working with gum printing comes from using
too weak a pigment dilution.* The prints constantly look pale and flat and
require unreasonable amounts of printing.

Accurately measure the required amount of gum into the cylindrical
graduate (Figure 4.20), pour it onto the pigment, and mix well with a
glass pestle. If a pestle is unavailable, almost any grinder, such as a
palette knife or hog's hair brush, will do for tube colors.

Pour the ground solution into a squeeze-drop plastic container (see
Figure 4.21). Use a stiff-bristle brush to force any remaining solution out.
Label the container, showing color, dilution, and date.

POWDER PIGMENTS

Prepare powders in the same manner as for tube colors, but include the
addition of a plasticizer. The plasticizer can be prepared as a stock
solution by following this formula:[15]

- 40g of white sugar in 20ml of hot, distilled water
- 150ml of stock gum solution
- 10 drops of photo-flo
- 30ml of glycerol

If you use the testing procedure outlined further in this section to find
the correct pigment-to-gum ratio, begin the test with a proportion of 1g
of dry powder pigment blended with 6ml of gum solution for all colors. To
begin printing immediately, without testing, use a ratio of 1g of powder
pigment per 10ml of gum.

Before blending the pigment and gum, work the powder up to a paste,
using a minimum amount of plasticizer. Then, pour the measured amount
of gum onto the pigment and mix well with the glass pestle. Thorough
grinding is essential. Manipulate until every particle has become com-
pletely dissolved into the medium. There will be a tendency of the
pigment to *agglutinate* or hold together. Once prepared, label each color
in the same manner as for tube pigments. Bear in mind that prepared
pigments should be given the opportunity to absorb the gum solution for a
day before printing. A brush or mixing rod should be used to stir the
mixture before use. Shaking the container is acceptable but creates air
bubbles that impair measurement.

Using charcoal as a pigment has its drawbacks. As H.G. Abbott states in *Modern Printing Processes,*

> As a rule, charcoal does not mix readily with the gum and water, and should be first ground into the gum and the mass thinned afterwards with water to the right consistency. Too much grinding will be ruinous to the identity of the substance and we might just as well use black paint. The best way to use charcoal is to first sift it through bolting cloth or a fine sieve and then work it thoroughly into the gum as explained above.[16]

Since pigments vary in printing intensity, it is impossible to provide any absolute rule for the proper amount of stock gum solution to use with the pigment. Formulas provide a useful working ratio, although tube pigment requirements could range from 5 to 30g of pigment per 100ml of stock gum solution, and powder pigments from 2.5 to 15g of pigment per 100ml of stock gum solution. To use a testing procedure for each color when beginning is not necessary, but could be considered as your methods improve. The objectives for determining the correct pigment concentration could be summarized in the following manner:

1. The pigment should not be so heavy as to stain the white of the paper.
2. It should be capable of coating without streaking or drying too rapidly.
3. It should provide a sufficient range of tone for three printings.

Paul L. Anderson, in Henney and Dudley's *Handbook of Photography* provides a good description for determining a "correct" ratio of pigment-to-gum solution:

> As the longest scale of gradation is secured when the coating mixture contains the largest possible amount of pigment and as a long scale is usually desired, it follows that the coating mixture should hold as much of the pigment as can satisfactorily be used. But for every paper, every pigment, and every gum solution there is a maximum relation of pigment to gum which can be used without staining the paper—or rather, to be precise, there are two such maxima, one for automatic development, the other for brush development. The method of determining these maxima is as follows:
>
> Squeeze into a small mortar an inch length of the pigment, and rub this up with ½ dram of the gum solution. With a fine brush dipped into the mixture, make a small mark on the paper which is to be used, and opposite this mark, pencil 1 in. to ½ dram. Add ½ dram of gum solution to the mixture, rub it up well, and make another mark, labeling this 1 in. to 1 dram. Add another ½ dram of the gum solution, and label the resulting mark 1 in. to 1½ drams. Continue this until a series of marks extending to 1 in. to 10 drams is reached. Then allow these gum-pigment marks to dry thoroughly, and let the paper float face down in a tray of water at room temperature for ½ hr. On inspection it will be found that some of the marks have entirely disappeared, while others remain visible. Suppose, for example, that the last visible mark is opposite the notation 1 in. to 4½ drams; then it is known that, if pure whites are to be secured with automatic development, the maximum proportion of pigment to gum solution in the

coating mixture must be 1 in. to 5 drams. Now with a soft camel's-hair brush, brush over the remaining marks, when it will be found that others will disappear. As an example, suppose that the last one visible after this brushing is opposite the label 1 in. to 2 drams; then it is known that, if brush development is to be used and pure whites are to be obtained, the maximum allowable proportion of pigment to gum is 1 in. to 2½ drams. If a note is made of these proportions, it will be possible at any future time to predict accurately the maximum gum-pigment relationship for that pigment and that paper. This should be done for the various pigments which are to be used and for the various papers. A table can then be drawn up giving the sundry relationships at a glance, thus avoiding the by-guess and-by-gosh method so common in gum printing.

This method serves also to indicate the possible maximum when two or more pigments are mixed to secure variations in color. Thus, if it has been determined that a certain black requires 5 drams of gum solution to 1 in. of pigment for automatic development and burnt umber requires 4 drams to 1 in., then, if it is desired to mix the pigments in the proportion of 2 to 1, it follows that the worker will use 1 in. of the black, ½ in. of the burnt umber, and 7 drams of the gum solution.

Note that no sensitizer is used in these determinations.

It may seem that this method of determination involves a great deal of work but actually the labor is not excessive, and, if the experiments indicated are carried out and the suggested table is drawn up, a vast amount of effort and disappointment will in the long run be saved.[17]

Don't be confused by trying to interpret drams of gum and inches of pigment in Anderson's outline. Instead, we could summarize his directions as follows:

1. For each pigment that is tested, prepare a color swatch on your (sized) paper that represents the strongest concentration of pigment-to-gum solution. For example, for tube pigments this would be 1g of pigment to 3ml of gum, for powder pigments this would be 1g of pigment to 6ml of gum.
2. Float the test paper (develop) emulsion down, and observe if the pigment density dissolves and/or if any stain remains on the paper. The objective is to find the pigment concentration that dissolves within a half hour. This indicates the "still bath" pigment concentration.
3. If the pigment does not dissolve, gently brush-develop the test, to find if the pigment concentration can be removed without staining.
4. Staining shows that the initial test concentration should be further diluted and retested.

Excessive pigment results in prints with an overall stain, degraded whites, or a grainy flake-like appearance. It is possible to support more pigment by strengthening the gum solution outlined in Step 4. The print's tonal scale expands (this is the technique used by one-coat printers). But a strong gum solution is difficult to coat and blend and has no multiple printing capabilities. Conversely, a weak gum solution will hold only enough pigment for weak coats. The emulsion is wet for so long that it often soaks into the sizing and stains the paper. It is best not to alter the gum solution, and to use it as suggested in Step 4.

When the emulsion is mixed, the paper should be sensitized immediately. Some preparation is therefore required; begin by tearing the sheets to the required size. Be certain to allow for a suitable border around each image, based on the size of the negative to be printed.

STEP
6

*Preparing Paper
for Printing*

REGISTRATION

Position the enlarged negative on the paper in the exact location desired for the final print. For accurate placement, use a see-through plastic ruler that can measure in equal increments from the center using both horizontal and vertical directions (see Figure 4.22).

Use *pinhole registration.* To do so, secure the negative with a small piece of masking tape. Pierce tiny pinholes through both negative and paper in two corners, as a registration guide for multiple printing (see Figure 4.23). Select two points as distant as possible to get the best registration. Then, trace a light outline on the paper in pencil to mark the registration and indicate the area to be coated with emulsion (see Figure 4.24).

Pinholes are a precise system for small prints, particularly on good paper stock that is well shrunk and sized. You may prefer to immediately begin the use of the punch registration and tab system mentioned before, provided that the tools suggested—metal male pins, adhesive female tabs, and a registration punch—are available.

A third system requires only a single-hole paper punch. Attach a short strip of black tape to two (or more) sides of the negative. Then punch through the tape and negative, creating a semi-circle in each strip of tape. This will then print a dark half-circle outlined by a white patch at each hole.[18] Register the negative in position and secure it by using masking tape. Work from the center for all four sides, so any dimensional changes

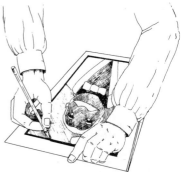

Figure 4.23 For a simple registration system, pierce two corners of the negative with pin holes.

Figure 4.24 Trace the negative area.

Figure 4.22 Position the negative using a see-through plastic ruler.

Figure 4.25 A layout for punch registration.

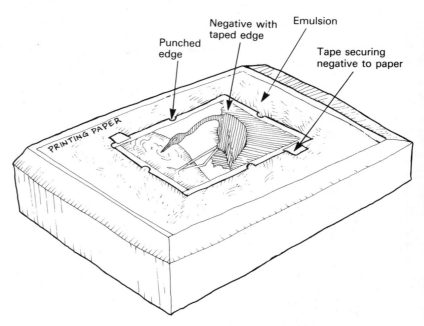

Figure 4.26 A print with unmasked borders is difficult to control and may require matting to cover the non-image area.

Figure 4.27 A print with masked borders permits the display of the entire paper surface.

to the paper are adjusted to the middle, reducing the error at the edges where it is more noticeable (see Figure 4.25).

You can also vary the punch method. Substitute pencil marks on the paper, at the center of each side of the negative. These marks could be indicated on the edge of the paper mask explained in the next section instead of on the negative.

A step wedge can also be attached to the edge of the negative. This provides a useful display of density changes taking place to the image with successive printings. If the step wedge is of adequate size, it also can be used as a test strip indicator, if you cover it progressively at each printing.

BORDER MASKING

The aesthetic appeal of many images can be improved by having a sharply defined border. Otherwise, the brush effects created by the manner that the emulsion was applied may look a bit messy (see Figures 4.26 and 4.27).

Prior to printing, place the enlarged negative on the light box. Using a 1cm hog's hair brush, apply a liquid *opaque* such as the one manufactured by Kodak, forming the desired image border (see Figure 4.28). Once the opaque has dried, hinge strips of black construction paper along all sides of the negative (see Figures 4.29 and 4.30). These must be of adequate length and width to protect any emulsion that is not within the actual image area from exposure. During development, the margin shielded by the liquid and paper opaque mask will discharge its pigment. Any pigment remaining in the margin can be lightly brushed off during development to prevent permanent staining.

Color Plate 1

Charles Macnamara, *The Elms,* gum bichromate print, 1911,
32.4 × 245.2cm. Collection: Estate of Jean Cunningham,
reproduced with permission of The Art Gallery of Ontario,
Toronto.

Color Plate 2

David Scopick, untitled, Kwik-Print on Kwik-Print Base
Sheet, 1990, 22.5 × 15cm. Collection: Roxy Photography.
Reprinted with permission.

Color Plate 3

Stephen Livick, *Siblings,* 1990. Collection: Artist.
Reprinted with permission.
An example of contemporary achievement in gum printing. This
image is an impressive 120 × 150cm. It shows the resolution
possible for a skilled printer.

Color Plate 4

David Scopick, *The False Bishop,* 1974, 13.5 × 18cm.
Collection: Artist.
Compare the results of this gum bichromate print to the
original image (see Figure 4.37).

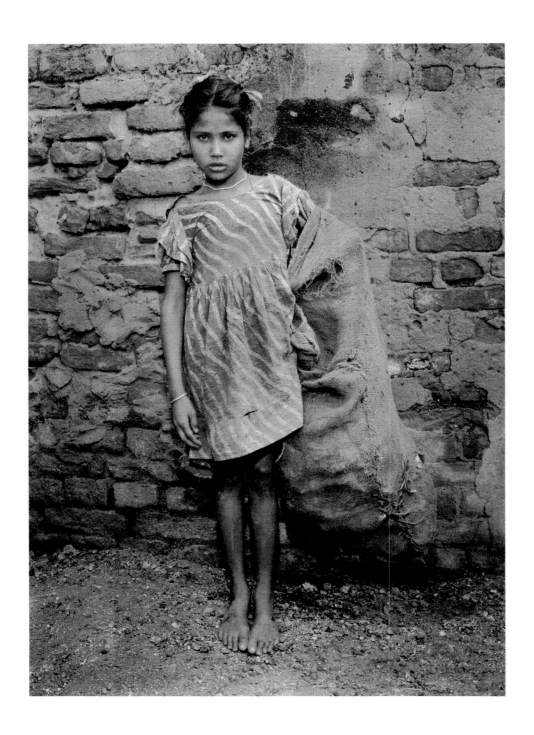

Color Plate 5

Stephen Livick, *Picker in Striped Red Dress,* 1987, 103.5 ×
74cm. Collection: Artist. Reprinted with permission.
A tricolor gum print of remarkable size, quality, and color accuracy.

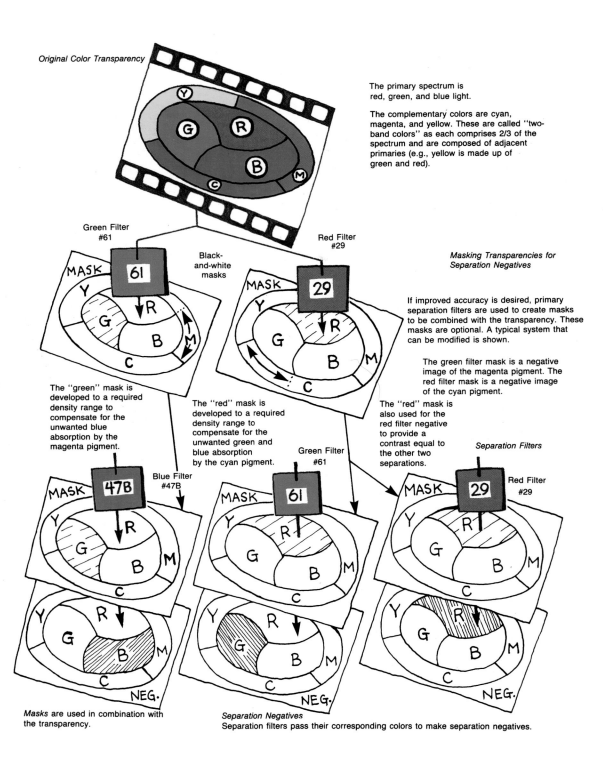

Original Color Transparency

The primary spectrum is red, green, and blue light.

The complementary colors are cyan, magenta, and yellow. These are called "two-band colors" as each comprises 2/3 of the spectrum and are composed of adjacent primaries (e.g., yellow is made up of green and red).

Green Filter #61

Red Filter #29

Black-and-white masks

Masking Transparencies for Separation Negatives

If improved accuracy is desired, primary separation filters are used to create masks to be combined with the transparency. These masks are optional. A typical system that can be modified is shown.

The green filter mask is a negative image of the magenta pigment. The red filter mask is a negative image of the cyan pigment.

The "green" mask is developed to a required density range to compensate for the unwanted blue absorption by the magenta pigment.

The "red" mask is developed to a required density range to compensate for the unwanted green and blue absorption by the cyan pigment.

The "red" mask is also used for the red filter negative to provide a contrast equal to the other two separations.

Blue Filter #47B

Green Filter #61

Separation Filters

Red Filter #29

Masks are used in combination with the transparency.

Separation Negatives
Separation filters pass their corresponding colors to make separation negatives.

Color Plate 6

Tricolor gum printing.

The pigment for printing is complementary to the color of the filter used for the negative. The complementaries control the primary visible (e.g., density in magenta controls the visible green).

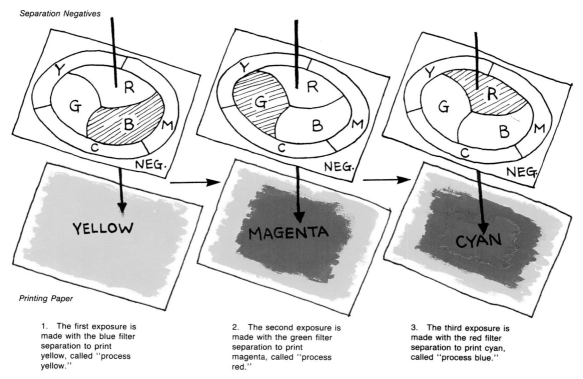

Separation Negatives

Printing Paper

1. The first exposure is made with the blue filter separation to print yellow, called "process yellow."

2. The second exposure is made with the green filter separation to print magenta, called "process red."

3. The third exposure is made with the red filter separation to print cyan, called "process blue."

Finished Gum Print

Basic adjustments can be made by single- or multi-exposure changes to the separation negatives.

Color Plate 6

Tricolor gum printing (continued).

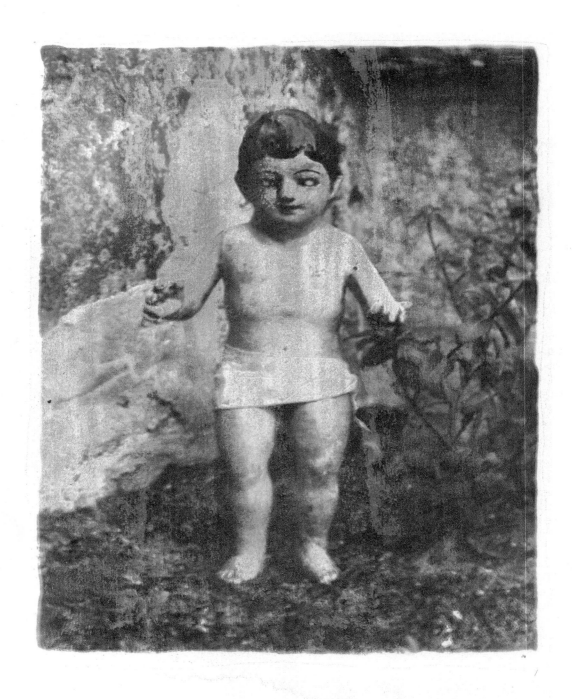

Color Plate 7

David Scopick, *Memoria y Olvido,* gum bichromate print, 1990,
19 × 24.5cm. Collection: Artist.

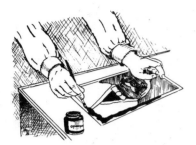

Figure 4.28 Apply liquid opaque to the negative border.

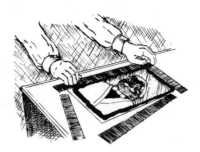

Figure 4.29 Position construction paper over remaining area.

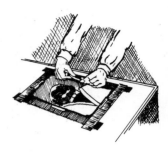

Figure 4.30 Tape the border mask onto the negative.

FORMULA: EMULSION PREPARATION

- 1 part prepared solution dichromate (3.0ml per 20 × 25cm print)
- 1 part prepared pigment and gum (3.0ml per 20 × 25cm print)

STEP **7**

Preparing the Emulsion

If the room temperature drops below 20°C, some of the sensitizer crystals can precipitate into a solid, settling at the bottom of the solution. Heat the container and redissolve them before use. Measure the required amount into a cylindrical measuring vial. Prefer to have more emulsion than needed since running short requires washing and drying the paper before recoating.

Select a color of stock gum-pigment and mix it to ensure a uniform solution. If the solution is used only periodically, remove the lid and stir up any settled particles (see Figure 4.31). (To simplify matters, begin printing with an unaltered pigment. Later, a selection of the various colors in different combinations will become standard practice. The hue of blended colors can be tested on a piece of printing stock before adding the sensitizer.) Measure the required amount of gum-pigment into the same measuring cylinder, gauging to the bottom of the *meniscus*. This is easy if the gum-pigment is to be added to the sensitizer, but the reverse is not true. The sensitizer color affects the color of the pigment, but this will fade during development.

Pour the solution into a wide-mouth bowl in preparation for coating. The mixed emulsion does not store, and must be applied to the paper immediately. Otherwise, it soon begins to harden and deteriorate, becoming a darkened gel.

The initial ratio for the emulsion should start with a standard dilution of 1 part dichromate to 1 part of gum-pigment. Several observations become evident if the variables are altered (see also guidelines from C. B. Neblette's *Photographic Principles and Practice* under Step 11):

1. Increasing the amount of pigment gives a broader tonal range, but degrades the whites and often produces a stain in the paper.
2. Reducing the pigment subdues the tinting strength of the emulsion. A reduced pigment helps build greater highlight density by exposure, with little effect on the shadows.
3. Increasing the amount of gum in the emulsion makes the solution difficult to coat. It also gives a higher contrast image and frequently causes the emulsion to flake off during development.

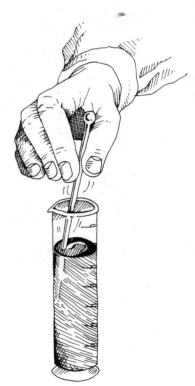

Figure 4.31 Stir the gum-pigment solution before measuring and when mixed with the sensitizer.

4. Reducing the amount of gum usually causes the emulsion to stain the paper. The pigment becomes so firmly embedded in the paper's fiber that it prevents proper clearing of the highlights by ordinary development.
5. Increasing the amount of sensitizer increases the speed of the paper, but decreases the print's contrast, producing flat lifeless prints.
6. Reducing the amount of sensitizer makes the emulsion too adhesive and difficult to apply.

Maskell and Demachy give an informative account of their emulsion preparation methods in *Nonsilver Printing Processes:*

> It would be possible to give a formula for the quantity of bichromate to be added to the mixture of pigment and gum, if the proportions of pigment were in every case constant. But they are not, for great depth of colour can be got with a small portion, say, of red chalk or lampblack, whilst a far greater bulk of colour is needed with the sepias, Van Dyck brown, bistre, or umber. On the other hand, there is a standard degree of thickness necessary for rapid and even coating. It follows therefore, that more bichromate has to be added to a sepia mixture to dilute it to proper fluidity than would be required for lampblack, because the smaller bulk used of the latter gives a much thinner consistency. Only repeated trials can teach the beginner what degree of thickness will allow an even coating. As a guide, let him begin with common red ochre, and taking equal parts of gum and bichromate, say, one drachm of each, use with this forty grains of the pigment.* A trial coating may then be made on a sheet of paper, and according to the conduct of the mixture under the strokes of the brush we can judge whether the proportions are correct or whether either gum or bichromate should be added to thicken or dilute the consistency.[19]

In *The Gum Bichromate Process,* W.J. Warren presents further indications of the flexibility inherent in the process:

> I may say that M. Demachy uses moist colours, and mixes his sensitising solution with the paint and gum solution, coating all together. In the lecture which he wrote for the R.P.S. [Royal Photographic Society], and which was read before that society in March 1898, he stated: "With regard to the strength of the gum solution I prefer to make my solution by adding two parts of cold water to one part of gum. Measuring by the eye only. Filter the gum through a square of muslin twenty-four hours after, and test it with a hydrometer—18° to 20° seems to be the proper thickness . . . The supply of gum must be sufficient to act as a sort of supplementary size, preventing the pigment from sinking into the fibre of the paper. A certain depth of colour is necessary to produce an artistic effect, and it varies according to the subject, the bulk of pigment changing also according to its colouring power. Finally, the operation of coating can only be successfully performed when the mixture is fluid enough to be evenly spread, and thick enough to set rapidly and form a continuous and homogeneous film before it has time to stain the underlying paper. I never measure my gum or bichromate solutions, neither do I weigh my pigments. I let myself be guided by the depth of colour, the feel of the mixture under the brush, and the way it spreads on trying it on a bit of waste paper.[20]

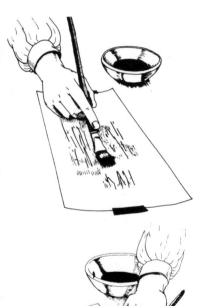

Figure 4.32 Apply the emulsion using a mix of horizontal and vertical strokes first with the spreader and then with the blender.

*1 drachm (dram) = 3.7 milliliters; 40 grains = 2.5 grams

Your chemistries are now complete and you can now begin preparation for printing. Refer back to these earlier sections frequently as your printing progresses and you become more advanced.

For practical purposes, consider the emulsion as insensitive to light until it has dried.[21] A dimmed incandescent light source is safe for the paper coating operation. A bare safelight without filter can be used with approximately a 25W bulb. You can also design your own darkroom safelights with filters cut from amber masking film or with inexpensive, colored, bare bulbs. Avoid unnecessary illumination after coating.

First, secure the paper with pushpins or tape to prevent any movement. Then prepare the spreading and blending brushes that, if wet, must be wiped dry to prevent diluting the emulsion. Coating dry paper will create an emulsion with subtle-to-distinct brush marks. To achieve a smooth airbrush finish, soak the paper in water and blot it with newsprint prior to application.

Then, dip the spreading brush in the emulsion, and draw it out over the edge of the bowl to remove any excess. Begin coating the image using light rapid strokes, painting vertically and horizontally across the full image area. Cover the sheet as quickly as possible (see Figure 4.32).

Using the blending brush, immediately blend the coat until smooth. (Attempt some variations on this method. For example, the blender can be used to daub the emulsion at right angles stippling the entire surface and creating a bold grainy effect.) Frequently remove the excess from the blender by drawing the brush over the edge of the coating bowl. Experience will enable you to evaluate when the emulsion is properly applied while it is still wet. Many visible brush marks will disappear when dry.

Blending the emulsion on the paper surface is crucial since it rapidly sets during brushing. Success in getting a wide tonal range on the print requires a thin emulsion coating. If the gum-pigment-dichromate solution is too thick, light cannot penetrate the highlights and midtones, causing them to dissolve during development. Light must penetrate the emulsion adequately so that insolubility is proportionate to exposure. A heavy pigment-to-gum ratio may also cause a thick coating, resulting in a similar loss of highlight detail and blocking up shadows.

To correct a coating that sets too rapidly while brushing, change the formula discussed in Step 5. Add more gum to the stock gum-pigment. Diluting the emulsion with more sensitizer also will correct a coating that sets too rapidly, but it may weaken the gum, resulting in stains or flaking off during development. Prefer to keep the ratio of the gum-pigment solution to sensitizer the same as that suggested in Step 7.

A properly coated emulsion does not run. You can thus suspend the sheets to dry using clothespins in the same manner as for sizing. In normal room conditions, drying will take 15 minutes. This time can be lessened by directing a fan to blow gently on the emulsion surface (heat-drying renders the image insoluble; see Figure 4.33). The paper curls slightly while damp, but flattens and appears matte when dry. Emulsion dried on the brushes can ruin them. Complete the coating and immediately place them in water for soaking, until you have time to wash them thoroughly.

Expose the print promptly once it has dried. If desired, storage for short periods of time without staining or loss in sensitivity is possible,[22] but intentionally storing coated paper beyond 24 hours will only lead to inconsistency and variations in the emulsion.

STEP 8

Coating the Emulsion on Paper

Figure 4.33 Use a fan to speed the emulsion drying.

PRESENSITIZING AND STORING OF PAPER

Variations in the coating of a gum emulsion can be considered. Maskell and Demachy present a method for presensitizing the paper in a favorable light:

> It consists in sensitizing the paper in the first place and then applying the gum and colour, instead of coating with a mixture of gum, colour, and sensitizing agents. Very simple indeed—as simple a matter as the balancing of Columbus' egg—but we think that it has not been noted before, or at any rate published with regard to any form of carbon printing.
>
> The paper, then, is to be first of all soaked in a ten percent solution of bichromate of potash for about two minutes, rocking the dish the while, to avoid air bubbles. It is then dried (bone dry), and is ready for coating in the manner previously described, the coating mixture consisting of gum at twenty percent, and a sufficiency of colour. We reduce the strength of the gum by one-half because it is not now so reduced by the bichromate solution.
>
> The sensitiveness of the paper is increased to an enormous extent. Instead of being, as in the earlier system, three or four times slower than chloride or platinum paper, it is now quite as rapid as either, or as ordinary carbon tissue: even more sensitive perhaps. Unexposed, the film dissolves and leaves the paper pure, so that the edges of a print protected by the rebates of the frame are quite white, and the highlights of the picture, also, are more amenable to control. This is especially marked with black and brown pigments, which formerly were very apt to stain.
>
> The rationale of this system would appear to be that each molecule of the pigmented gum with which the dried bichromate paper is coated absorbs, or is in contact with, just its molecule of bichromate and no more. The rest of the bichromate, protected by the coating of colour, is probably very little acted upon.
>
> In our earliest essays on the newer system we found that the images were apt to be hard; the highlights dissolved away too quickly and cleanly. This, however, clearly resulted from wrong proportions of the materials used, and so again, as we laid down in a preceding chapter, we shall not attempt to give an empirical formula. A very little patience and practice will teach each worker what is best for his own requirements.
>
> The general practice is, we think, rendered more easy. We may now sensitize as many sheets of paper as we like in advance, we can keep our colours mixed with water in any quantity, and have only to add, as required, in equal proportions, gum solution of the desired strength (i.e., at about 40 percent). There is in this way also, far less waste. The results appear to be much more certain, and if we remember how very sensitive the film is and that where formerly, perhaps, four actinometer tints were required, less than one will suffice, failures will not so often occur.[23]

Their enthusiasm for presensitizing can be questioned on several aspects:

1. Contrary to their statements, the sensitivity of the emulsion is not increased by a significant amount. This is especially true with the ammonium sensitizer and the high intensity of modern artificial light sources.
2. The highlights are easily controlled regardless of whether the paper has been presensitized. Paper that is properly sized does not cause a problem with pigment staining.

3. A volume of paper sensitized in advance can deteriorate in a short time. The speed and clearing quality are reduced.
4. The suggestion that "colours may be kept mixed with water in any quantity and [that you] have only to add gum solution of the desired strength" is of no consequence. It is not superior to the method outlined in Steps 5 and 6 of this text.
5. There may be slightly less gum-pigment solution waste in coating after the sensitizer has been applied, but this would not be a significant amount.
6. Presensitizing is more time-consuming for both single and multiple printing, since two drying operations are necessary. Additionally, the technique previously suggested—to dampen and blot the paper prior to coating—is not possible.

The following statements from *Modern Print Processes* may further help you form an opinion on this matter:

> The process is worked out in two different ways but the results are identical. The paper may be coated with a mixture of gum, pigment, and bichromate, the paper may first be first sensitized with the bichromate and a mixture of gum and pigment applied over it . . .
>
> Sensitized paper, if kept between blotters or in a book in the dark will keep for about six weeks, so that a supply of paper can be sensitized in one evening which will last for a month . . .
>
> So long as the sensitized surface presents a brilliant yellow color, as it had when packed away, it is in good condition, but when the color has changed to a dirty green-brown, the paper is no longer fit for use.[24]

Register the negative on the paper using the preferred method. If necessary, lightly press a few small pieces of masking tape around the negative's perimeter, securing it to the paper. Place the assembly in the contact frame and position it for exposure below the exposure light.

STEP 9

Exposure

You can figure out the exposure by using test strips, the *zone system,* or sensitometry (see Appendix A). Basic intuition is also excellent since the results of a gum print are very subjective. The latent image becomes visible during exposure, but unfortunately this does not provide an adequate assessment of the "correct" exposure time. (In the history of the gum process, actinometers were used to gauge exposure. As outlined in Chapter 1, these were a form of print meter that exposed a piece of sensitized printing-out paper (p.o.p), to light until it darkened to a standard tint. The time it took to reach this tint was measured by a stop watch—a calculator converted the time into the correct exposure for any type of sensitized material. Although they were suitable for slow, sensitive products of the early days, with the invention of the photoelectric cell, they have now become obsolete).

Exposures can vary widely. Use a large interval for initial testing. Begin with 2 to 15 minutes, using a 500W photoflood 40cm away. (Review exposure results for Kwik-Print in Chapter 2 or look at the manufacturer's suggested times). Familiarity with the options for development manipulations render many exposure tests unnecessary. The possibility of attractive results resulting from both over and underexposure, combined with manipulation in development, are among the unique advantages offered by gum printing.

Theoretically, the color of the pigment does not affect the sensitivity of the emulsion since the action of the light is on the sensitizer and gum.

But due to the pigment concentration (density) in the gum, the greater the density, the longer the exposure required. Further complicated by the "genetic" density differences of pigments, the rule that sensitizer is not affected by color is invalid.

Some writers will also attribute any necessary exposure changes to color differences instead of pigment densities:

> No exact time can be given for the printing as it varies with the density of the negative, the amount of bichromate in the mixture, the amount and color of the pigment used, and with the results desired. Light colors print faster than dark ones and the blue end of the spectrum prints faster than the red. Browns contain so much red that they print very slowly. A visible image is formed when printing and, especially with the lighter colored pigments, this is plain enough to serve as a guide to the experienced worker.[25]

STEP 10
Development

Follow exposure immediately with development. Even a short delay may lead to overexposure by the "continuing action" of the hardening that occurs within the exposed areas of the print.

Development is a reductive process using plain water. Prepare at least one more tray than the total number of prints that will be processed and keep only one print per tray. The print should be gently inserted with the emulsion side up (see Figure 4.34). The emulsion loses sensitivity in water and can be developed under normal room illumination.

At this point, you can follow two methods for developing the gum print, still development and brush development. Each method has its benefits and will be discussed in this section. Your decision will be partly influenced by the gum pigment dilution prepared in Step 5 (refer again to the testing procedures outlined by Anderson from *The Handbook of Photography*).

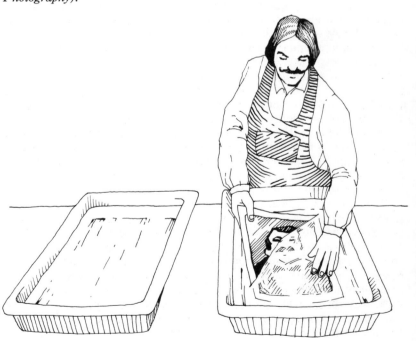

Figure 4.34 Begin development with the print face up to observe the effects of the exposure.

The unexposed gum begins to dissolve immediately; the emulsion becomes soft and delicate. For still development, any agitation of the water will produce an uneven result and must be avoided. Within 1 minute, gently remove the print and carefully lower it emulsion side down, in a U shape into the second tray. To avoid air bubbles, let the center come into contact with the water first, then slowly lower the corners (see Figure 4.35). The unexposed emulsion continues to dissolve, falling to the bottom of the tray. *Developing the print face up causes a stain from the sensitizer and pigment resting on the surface.*

As the water becomes saturated with the color of the dichromate pigment, continue to change the fresh water trays. The time in each tray can increase as the deposits of emulsion given off lessens.

Unexposed emulsion is not hard and is soluble in water at any temperature. When desired, speed up the process by increasing the temperature. The total time required for development can vary from 15 minutes to 1 hour. Many factors come into play: original exposure, water temperature, number of tray changes, and the results desired. Do not hang the print to dry following a (short) development time that results in the emulsion "running." Prints can be removed from the developing water before the highlights wash out completely, and placed face up on a piece of blotting paper. To prevent the pigment from staining the edges by "bleeding," a hot air fan (or hair drier) can be used around the image perimeter for a few minutes. Allow the print to partially dry. The shadows can then be further developed, with the pigment in the highlights firm and more resistant.

Prints that appear either over or underexposed during development should not be discarded. To reduce over exposure, add a few drops of ammonia or other alkali to the development water. The quantity must be small—15ml of anhydrous sodium carbonate to 2 liters of water will have a noticeable effect. A stronger dilution may alter the paper dimensions, causing registration errors. An underexposed print may be corrected with multiple printing, as described in Step 11.

Brush development—a trait unique to gum printing—makes the manipulation of the wet-soft emulsion possible during development. (See Figure 4.36). A series of brushes ranging in hardness and width can be used to lighten highlights or remove areas of the image. Apply the brush with the print submerged in water for a very delicate effect. Remove the print out of the water to create more pronounced brush marks. It is difficult with brush development to maintain the delicacy and range of a print that has been still-bath developed. Note that brush development or other methods of development manipulation should not be undertaken until the development time is at least half complete. This provides an accurate indication of the exposure on the print.

Begin by removing or "erasing" pigment in selected areas to produce an even brush stroke quality throughout the image. Color and detail can be fully removed from an area and replaced by exposure with an emulsion of an alternate color. Water can be used to produce an interesting stippling in a flow that either gently or forcibly strikes the surface. Small quantities of sand in the water can also effectively abrade the print (historically, sawdust was used). One technique used by Demachy to soften the effects of the brush strokes involved putting glycerine over the print prior to development.[26] As your printing experience broadens, new and personal methods can produce striking results at the development

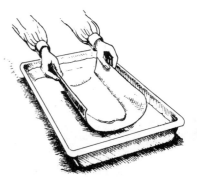

Figure 4.35 Invert the print face down to complete development in a U shape to avoid air bubbles.

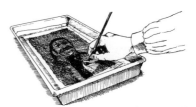

Figure 4.36 Brush development manipulation.

stage. This potential extends the range of gum printing capabilities beyond the level of mechanical processes and should be fully used.

Finally, carefully remove the paper from the water when the desired degree of development is reached. Again, suspend it with clothespins to dry. After a few minutes, the drying process can be speeded up by directing a fan to blow gently on the surface.

STEP
11
Multiple Printing

It is possible in gum bichromate printing to render the tonal scale of a suitable negative and emulsion in one printing.[27] But this procedure does not use the complete range of possible tones, nor does it fulfill the potentials of multiple printing. Multiple printing involves building additional layers of pigment on the print by repeating the process and overprinting the image. Paper coating, negative registration, exposure, and development are reapplied, manipulating the potential variables as desired. Paul L. Anderson provides an informative account of multiple printing in Henney and Dudley's *Handbook of Photography:*

> One reason that so many beginners in gum work get into trouble is that they expect the first printing from the negative to look like a print and try to make it do so. It should not; it should look like a very sick imitation of a print—pale, washed out, very likely no more than a flat tone in the shadows, and in general thoroughly unsatisfactory. It is astonishing to an inexperienced worker to see how the print assumes vigor and character with the addition of subsequent printings.
>
> If the negative is soft enough so that its entire range of gradations is rendered in one printing of gum, then when the print has been developed and dried it may be coated a second time and printed again, for the same printing time, and developed as at first. Thus the second and subsequent printings are used merely to add depth and contrast. It is much more likely, however, that the scale of the negative will be too great to render in one printing of gum, in which case the shadows—perhaps even the halftones— of the first printing will be merely a flat tone and must be brought out by the later printings. The coating mixture may, perhaps, be the same as for the first printing but the printing time less, e.g., if the negative requires three printings to render its full scale, the first one may be timed for four minutes, the second for two, and the third for one, each printing being developed fully. Some workers have been known to use sixteen or seventeen printings, and the writer knows of one who went to twenty-five, but this is sheer frivolity. Using a well-sized paper, which permits the use of a fairly large amount of pigment, the utmost richness and depth of blacks can be got in five printings, and the scale of practically any negative can be rendered in six or eight printings.
>
> It will be apparent that very great variations in coating and printing are possible in order to secure various effects. Thus a long scale may be secured with little depth of shadow by using a relatively small amount of pigment in the coating mixture; or the shadows may be emphasized by using light doses of pigment for the high-light and half-tone printings, with a heavy amount, printed lightly, for the shadows. Each worker will think up these variations for himself, but it cannot be too strongly urged that he keep a record of what he has done in each case. If he fails to do this he will not know where he is; he will be unable either to duplicate or to predict results, and he is likely to abandon gum printing under the impression that

it is too difficult. As a matter of fact, gum printing is not at all difficult, but it does demand care and accuracy. Given these and a moderate amount of experience, gum printing will be found not only much easier than bromoil or even than plain bromide enlarging, but far more satisfactory in its results.[28]

The theme of this guideline and many others seem to center on "adding depth and contrast" to the image. The concept usually involves three printings, one each for the highlights, midtones, and shadows. The exposure is reduced progressively and pigment density can be increased.

Neblette offers a guideline with indications for a specific emulsion in *Photographic Principles and Practice:*[29]

> The actual mixture used for coating varies with the paper and the negative and also with the effect desired. Practically every worker develops a different formula after practice and while there may be little difference, yet it is better adapted to his own personal methods of working.
>
> However, the following formulas are given for the benefit of the beginner:

SHADOW COATING

Gum solution	15 c.c.	½ oz.
Sensitizer	15 c.c.	½ oz.
Ivory black from tube	4 in.	4 in.

> If the negative has a short scale of gradation it may be possible to use the above for all the printings; if, however, this is not the case and the negative has a long scale of gradation and prints well with bromide or platinum, then it will be necessary to vary the coating mixture so as to secure a longer scale. It is generally necessary to make three printings: one for the shadows, another for the halftones and finally one for the highlights. The following are advised for the halftone and highlight coating mixtures.

HALFTONE COATING MIXTURE

Gum solution	15 c.c.	½ oz.
Sensitizer	15 c.c.	½ oz.
Ivory black from tube	2 in.	2 in.

HIGHLIGHT COATING MIXTURE

Gum solution	15 gm	½ oz.
Sensitizer	17.75 c.c.	5 dr.
Ivory black from tube	1 in.	1 in.

To summarize Neblette's outline, it can be stated that:

1. It should be possible to complete an image with three printings.
2. The respective highlight, midtone, and shadow emulsions, use different pigment concentrations. It might also be possible to use half the strength of pigment for the first (highlight) printing, and a normal pigment density for the midtone and shadow printings.
3. The exposure also varies. The highlight printing receives the most and time is reduced for the midtone and shadow exposures.

Still, Neblette's and Anderson's comments are directed towards printing the proper gradations of a continuous tone image. We can also suggest more flexible methods. The outlines do not comment on burning-in pigment or on brush developing, which can intentionally flake the emulsion. Color is also ignored; why not selectively color small areas of the image? In effect, the possibilities are so vast that a definition or scientific approach is not possible and you must find your own "stratagem" by trial and error. The following comments may be useful:

1. Another emulsion can be applied when the print has dried following development or at a later convenient time. However, how long the print can remain stable without being "cleared" is not established (see Step 12). Nevertheless, you can confidently store prints for one year without visible change.

2. The time involved in the coating, printing, and development of one gum print is considerable. There are many ways to increase productivity, by testing several different negatives simultaneously or by working several prints from the same negative. Keep the prints in a flow of various stages, changing each emulsion, exposure, and development technique. Keep a positive mental attitude and learn to appreciate working on prints for a period of time. Three to six printings can be necessary for many images. (See Figure 4.37 and Color Plate 4.)

3. Do not discard problem images. Continue working on them by using multiple printing. The variety of the process can eliminate blemishes or streaks and easily change irregularities to impressive effects.

4. Plan the color sequence for each image before you print. Try all the options—any combination can be used. Begin using bright warm colors and finish with cold transparent ones, perhaps using some shade of blue. If the print is too hot or bright, it can be subdued and modified by the addition of a thin coating of gray or blue. If the image is too cold or dull, it can be given warmth by a coating of a color in the red range. Keep a record of your color sequences when printing so that you can find the color combinations that work well. Remember that the print cannot be darker or deeper than the amount of pigment in the emulsion. For example, if an emulsion of black has so little pigment that it appears gray, the deepest shadows of the picture can only be gray. Mixing the pigments (including white) should be standard practice.

5. The emulsion is routinely applied to the entire image area. Still, it is possible to devise methods for local application to small segments. This may involve techniques using an airbrush or perhaps, while coating, two or three different emulsions can be blended. Apply artist's maskoid (available at an art supply store), by brush for a liquid rubber mask. Paint over it with emulsion, and once dry remove it by rubbing with an art eraser. Lift undesired color from the emulsion prior to exposure, using a brush, blotting paper, and water. A multicolored impression can be created in one printing!

6. The possibilities are endless. Once a print has an initial coating, expose it face down without a negative; the light passes through the paper and affects the emulsion in the unprinted areas. The print acts as its own negative!

Figure 4.37 Compare this black and white image on modern silver paper to a finished gum print, see Color Plate 4. David Scopick, untitled workprint, 1974, 14 × 20.5cm. Collection: Artist.

Allow the print to thoroughly dry after the last development. Then soak it for 5 minutes in water, followed with a soaking in a 1 *percent solution* of potassium metabisulphite.* Use a stronger dilution if the clearing is not sufficient or is too slow, but the vapor is extremely strong and can cause a slight effect to some colors. It is unlikely that the emulsion will soften, but be careful to prevent any abrasion.

Clearing may take from 1 to 5 minutes. This depends on the sensitizer (ammonium requiring more clearing), number of printings, time used for development, and so on. When the dichromate stain (sometimes more apparent as a yellow cast on the back of the print) is removed, you have almost reached an acceptable clearing of the print. Allow for a little bit more time (an extra 25%) to complete removal. If a print has little or no visible stain—the result of good sizing, proper coating, and full development with each printing—a 1- or 2-minute soaking is adequate. Transfer

STEP
12

Print Stabilization

*When handling metabisulphite, follow the same precautions as with formaldehyde. Use a vapor mask and work in a well-ventilated room.

Figure 4.38 Deckle the paper before presentation.

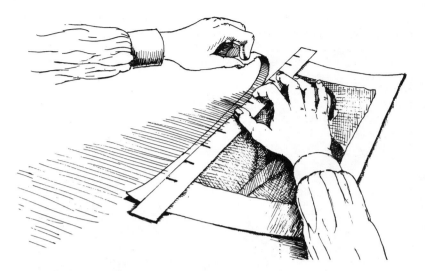

is made to a running-water rinse at 20°C for 10 minutes and then the print is chemically stable. Hang to dry.

The clearing bath can be affected by overuse. When enough prints change it to a muddy green color, discard it and prepare a fresh solution. Note that paper prints should be cleared only after the last printing is complete. Otherwise the paper's dimensions may be altered, affecting further registration.

If necessary, spot the print with watercolor. An option is to spray it with a product for protecting crayon or charcoal drawings. The appeal of the finished print can also be improved by deckling the paper's edge. (See Figure 4.38). Lay a rule over the front of the print and carefully tear off the excess paper by pulling it straight up, to create a jagged hand-torn edge. For a nice look, tear a strip about 1cm wide or first remove the larger section with one tear, and leave the required amount for a second pull. Study various prints in graphics galleries to observe how this treatment influences the image presentation.

STEP

13

Color Separation Techniques

This section covers the specifics of producing color separation. The question "Why include such information when so much color technology is mechanized and affordable?" can arise.

Definitely the simplicity of purchasing commercial separations appeals to some printers as an alternative to the time and investment required for manual separation. But the principles of gum printing appeal more to the artist than to the commercial printer. Artists are likely to enjoy the individual methods of learning color separation in their home darkroom.

Any up-to-date survey of color separation printing involves separations by computer *scanning* and advanced printing technology. Stephen Livick has proven that a gum printer can use these systems to attain the ultimate in gum print quality. He creates large-scale prints of remarkable accuracy, with color and resolution that parallel the best of contemporary processes (see Color Plate 5).

Yet, color separation does not necessarily means "realistic" color printing or must emphasize methods designed for the most accurate

The author gratefully acknowledges assistance by Gary Shennette, from the Film and Photography Department of Ryerson's Polytechnical Intitute, Stephen Livick, and Herzig Somerville Printers for assistance with color separation.

reproduction. Too much theory can be a disadvantage, making the artist reproductive and overly precise; interpretation is abandoned. You can decide how the final image will be; technique does not supersede ideology.

In addition, the study of a manual color assembly print process such as dye transfer or tricolor gum is useful. Observing the separation of images into distinct layers is excellent preparation for any other color print process.

Finally, the methods outlined for separation, including references to masking and other aspects, are only basic principles. The theory and practice of separation work fill the text of many books on color printing. Refer to the many excellent sources available.[30]

GENERAL COLOR THEORY AND BACKGROUND

Since the first days of photography, there has always been an instinctual desire for photographers to create naturalistic color. In 1861, James Clerk Maxwell gave a demonstration of three-color *additive primary light*. This used a simultaneous projection of red, green, and blue light. White was produced by their combination, black by their absence.[31] Since then, photography has used filters of red, green, and blue, or their subtractive primaries (complementaries) of cyan, magenta, and yellow, for all color methods (see Figures 4.39 and Color Plate 6).

Interest in tricolor gum prints began in the late 1890s, with the first ones exhibited by P.R. Von Scholler in Vienna in 1898.[32] The fundamentals of the process are the same today: separate and permanent records of a color subject can be produced photographically by exposing films through the primary filters. Each filter, like the eye, absorbs some

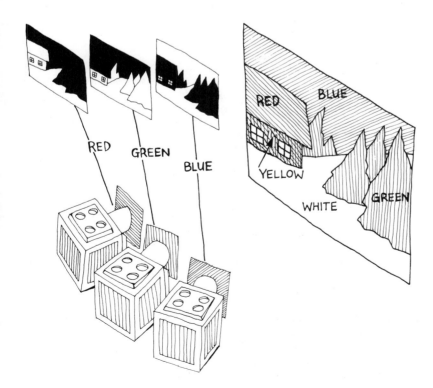

Figure 4.39 The additive color system. Black-and-white positive images exposed with red, green, and blue filters are projected with the corresponding filters and superimposed.

Figure 4.40 The tricolor principle of a "one-shot camera."

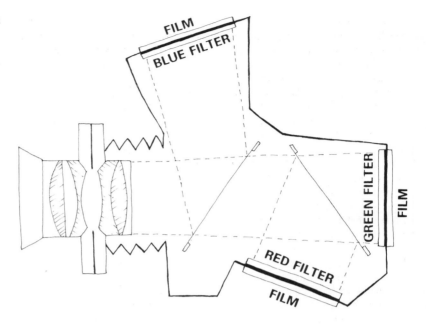

wavelengths while showing a visual color of the wavelength it passes. This is the basis of color separation negatives. These separation negatives are converted to separate overlapping positive images, printed using the complementary colors.

Unlike Maxwell's additive process, nature creates colors by the objects' absorbing or subtracting certain colors from *white light* and reflecting the remainder. This gives the "natural" color of the object, and is the foundation of the *subtractive color process* first described by Ducos duHauron in 1869.[33] It remains the main basis for color print processes.

Various methods to create color prints from separation negatives evolved in history before the modern method of *scanning* came into being. An interesting process was the use of "one-shot cameras" (see Figure 4.40). These experienced a "boom" in America during the depression and early 1940s. Using this system, two partially reflecting mirrors (also prisms or semitransparent reflectors) split the light from a single lens into three paths. The mirror reflected part of the light onto a plate near the front, splitting it into two parts, one reflecting onto a plate on the other side of the camera and the other passing through to a plate on the back. The correct filters were in front of each film holder.

As stated by Jack Coote,

This camera has been described as 'the original one-shot'; certainly the firm of Bermpohl has the longest record of production of these cameras.

The Bermpohl [Figure 4.41] is of the three separate plate two-mirror type, and is made in three sizes, its reflectors are made of glass and are semisilvered on their front surfaces. The body of the camera is mahogany and the layout can be seen from the diagram.

The most popular model is the 9 cm. by 12 cm. camera which can now be obtained with a rangefinding attachment to convert the camera to a twin lens reflex.[34]

Figure 4.41 The Bermpohl camera, described as "the original one-shot," had the longest record of production.

Photographers, initially excited by this camera, became disenchanted. Problems arose: obtaining accurate registration was difficult, its size and shape were inconvenient, changing three plate holders for every exposure was time-consuming, and there was a lack of versatility in changeable lenses and movements.

Before the advent of one-shot cameras, photographers were using separations created directly from the subject. These methods were based on one camera making three consecutive exposures through the separation filters. Many photographers continue in this tradition today. Others prefer the creation of separation negatives from original transparencies, by contact or enlargement. Either system suits the home darkroom.

A third option is the production of separations from color negatives. This has not been a popular method in spite of some advantages. The differences between making separations from a color negative and color transparencies are as follows:

1. Masks are built into the color negative film. Transparencies are unmasked, but masks can be made for them.
2. When producing a separation from a color negative, the printer goes from a negative to positive to negative, whereas with a transparency you go directly to negative. (A film that can be used for positives is Kodak Separation Negative Film Type 1, and for separation negatives is Kodak Commercial Film.)

The following highlights some of the advantages and drawbacks inherent in the two main methods.

IN-CAMERA SEPARATIONS
- When the objective is a still-life subject, separation negatives taken directly from the subject give results that are difficult to equal when working from a transparency.
- In-camera filters require lengthy exposures and a tripod is essential. The light also must remain constant in color and brightness throughout the exposures.
- Because of the need to expose film sequentially, the photographer cannot photograph moving subjects. An alternative might be to hand-color a black-and-white photograph and rephotograph it.
- A large camera must be used. Even so, separations often have to be projected to obtain an enlarged negative suitable for gum printing. Balance must be maintained twice and the chance of errors doubles. Negative production also takes up time that could be used for printing. Shortcuts are desired.

SEPARATIONS FROM TRANSPARENCIES
- The print becomes "second generation," an approximation of an approximation. The color rendering is further complicated by the pigment (watercolor) imperfection.
- More masking is required when making separations from positive transparencies than with separation negatives made directly from the subject.[35] However, discussing masking in relation to color separation can easily complicate methods unnecessarily.[36] For purposes of tonal

corrections, masking offers a useful procedure that is covered under Appendix B. The methods outlined are also applicable for other color processes. Masking for the Cibachrome process may benefit approximately 50% of the transparencies used. Most other printing methods also have contrast problems. The need for masking in the control of negatives for gum printing lessens with the use of various methods such as multiple printing, modified exposures, handwork, and so on. Despite how accurate filters might *theoretically* be, if the printing pigments or dyes are not accurate, masking may be required.

- One transparency contains all the subject information. The transparency is easily and inexpensively processed by a lab with great accuracy. It also can serve as a "master" record of the subject and is useful for color correction. With in-camera separation, the printer lacks a reference for color corrections—it's all recall!
- Emphasis must always be placed on getting the best quality in the original (there is a minimum of *exposure latitude* with a transparency). A low-contrast subject always helps, preferably slightly underexposed to increase saturation and highlight separation.

Based on experience and on the above information, a transparency system is recommended; so the directions in this text apply to separation by enlarging techniques from transparencies. (The assumption is made that the worker does not have convenient access to a process camera. If such a resource were available, other systems may be more suited to the individual worker, such as copy separations produced from a color print or transparency. An extension of this is outlined in *Dye Transfer Made Easy.*[37] Beede incorporates the use of a 35mm camera with an "on-camera" slide duplicator and a light box for illumination.)

THEORY OF PRINTING
FROM SEPARATION NEGATIVES

The subtractive process is important in understanding the theory of printing color photography. The principle suggests that the primary spectrum comprises red, green, and blue light. Subtract blue, and you are left with green and red which, when mixed, give yellow. It follows that:

White Light Has 3 Primary Colors	*Subtract*	*Remaining Complementary Color*
1. Blue	Blue	(Red and green) = yellow
2. Green	Green	(Blue and red) = magenta
3. Red	Red	(Blue and green) = cyan

Conventional photographic prints are colored mainly with dyes. Tricolor gum printing substitutes specific watercolor pigments. Each negative is printed with a pigment that is the complementary color of the filter used in making the negative. The red negative prints a cyan pigment. Cyan absorbs red and the amount printed controls the quantity of red light reflected, as a result of the white paper reflecting all colors. The entire spectrum from violet to red can be reproduced by combining various proportions of the three primary colors.

Each separation negative must be printed with a pigment that absorbs just one color. Primary-color pigments absorb two colors (e.g., red absorbs both blue and green). But cyan pigment has a translucency

containing blue and green and absorbs only red. When light strikes the print, the amount of cyan pigment controls the red reflected to the eye. *It follows that complimentary colors control primaries.*

The amount of each complementary pigment printed controls the amount of primary visible. If all the pigments are printed to a maximum intensity, the primary colors are fully absorbed, resulting in black. The reason why a black printer is not always required depends on the quality of the complementary printing. If no complementary pigments are printed, then white is present.

Sometimes a fourth negative, or "black printer" is used. This can be exposed through a yellow or light green filter, or through each three-color filter in turn on the same emulsion—about a third of that necessary to obtain an image of normal density. As pointed out,

> due to the relative purity of the dyes used in the [dye transfer] process, rich blacks and good contrast are obtainable without a black printer. Some workers will eventually find a black printer useful for special effects and highly rich shadows, but this procedure remains entirely supplementary.[38]

> Theoretically, this fourth grey printing is unnecessary, and it is rarely used by color photographers producing continuous-tone prints on paper. On the other hand, in photo-mechanical reproduction where color prints are eventually produced on a mass scale, such a (black printer) helps to produce a good scale of greys even when using unsuitable inks or second-quality printing and adds "punch" to the reproduction. This "punch" is often obtained at the expense of the impression of naturalness in the colour rendering.[39]

Blacks also can be improved and a *gray balance* achieved by increased density from the cyan printer (see Step 14). In the 1990s, there is a move toward a system called *Achromatic Color* that uses maximum black and minimum color for all printings. Some of the commercial advantages of this method are based upon its use in typography contained in most ads as well as reduced drying time and cost for inks.

Film, separation filters, and pigments do not attain perfection in any color process. The challenge lies in the accuracy, density, and contrast required to produce balanced color, and in the quality of the pigment being printed. Gum printing offers some advantages since the pigments are printed separately.

EQUIPMENT AND MATERIALS

The following outline relates to specific needs for continuous tone negatives as applied to color separation. (For specific requirements and methods for halftones, refer to Appendix C.)

STEP
14

Color Separation Negatives

Filters The specifics of filtered separations involve two methods of filter selection, broad-band filters and narrow-band filters (see Figure 4.42):*

*The choice of filters can depend on the brand of the separation film and transparency emulsion for separation. The filters listed work well with Kodak Super XX film and Ektachrome transparencies and should be acceptable for products from other manufacturers. Dyes vary with different manufacturers (e.g., the separation of Kodachrome and other emulsions require distinct separation [and masking] filters). Determine compatibility in advance if precise standards are to be followed.

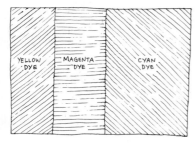

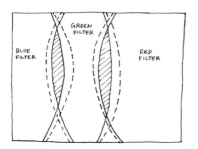

Figure 4.42 Transparency dyes and filter separation. As each dye rises over its color range, it absorbs some of the other colors. For good separation from the transparency, the filter should conform to its color record with a minimum of transmission from other colors. The solid filter curves represent narrow-band filters, and the dotted curves are wide-band filters.

1. Filters numbered 25 red, 58 green, and 47 blue, comprise the broad-band filters. Their specific application is the production of daylight in-camera separations. Filters must be able to cover the diversified daylight color spectrum. When applied to daylight, their filter factors are equal.
2. Numbers 29 red, 61 green, and 47B blue, are narrow-band filters designed for the production of separation negatives from transparencies with the use of a tungsten light source. Transparencies simulate the original scene in a reduced spectrum, in dyes of three complementary colors. No filters can separate transparency dyes completely, but narrow-band filters reduce some color overlap, since their range is similar to that of a transparency. They give better color saturation.

Obtain filters from a graphic arts supplier. Gelatin filters are the most commonly available, but may require special ordering. Prefer to select a large size for above the lens. Otherwise, gelatin filters used below the lens need to be carefully protected.

Lens Most modern *multi-coated lenses* are suitable for the separations. An older lens can create a very slight registration problem that results from the separated bands of light not focusing on the same plane (chromatic aberration). As Jack Coote stated,

> However, if your enlarger or the lens is not quite so up to date, it would be wise to carry out a simple test. Take a completely fogged and fully processed plate of film of the maximum size that your enlarger will take, and scratch a pattern of very fine lines all over the surface of the emulsion layer. Project the image of this test negative onto a sheet of white paper at a fairly high degree of enlargement. Focus the image as sharply as you can, and then examine it with a magnifier. If there is noticeable colour fringing of any of the lines imaged on the enlarger easel, then your lens is suffering from too much chromatic aberration and would not produce sharp colour prints.[40]

Film For continuous tone, select a film manufactured especially for separation work such as Kodak's Super-XX Pan film. It has an even sensitivity, producing a straight-line characteristic curve (refer to Appendix A, Figure A.16). Other current recommended products are Kodak's T-Max and Separation Negative Film Type 1. Also, note that color separation film is panchromatic. Use absolute darkness for all procedures. If any sheets require cutting, code notches must be made to help emulsion orientation.

Developer For color separation processing, Kodak recommends the use of HC-110 developer. If a larger volume of production and greater consistency is anticipated, DK-50 is a preferred choice.

Process and Color Controls Separation printing requires the use of processing controls (density wedges) to assist color accuracy (approximation). The suggested items are:

1. Transmission gray scale: the gray scale, also called step wedge, is helpful in separation photography. With an ideal set of separations, the measured scale from any transparency is identical. Since gray is

a color that transmits equal amounts of primary red, green, and blue light, it prints equal densities of complimentary cyan, magenta, and yellow pigments. *If gray can be reproduced, then all other colors are in equal proportion.*

Step wedges are available in a variety of scales such as ½- or ⅓-stop increments and are available from graphic arts suppliers.* The Stouffer Density Scale is a good choice (see Figure 4.43).

2. Three-point color separation guide: three-point color separation guides such as the Kodak Q6C or smaller Q6M, include small red, green, and blue patches, as well as 3-aim density steps for highlight, midtone, and shadow readings. Use it to check for correct exposures, printing ratios, and negative identification (see Figure 4.44). Some confusion may arise over the recommendation for three-point density patches, besides the gray scale in point 1. The three-point density guide alone is sufficient for gum print separations, but the gray scale gives greater accuracy and different information. With the application of both density guides, development [contrast] is read on the graded strip, and the three-point guide gives exposure.[41]

Using a densitometer and density readings can help you improve your technique and understanding of the process. The densitometer specifically can:

1. Suggest exposure by comparing the densities on each negative.
2. Suggest development to parallel contrast.
3. Indicate, once the separations have been made, their suitability for the gum process or alternate forms of printing.

Heat-Absorbing Glass
Heat-absorbing glass properly placed in the enlarger will prevent heat from reaching the negative during long exposures and act as a filter system for unwanted infrared radiation caused by the heat. Its use is not mandatory.

Negative Carrier
The requirements for separations from a transparency require a glass negative carrier. Improvise one with an anti-*Newton's ring* slide mount for 120 film and a homemade carrier constructed from cardboard (see Figure 4.45).

Ultraviolet Filter
An ultraviolet filter can be used above the lens while exposing the separations. Its use is not mandatory and is not as important as the heat-absorbing glass. A UV filter is more important for color paper processes than film separations.

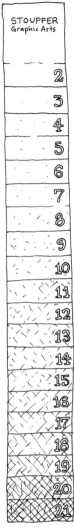

Figure 4.43 A Stouffer Sensitivity Guide. Refer to Appendix A, Table A.1.

Figure 4.44 A Kodak Three-Point Transparency Guide. The approximate densities of the Kodak Three-Point Guide are .50, 1.30, and 2.50.

*You can order directly from Stouffer Arts Equipment, 319 North Niles Ave., South Bend, Indiana 46617. Tel.: 1-219-234-5023.

Figure 4.45 A homecrafted negative carrier and 120 glass transparency (slide) holder.

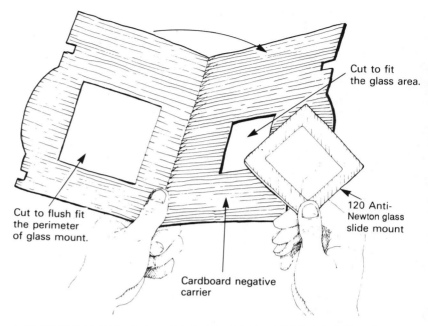

Cut to fit
the glass area.

120 Anti-
Newton glass
slide mount

Cut to flush fit
the perimeter
of glass mount.

Cardboard negative
carrier

TECHNIQUES FOR SEPARATION NEGATIVES

Ensure that the transparency is acceptable in quality. Examine it on a *daylight balanced* light table for color precision. Prefer a first transparency that will be easy to separate and will reduce the need for masking. The image should contain a low-contrast subject with a limited range of color (i.e., possibly only one color of importance, such as a fleshtone). Also, it might be photographed in cloudy, overcast or early morning conditions. Slight underexposure helps saturate color and highlight density. A good density range is 2.2 or less (not to be confused with maximum density—D_{max}).

Guidelines for Continuous Tone Separations

1. Position the transparency in the anti-Newton slide mount (only one side of the slide holder is anti-Newton glass. Find this by visual inspection, and orientate it to contact the backing side of the film [the emulsion, being a matte surface, does not form Newton's rings]). Depending on the size and arrangement of the film, control strips, and glass carrier, large clear areas either around the transparency or control strips must be avoided. A jig or holding mask may be required. The simplest can be made with the special tape used for masking transparencies for projection (silver or black). Use the tape to cover the perimeter of glass around the transparency and to hold it in position—this is important to prevent any *adjacency effect* and flare (see Figure 4.46). Depending on the size of the transparency and control patches being used, it may be necessary to prepare the above mask from a film emulsion. The film is flash-exposed and developed to a density of .7 to 1.0. This range is designated as an "average density" of the transparency. Any film stock would do, and can be developed in bromide paper developer for the required density. This mask is usually required in large-scale work when contact-printing separations (see Figure 4.47).[42]

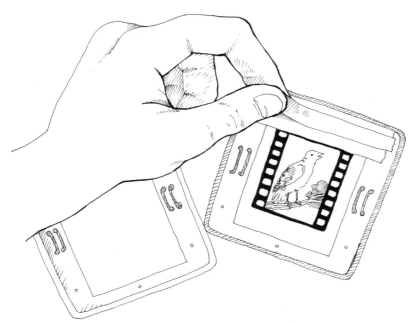

Figure 4.46 Silver tape the exposed glass area around the transparency to prevent adjacency effect.

2. Secure the transparency to the mask within the glass carrier, emulsion side up. If you are working from a 35mm transparency, the Q6C three-point guide could be cut in half and positioned to project through the sprocket holes of the transparency (see Figure 4.48). This is an excellent arrangement for 35mm, since the negative is narrower than the standard 20 × 25cm film and the excess margin can be used. The gray scale, if desired, can be positioned below the narrow margin of the transparency. (It may also be necessary to cut the gray scale to a more convenient size.) Note that the light used for printing the control patches must be the same quality as for the

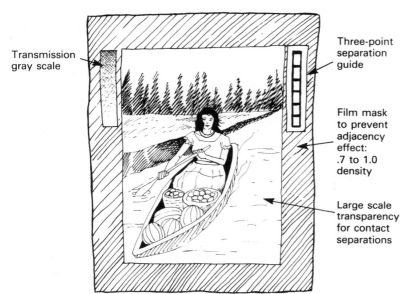

Transmission gray scale

Three-point separation guide

Film mask to prevent adjacency effect: .7 to 1.0 density

Large scale transparency for contact separations

Figure 4.47 A film mask for contact-printing large transparency separations. Cut openings to drop in the transparency and control strips.

Figure 4.48 Include the segments of a Q6C control patch, cut in half, to project onto the separation negative.

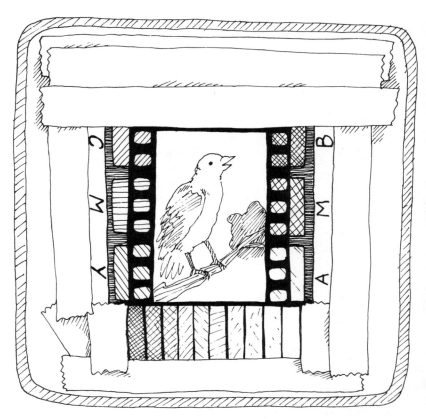

transparency. If the transparency is being projected, the control patches must be projected, not contact-printed.

3. Position the assembly image in the enlarger and adjust the enlarger for projection (see Figure 4.49). Use the baseboard of the enlarger to secure (tape) the registration pins since an easel or other arrangement would interfere. Punch-register the film as required. Cover the enlarger with fabric, making it "light-tight" to avoid fogging (color casts) in the separations.

 An alternate method is to produce the separations, but organize registration at a later time. If this is preferred, "score" the margin of the transparency with a knife, to provide better registration marks (see Figure 4.50). Later, produce a paper positive by contact from one separation, and make the registration for the negatives to the positive.

4. Make exposure tests. A standard transparency can be used and positioned in the enlarger using the printing mask.[43] Adjust the lens aperture (since few modern lenses suffer from chromatic aberration, the worker should take advantage of the lens's optimum resolution, which is generally two to three stops from maximum aperture). Test results can be assessed with sensitometric guidelines or visual examination.

 Note that narrow-band separation filters have varying densities. If exposures vary too widely, *reciprocity failure* will increase. (The ideal ratio of filter factors would be $1:1:1$.) There may be an advantage to eliminating reciprocity if filter factors are known. It is possible to adjust the aperture or provide neutral density filters

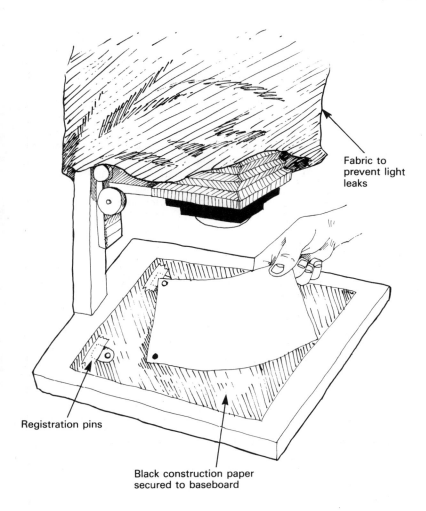

Figure 4.49 Prepare the enlarger for separation printing.

Fabric to prevent light leaks

Registration pins

Black construction paper secured to baseboard

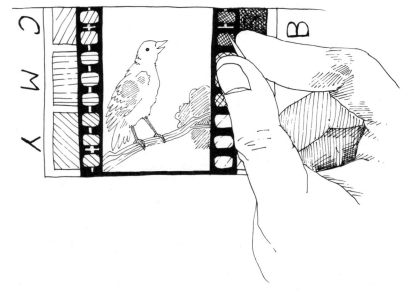

Figure 4.50 If registration is not made at the enlarging stage, "score" the transparency to provide registration guides on the separations.

instead of adjusting exposure. Still, factors vary drastically depending on the film, filters, enlarger, and development, so that a standard can only be determined by the printer. A simple, useful test could expose and develop a step wedge exposure for each filter and apply sensitometric readings to establish guidelines.[44]

Base your first test on the product data sheets provided with the film. For Kodak Super XX Pan film, Kodak advises to adjust the enlarger magnification using a bare enlarger tungsten light source (without transparency or filters), and then magnify to three footcandles at the exposure plane, at a lens setting of f/4.5.* The (Kodak) working aperture is adjusted to f/8 for the exposure and development.[†]

Preferred measurements, using similar guidelines (in a condenser enlarger), follow. They were obtained using the three-point density guide to get a density range of .9 to 1.1 (it should be slightly less in the red separation).

Filter	Exposure time	Development‡	Practice[§] Exposure	Practice[‖] Development
Red 29	25 seconds	4½ minutes	15 seconds	2¼ minutes
Green 61	15 seconds	3½ minutes	15 seconds	2¼ minutes
Blue 47B	30 seconds	7½ minutes	30 seconds	4¼ minutes

Attention should be given to developer *volume,* not only dilution. If the quantity of developer prepared is generous for the size of film (possibly a large size of tray is being used), then overdevelopment will result. Consequently, standardize volume and tray dimensions. The theoretical guidelines listed provide some good starting information to vary on. If a tungsten light source is used for exposure, the blue filter requires approximately about 30% to 50% increase in exposure and development; red should be reduced by about 5% in development for gum printing. Be consistent in the testing to help standardize all aspects of the separation process.

The following measurements will help those who want to use the three-point density guide:

	Transparency Highlight	Transparency Midtone	Transparency Shadow
Actual 3-point density guide	0.50	1.30	2.50
Approximate practice separation negative desired	1.30	0.80	0.30

*Footcandle readings can usually be obtained from information scales given on the back of most hand light meters. Three footcandles at f/4.5 refers to an approximate exposure of 2 seconds for 100 ASA.

†The suggested development is designed to get color separation negatives (made from unmasked transparencies) of an approximate gamma of 0.70 and suggest adjustment to a density range of about 1.20 (slightly greater than the one desired for gum printing).

‡Times represent the use of HC-110 developer, dilution B.

§A sample transparency with a density range of 2.2 was used at an aperture of f/8.

‖ A density range of .99 was concluded in the green and blue filter separations and .95 in the red separation.

Remember that when determining separation densities, the rule is to place emphasis on highlights and midtone accuracy. To evaluate separations without a densitometer, contact-print the negatives onto black-and-white paper, using the appropriate filter (see Appendix A). By using the same filter and exposure for each print, you will have an indication of the contrast and corresponding densities you can expect when color printing.

5. For testing purposes, the film can be cut into small strips and code-notched as follows: red: untrimmed; green: one corner trimmed; and blue: two corners trimmed.

6. Films can be tank- or tray-developed. If tray-developing, use a flat bottom developer tray or place a sheet of glass over the indentations (see Figure 4.51). Keep emulsions down during processing. Films can be processed collectively or individually. Use the most comfortable system. Later, your standards and print objectives will prescribe the necessary precision (e.g., whether to use fresh developer for each separation, agitation, etc).

7. Based on the manufacturer's suggested criteria, develop to desired density range of 0.90 to 1.10 (see Appendix A). The use of a special color separation film is enormously beneficial. The emulsion is designed to give identical contrast from all filters at a given development time, bringing the gray scales into balance. Unless absolute results are required, the negatives need match only approximately in contrast and density. The individual exposures of the negatives can vary when printing.

8. Dry all films from the same corner. Avoid heat-drying.

Figure 4.51 For even development, place a sheet of glass on the bottom of trays with grooves.

Once the criteria for a transparency are known, apply the same methods to help standardize future work. Initially, the bare enlarger illumination (without a transparency or filters) can be read with an incident light meter to provide guidelines for different magnifications.[45]

PROOFING

If proofing is desired, you can take into consideration the following:

1. The previous suggestion for proofing negatives on black-and-white paper may provide enough information.

2. Kwik-Print gives the perfect proofing system for gum printing. Use the manufacturer's process colors.

3. Color separation can closely follow the mathematics of sensitometry and proofing is not necessary if the proper calculations are observed.

PIGMENT PREPARATION

The pigments, printing papers, and supplies often recommended for gum printing are frequently those most readily available. The benefits of "generic" products is obvious in the acquisition of esoteric supplies for experimental or historic techniques. Other products can frequently be tested and if improvements occur, the gum printers may feel that they have "discovered" better pigments or papers.

STEP

15

Tricolor Gum Printing

A writer may be aware of excellent brand names that are best *not* included. The lack of availability of some brand products would unnecessarily discourage the enthusiast and consistent workers will ultimately discover more effective printing materials and methods.

The pigments suggested in this text (Windsor Newton & Rowney) are endorsed by other contemporary texts.[46] Consider the following comments on tricolor pigment selection:

1. A range of process colors that testing has proven useful are: (Windsor Newton & Rowney's) Cadmium Yellow, Cadmium Yellow Pale, Cadmium Yellow Lemon or Hansa Yellow for the yellow printer; Permanent Rose or Alizarin Crimson for the magenta pigment; and Monastral (Thalo) Blue, Prussian Blue, or Windsor Blue for the cyan printer. There are other manufacturers of pigments that print more efficiently, wash out better, and give better color saturation in a *single* printing, but have proven difficult to locate. If you enjoy experimentation, invest in testing pigments, particularly those from Europe, as they may lead to a vast improvement.

2. If a new pigment line is selected for testing, ask the supplier for recommendations on tricolor work. Test these in your preferred manner, using standardized paper, and so on, against other familiar pigments. Note that within some product lines, some pigments may be quite exceptional while others may fail (from a gum printer's standpoint).

A few manufacturers provide an "in-store" chart, made using actual pigment densities. Otherwise, color charts are reproduced commercially, from printer's inks. The bias of a printed chart may only complicate the selection. It would be better to begin with a small palette of colors that are likely to work out and prepare swatches to discuss with a color separator.

Pigments for tricolor printing should be mixed with gum arabic in "maximum densities." The application of a suitable pigment having the proper densities may eliminate the repeated printings of each negative.

ASSEMBLY AND REGISTRATION OF SEPARATIONS

Follow Figure 4.52 for guidelines on the assembly of films and paper, using the register tabs or punch register and registration pins.

PRINTING

The order of print is 1) Yellow base; 2) Magenta center; and 3) Cyan top (see Color Plate 6). The sequencing may vary with different processes and printing concerns. For example, printing magenta first is necessary in some processes where registration is more visual.

If a densitometer is not available, print exposure ratios can be established from the testing on black-and-white paper. Compare the results required to reproduce corresponding gray scales from each negative (see also Appendix A).

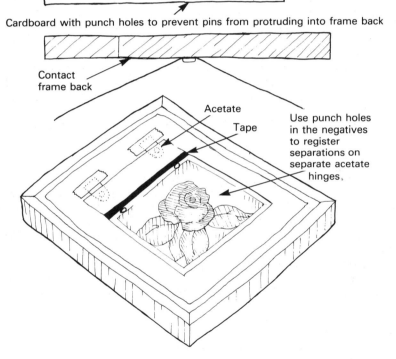

Figure 4.52 A possible printing assembly.

COLOR CORRECTION

Density Corrections for Primary Colors

When density corrections that include a primary color correction are required, if the print is too dark, exposure can be reduced through the adjoining primary negatives of the cast. For example, if a dark print is green, the printer can reduce exposure through the blue and red filter negatives; if the print is too light, the printer can increase exposure to the primary negative of the cast.

Density Corrections for Complementary Colors

When density corrections that include a complementary color correction are required, if the print is too dark, exposure can be reduced through the primary negative of the cast. For example, if a dark print is magenta, the printer can reduce exposure through the green filter negative; if the print is too light, the printer can increase exposure to the adjoining primary negatives of the cast.

Primary Color Casts

Red, green, and blue casts can be reduced by increases in exposure to the negative made through the same filter of the cast. For example, if the print is blue, exposure is increased through the blue filter negative, which prints a yellow subject area. Any resulting change to density is balanced with slight exposure reduction to the adjoining primary negatives.

Complementary Color Casts

Cyan, magenta, and yellow casts can be reduced by decreases in exposure to the negative made through the filter complementary to the cast. For example, if the print is yellow, exposure is reduced through the blue filter negative, which prints a yellow subject area. Any resulting change to density is balanced with slight exposure increase to the adjoining primary negatives.

Corrections become more difficult when the casts are integrated with two colors and further study from some of the books listed in the Bibliography is recommended.

NOTES

1. Jack H. Coote, *Making Colour Prints* (London: Focal Press, 1944), pp. 43–45.

2. Jack Eggleston, *Sensitometry for Photographers* (London: Focal Press, 1984), pp. 205–206.

3. See Catherine Reeve and Marilyn Sward, *The New Photography* (Englewood Cliffs, NJ: Prentice-Hall, 1984), pp. 95–120 for an understanding of paper making for the photographer: "It is a simple and gentle process, and one we believe you will want to incorporate into your own work" (p. 35).

4. For a listing of fine art papers and their characteristics, see John Ross, Clare Romano, and Tim Ross, *The Complete Printmaker* (New York: Free Press and Macmillan, 1990), pp. 342–343.

5. Suda House, *Artistic Photographic Processes* (New York: Amphoto, 1981), p. 60. More details on the use of sizings are provided by Reeve and Sward, *The New Photography*, pp. 37–43.

6. Keith Henney and Beverley Dudley, eds., *Handbook of Photography* (London: Whittlesey House and McGraw-Hill, 1939), p. 468. Reprinted with permission from McGraw-Hill, Inc.

7. Supposedly named after a Mr. Bright. Ralph Mayer, *The Artist's Handbook of Materials and Techniques* (New York: Viking Press and Macmillan, 1972), p. 541.

8. Alfred Maskell and Robert Demachy, "Photo-Aquatint and the Gum-Bichromate Process" (Reprint of 1898 article). In Peter Bunnell, ed., *Nonsilver Printing Processes* (New York: Arno Press, 1973), p. 22. Reprinted with permission.

9. "Make sure that the pigment you use has no chromium in it (such as chrome yellow) because it reacts negatively with the bichromate." In Laura Blacklow, *New Dimensions in Photo Imaging* (London: Focal Press, 1989), p. 95.

10. Mayer, *The Artist's Handbook*, p. 669.

11. William Crawford, *The Keepers of Light* (Dobbs Ferry, NY: Morgan & Morgan, 1979), p. 207.

12. Criteria for the recommended density range established by a few other sources are as follows: Ernest M. Pittaro, ed., *Photo Lab Index,* Lifetime Edition (Dobbs Ferry, NY: Morgan & Morgan, 1979, Sup. 139, sec. 11), p. 18 states .9 to 1.2; Leyland Whipple states .9 to 1.0 in "The Gum Bichromate Printing Process" (Rochester, NY: International Museum of Photography at George Eastman House; unpublished manuscript, 1964, Cat. 81.4W574, #9998); Luis R. Nadeau states .7 to .9 in *Gum Dichromate* (Fredericton, Canada: Atelier Luis Nadeau, 1987), p. 30.

13. Private communication, May, 1990.

14. Henney and Dudley, eds., *Handbook of Photography,* p. 488.

15. For specifics on the use of a plasticizer, see Mayer, *The Artist's Handbook,* pp. 299–302.

16. Henry G. Abbott, *Modern Printmaking Processes* (Chicago: Hazlitt, 1900), p. 20.

17. Henney and Dudley, eds., *Handbook of Photography,* pp. 489–490.

18. Based on a method used by Whipple, "The Gum Bichromate Printing Process," pp. 13–14.

19. Maskell and Demachy, "Photo-Aquatint and the Gum-Bichromate Process," p. 21.

20. W. J. Warren, *The Gum Bichromate Process* (London: Iliffe Books, c. 1899), pp. 44–45.

21. Nadeau in *Gum Dichromate* emphasizes the aspect of Poitevin's patent which states that the "wet dichromated emulsions are sensitive enough to produce a photographic image," p. 4. Later, Nadeau acknowledges that "emulsions made of dichromated colloids have little sensitivity to light;" that "(gum) processes require tremendous amounts of damaging light and heat to produce an image;" and that "for all practical purposes, gum printing is essentially a contact printing process, requiring a very powerful light source," pp. 21, 22, 36.

22. Maskell and Demachy, "Photo-Aquatint and the Gum-Bichromate Process," p. 26, claim that they have used paper as much as eight days after coating.

23. Maskell and Demachy, "Photo-Aquatint and the Gum-Bichromate Process," pp. 54–55.

24. Abbott, *Modern Printmaking,* pp. 9, 10, 17, 18.

25. E. J. Wall and Franklin Jordan, *Photographic Facts and Formulas* (Boston: American Photographic Publishing Co., 1940), pp. 227–228.

26. Warren, *The Gum Bichromate Process,* pp. 68–69.

27. "All his (Demachy's) beautiful work is produced by one printing, and if I had any hope that my readers could attain to his proficiency, I would strongly advise them to give every attention to so doing." In J. Cruwys Richards, *Practical Gum Bichromate* (London: Illife Books, c. 1904), p. 66.

28. Henney and Dudley, eds., *Handbook of Photography,* p. 492.

29. C.B. Neblette, *Photography Principles and Practice* (New York: Van Nostrand Reinhold, 1939) p. 670. Reprinted with permission.

30. See Ira Current, *Photographic Color Printing* (Boston: Focal Press, 1987); Philip Zimmermann, ed., *Options for Color Separation* (Rochester, NY: Visual Studies Workshop, 1980); D.A. Spencer, *Colour Photography in Practice* (Boston and London: Focal Press, 1969); and Robert Hirsch, *Exploring Color Photography* (Dubuque, Iowa: Wm. C. Brown Co., 1989).

31. Willard D. Morgan, *The Encyclopedia of Photography* (New York: National Educational Alliance, 1949), p. 824.

32. Nadeau, *Gum Dichromate,* p. 59.

33. Morgan, *Encyclopedia of Photography,* p. 824.

34. Coote, *Making Colour Prints,* p. 30.

35. Eastman Kodak Co., *Color Separation and Masking* (Rochester, NY: Eastman Kodak Co., Data Book E-64, 1959), p. 13; and Spencer, *Colour Photography in Practice,* p. 241: "It is easier to make a faithful assembly colour print when separation negatives are taken direct from the subject than when they are obtained from a colour transparency."

36. Many texts suggest (and I agree) that masking is not necessary: "Masking is a highly specialized skill, besides being an additional step in the dye transfer process. We will not cover the procedure here; it will be easier for you to learn and use masking if you need it, after you have learned the basic skills for dye transfer," Mindy Beede, *Dye Transfer Made Easy* (New York: Amphoto, 1981), p. 48; Crawford, *The Keepers of Light,* pp. 232–233 outlines the general theory, but states that "A step-by-step explanation of masking is beyond the legitimate scope of this book;" Arnold Gassan, *The Color Print Book* (Rochester, NY: Light Impressions), p. 110, gives reference to the appropriate Kodak literature and states that "All these (masking techniques) are ignored here because they are not necessary to the printmaker working with nonstandard processes, and the rewards are not commensurate with the investment in time and materials until a degree of expertise is established that justifies them."

37. Beede, *Dye Transfer Made Easy,* pp. 39–58.

38. Zimmerman, *Options for Color Separation,* article by Lee Silverman, p. 34.

39. Spencer, *Colour Photography in Practice,* p. 236.

40. Coote, *Making Colour Prints,* p. 121. A more technical description titled "Testing a Lens for Color-Separation Work" can be found in Eastman Kodak's *Fundamental Techniques of Direct-Screen Color Reproduction* (Rochester, NY: Eastman Kodak, 1975), p. 42.

41. For more information, see Spencer, *Colour Photography in Practice,* Reference Charts, pp. 237–238.

42. For more information, see Eastman Kodak Co., "Preparing the Transparency" in *Silver Masking of Transparencies with Three-Aim Point Control* (Rochester, NY: Eastman Kodak, 1974), pp. 4–5 or Eastman Kodak Co., *Fundamental Techniques of Direct-Screen Color Reproduction* (Rochester, NY: Eastman Kodak Co., 1975), pp. 3–4.

43. A standard transparency can be reproduced from several different grays. See Current, *Photographic Color Printing,* pp. 141–142, 201–209.

44. For more information on the theory and determination of filter factors in color separation, see Spencer, *Colour Photography in Practice,* pp. 235–245.

45. For more information on standardizing exposures, see "On-Easel Photometry" and "Off-Easel Densitometry" in Current, *Photographic Color Printing,* pp. 212–219.

46. Crawford, *The Keepers of Light,* pp. 201, 212; Gassan, *Color Print Book,* p. 58; Nadeau, *Gum Dichromate,* p. 69.

APPENDIX A
Sensitometry

The following information on sensitometry covers only basic principles. Refer to Jack Eggleston's *Sensitometry for Photographers* for complete information.[1]

SENSITOMETRIC READINGS

Gain access to a densitometer or construct one as shown in Chapter 4 (see Figure 4.8). If this is not possible, you can use the following methods:

1. Gray scale comparison: a transmission gray scale also called density or sensitometric step wedge, provides a strip of film with varying densities that can be used as a visual comparison of negative quality for gum printing purposes. (See Figure A.1.) Step wedges can be purchased from Stouffer Graphic Arts Equipment and other manufacturers. (The purchase price of a calibrated step wedge is prohibitive and a densitometer may be available somewhere to read your own densities.) See Table A.1 for a guideline to follow.
2. Kodak Projection Print Scale comparison: For more information, see the Kodak Workshop Series, *Advanced Black-and-White Photography*.[2] The principles involve a visual comparison of densities and negative similar to using the transmission gray scale. (See Figure A.2.)

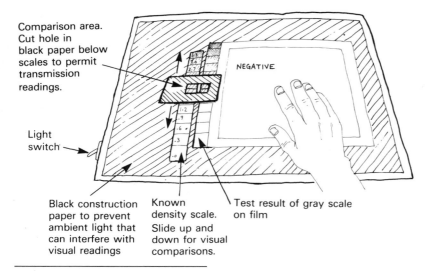

Comparison area. Cut hole in black paper below scales to permit transmission readings.

NEGATIVE

Light switch

Black construction paper to prevent ambient light that can interfere with visual readings

Known density scale. Slide up and down for visual comparisons.

Test result of gray scale on film

Figure A.1 A visual density comparison can give a transmission reading of acceptable accuracy.

The author gratefully acknowledges F. William Scanlon from the Film and Photography Department of Ryerson's Polytechnical Institute for assistance with this appendix.

The following gives density measurements from a specific Stouffer Density Scale. Use the "estimated" density readings as acceptable measurements for a Stouffer or other scale until precise readings are made.

TABLE A.1 21-STEP SENSITIVITY GUIDES

Step	Exact	Estimated	Step	Exact	Estimated	Step	Exact	Estimated
1	.08	.05	8	1.10	1.10	15	2.10	2.15
2	.21	.20	9	1.25	1.25	16	2.25	2.30
3	.37	.35	10	1.40	1.40	17	2.41	2.45
4	.53	.50	11	1.53	1.55	18	2.58	2.60
5	.67	.65	12	1.67	1.70	19	2.73	2.75
6	.82	.80	13	1.81	1.85	20	2.87	2.90
7	.96	.95	14	1.95	2.00	21	3.00	3.05

TERMS AND ELEMENTS OF SENSITOMETRY

Readings with the densitometer are based on the transmission of light through the negative. This provides information in three ways, measured in terms of density, transmission, and opacity and expressed by logarithmic formulas.

Density Density is the result of exposure. Exposure is light multiplied by time, measured in millilux, and expressed as millilux seconds.* Exposure and density are expressed in *logarithmic* form and abbreviated relative log E for exposure, and D for density (see Table A.5). Therefore, values of density can be understood as direct changes in the relative exposure; for example, twice the density represents twice the exposure when there is a gamma of 1 (see Figure A.7).

An understanding of logarithms is not essential. But it must be known that each change of 0.30 in density or exposure represents doubling or a change of one stop. Therefore a .3 change in *exposure* is either .5x or 2x and a .3 change in *density* is either a .5x or 2x. (See Table A.2.) One reason for using logarithmic values is to provide a graph with corresponding equal changes in light to equal changes in density.

Transmission Transmission is expressed as a percentage. Percent transmission represents the difference between reading a beam of light through a negative and without a negative. A measurement of light without a negative yields 100% (units) transmission. If the negative is read and 50 units transmit, the transmission is 50/100 or 1/2 or logarithmically 0.3 (see Table A.2). If you use a densitometer, it is not necessary to calculate transmission, opacity, or logarithms, because the instrument will show the density on a scale.

Opacity Opacity can have two interpretations:

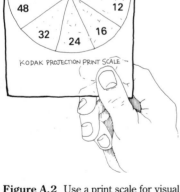

Figure A.2 Use a print scale for visual density readings.

*Light was previously measured in meter candles or lux, which also corresponds to meter candles. The revision to millilux can be stated as .1 Meter Candle (.1 lux) × 1,000 = 100 millilux. The purpose of this change is to eliminate the negative or "bar" log measurements previously necessary when using sensitometry.

**TABLE A.2 THE RELATIONSHIP BETWEEN PERCENT
TRANSMISSION AND FILM DENSITY**

Percent Transmission	Decimal Equivalent	Density
100	1.00	0.00 represents a transparent film
50	.50	.30 represents a one stop increase in density
25	.25	.60 represents an additional stop in density and a shadow area of a negative
1	.01	2.0 represents midtone to highlight areas of a negative
.1	.001	3.0 represents a nearly opaque negative

1. In sensitometric terms, opacity represents how much light does *not* transmit through the film. For example, the division of a full-scale reading of 100% (units) by a lower reading of 50% gives an opacity of 100/50, or of 2. (See Table A.3).
2. On the practical side, the opacity is the real number, called antilog, for a logarithm. For example, an opacity of 2 has a logarithm (density) of .3 (one f-stop). The density of 3.0 has a real number (opacity, antilog) of 1000. Density is the logarithm of opacity (see Table A.3).

**TABLE A.3 THE RELATIONSHIP BETWEEN
OPACITY AND DENSITY**

Opacity	Density	Percent Transmission
2	.3	50%
4	.6	25%
5.5	.74	18% (middle gray)
8	.9	13%

Logarithms Logarithms are short forms of numerical value—1000 can be written as 3 as a log. They offer a method of simplifying calculations by reducing multiplication and division to addition and subtraction. As previously stated, each regular f-stop varies by .3; four f-stops are 1.2 apart. Each .3 density represents a factor of 2 or 1/2. Logarithms also describe light in a more visual manner—our eyes respond logarithmically to changes of light, not arithmetically.

To visualize how logs simplify numbers for use on curves, see Table A.4.

**TABLE A.4 A COMPARISON BETWEEN LOGS AND
ARITHMETIC NUMBERS (ANTILOGS)**

Log	Arithmetic Equivalent (Antilog)
.3	2
1	10
1.2	16
2	100
2.5	320
3	1000

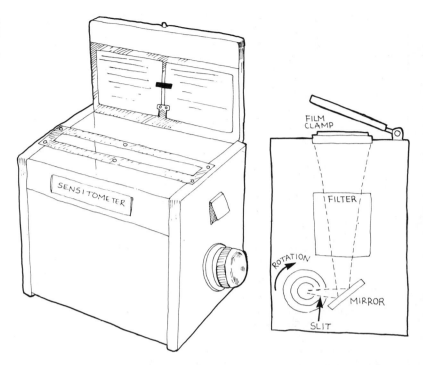

Figure A.3 An exposure system for a commercial sensitometer. Adapted from *Sensitometry for Photographers,* Jack Eggleston. (London: Focal Press) 1984, p. 14.

A log is the exponent that indicates the power to which a number is raised to produce a given number. For example, since $10^2 = 100$, 2 is the log of 100. In this case, the original number, 100, is the opacity. It can also be called the antilog. For example, 100 is the antilog of 2.

Logs can considerably simplify the calculation of some values. If you want to multiply two numbers, figure out the sum of the two logs representing the numbers (see Table A.5). For example, to multiply 7.94 by 5.62, add the log of 7.94 (.90) and the log of 5.62 (.75), which gives 1.65. The original number (antilog) for 1.65 is 44.7. One simple operation, an addition, and one look at a table are enough to give you the answer.

Sensitometers A sensitometer exposes film with a precise time through a step tablet of calibrated densities. See Figure A.3 and also refer to Jack Eggleston's *Sensitometry for Photographers.*[3] A sequence of exposures on a film are made in a sensitometer. A specific development is used and the resulting densities are applied to a characteristic curve to integrate the measurements. The relationship is shown for different exposures and density (image blackness) expressed by the *"D/log E curve"* or "cause and effect relationship" (the relationship is between changes in exposure and image density when using a specified developer). The curve is calibrated in log values.

THE CURVE OF A NEGATIVE

Characteristic Curve of a Negative Construction of a graph requires that the scales be equal (e.g., a 3.0 density change must match a 3.0 exposure change) (see Figure A.4). In the straight line

**TABLE A.5 COMMON LOGARITHMS FOR NUMBERS
FROM 1 TO 1000 FOR LOG$_{10}$**

Number	Log$_{10}$	Number	Log$_{10}$	Number	Log$_{10}$
1.00	0.00	11.2	1.05	112	2.05
1.12	0.05	12.6	1.10	126 **(f11)**	2.10
1.26	0.10	14.1	1.15	141	2.15
1.41	0.15	15.8 **(f4)**	1.20	158	2.20
1.58	0.20	17.8	1.25	178	2.25
1.78	0.25	20.0	1.30	200	2.30
2.00	0.30	22.4	1.35	224	2.35
2.24	0.35	25.1	1.40	251 **(f16)**	2.40
2.51	0.40	28.2	1.45	282	2.45
2.82	0.45	31.6 **(f5.6)**	1.50	316	2.50
3.16	0.50	35.5	1.55	355	2.55
3.55	0.55	39.8	1.60	398	2.60
3.98 **(f2)***	0.60	44.7	1.65	447	2.65
4.47	0.65	50.1	1.70	501	2.70
5.01	0.70	56.2	1.75	562	2.75
5.62	0.75	63.1 **(f8)**	1.80	631	2.80
6.31	0.80	70.8	1.85	708	2.85
7.08	0.85	79.4	1.90	794	2.90
7.94 **(f2.8)**	0.90	89.1	1.95	891	2.95
8.91	0.95	100.0	2.00	1000	3.00
10.00	1.00				

*Cameras, meters, and film are marked in logarithmic scales. A series of
common f-numbers as shown in bold type increase or decrease exposure
by a factor of 2, halving or doubling the exposure.

portion of the curve, exposure changes equal density changes. Yet, in the
toe and shoulder areas, the brightness and separation of the original
subject are not proportionate. Changes in brightness do not produce
equivalent changes in density. The curve of a negative features the
following characteristics:

- $A = D_{min}$ *(minimum density):* This point represents the transparent
film base plus chemical fog, called "base plus fog." In color, this is
termed "base plus stain."
- $B =$ *Toe of curve:* The toe represents the negative shadows. It also
informs us of the "inertia point," which is the point where we can start
"seeing" the effect of light. Note that in the toe of the curve, the line is
not straight. This demonstrates that as film first begins to respond to
light, density change is minimal in relation to the exposure. Tonal
separation is also at a minimum.
- $C =$ *Straight line portion:* This section represents the midtones of the
photograph. Equal changes in exposure result in proportionate
changes in density.
- $D =$ *Shoulder:* This is the highlight of the subject. The shoulder has a
similarity to the toe in that changes in exposure do not result in
proportionate changes in density. There too, tonal separation is at a
minimum.
- $E = D_{max}$ *(maximum density):* This is the maximum density of the
negative under the given conditions of exposure and development.
- *Relative Log E = Relative log of exposure:* Exposure is always relative.

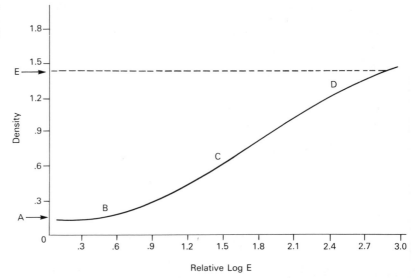

Figure A.4 A characteristic curve for a film negative. Letters mark the significant points of exposure and processing referred to in the text.

A comparison of various films and developers can be made within the same family of curves. This provides speed and contrast information for variations in developers and time of development. Films with the toe located to the left of the graph, are more sensitive, that is they have a greater speed (see Figure A.5).

The use of duplicating film, a reversal film that produces a mirrored curve from standard film, is discussed in the text (see Figure A.6).

High-contrast lith films are also used in many applications of photography and gum printing (see Figure A.7).

Data as Determined from the Curve

1. Development (Gamma): A measurement of the slope on the straight line portion of the curve provides a measurement of negative con-

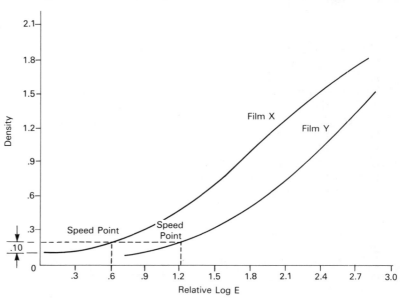

Figure A.5 A speed comparison of Film X and Film Y, developed the same way. Film X is .60 exposure units (2 stops) "faster" than Film Y.

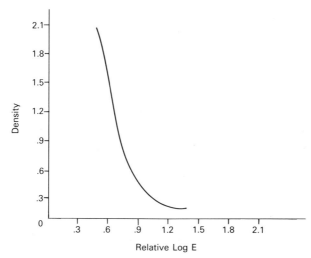

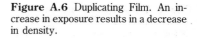

Figure A.6 Duplicating Film. An increase in exposure results in a decrease in density.

trast. The development changes the density of the negative more at the shoulder or highlight end of the curve. The toe is not affected to a great degree by development, thus the phrase "expose for the shadows, develop for the highlights," or "expose for the toe of the characteristic curve and develop for the slope"[4] (see Figure A.8). As Spencer stated, "A quick way of measuring the gamma from a characteristic curve is to mark off two points along the exposure axis, separated by an interval of 1.0 log exposure units, within the straight line portion of the curve. The

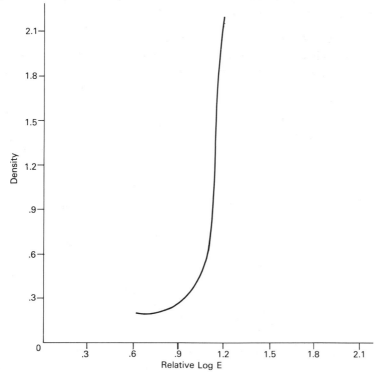

Figure A.7 A typical high-contrast lith film.

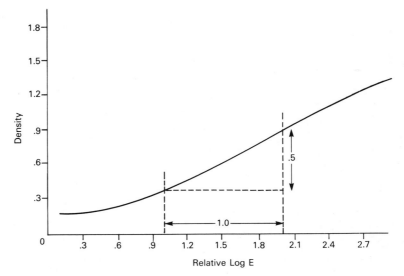

Figure A.8 Calculating gamma. Use of Spencer's method illustrates that the gamma is .5.

corresponding density difference of those two points is then equal to the gamma."[5]

Contrast Index is another calculation of contrast. It uses the minimum and maximum points useful for high-quality negatives. Gamma is not as precise, but it is adequate at this level.[6]

2. Film speed: Determined from a developed negative (standardized) and from an equation based on the characteristic curve,[7] the effective speed in a camera is determined by minimum printable densities.
3. Development changes for controlled contrast: Gamma can be plotted from the contrast information. In gamma curves, the exposure is constant and we observe what the rate of change in contrast is for specified development times (see Figure A.9).

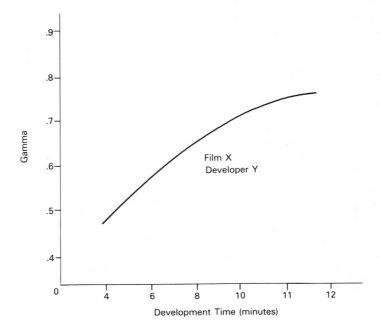

Figure A.9 A gamma development curve.

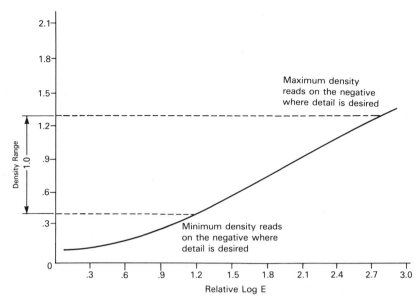

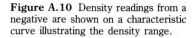

4. Density range: This can be measured from the minimum and maximum printable densities (some densities don't print). These represent the extreme areas of the negative for which we want to maintain detail in the print. The range is limited and, based on the readings, the negative can be matched to the printing process. Density range can be altered by developer, agitation, temperature, and so on. Increases or decreases of any of these result in an increased or decreased density range (see Figure A.10).

5. Exposure latitude: We can find the suitability of an exposure for a negative from the subject brightness range. A curve is drawn and the speed point marked.* The brightness range is read from the subject (change in stops from the light-to-dark picture areas). For example, a six-stop change corresponds to a brightness range of 64:1. The brightness range is converted to a log value (curves are expressed in logs) (e.g., a range of 64 is 1.8). Observe that there is an exposure latitude of 0.6 (2 stops) on each side of the scale before going off the curve (see Figure A.11).

PAPER

All the previous information is applicable to printing papers. Data must be interpreted using a reflection densitometer. In gum printing, the printing paper cannot change contrast, as modern papers using filters do. The following should be noted:

1. The characteristic curve displays the range of exposure for paper with the highlights (paper white) in the toe of the curve and the shadows (paper black), in the shoulder of the curve. The curves appear similar to that of negatives, except for the fact that it is somewhat steeper (see Figure A.12). They have a minimum base plus fog level.* They do not have an easily visible or measured base plus fog level as paper is not as sensitive as film.

*The speed point = Base + Fog (D_{min}) + 0.10 unit of density.

Figure A.11 Exposure latitude. A subject brightness range of 6 stops has 1.8 Log E units. This permits a latitude of 2 stops over and under exposure before going off the curve. Note that latitude on the curve means that detail is recorded on the negative, but not that it is of optimum quality, or printable. A gum print is capable of a range of 1.0 and medium grade photographic paper can print a 1.3 range. Negative densities below the speed point are not printable.

2. Variable contrast paper using a low filter has a long exposure range suited to a "contrasty" subject condition. High filters print short exposure ranges for a "flat" subject condition. The density range of the negative should equal the density range of the paper. See Figure A.13. (As later shown in this section, the negative range of the gum print is approximately suited to an Ilford Multigrade paper filter of 3½.)

3. Paper has more contrast than film, to balance the typical contrast characteristics of a negative (see Figure A.14).

The following curves are typical of films you can work with.

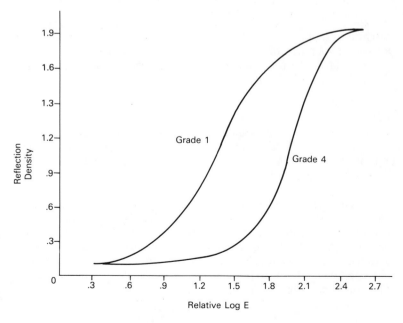

Figure A.12 Paper curves for two contrast grades.

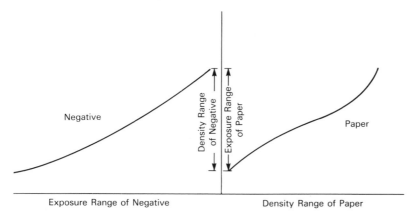

Exposure Range of Negative Density Range of Paper

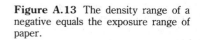

Figure A.13 The density range of a negative equals the exposure range of paper.

Duplicating Film
Duplicating film can be used for enlarged continuous tone or halftone negatives, from black-and-white originals. If enlarged negatives are produced on duplicating film, you don't have to be as concerned with the original negative density range. Produce the highest quality master negative in the camera (for modern printing materials) and modify the quality using duplicating film for gum printing. This permits greater latitude in the use of the original negative (see Figure A.15).

Kodak Super-XX Pan
Kodak's Super-XX Pan Film can be used for continuous tone color separation (see Figure A.16).

Fujilith Panchro HP-100
Fujilith Panchro HP-100 can be used for halftone color separation (see Figure A.17). This manufacturer's curve is made for an industrial printer concerned with color separating prints and machine press-printing with inks. The only significance for this text is as a comparison to Figure C.4.

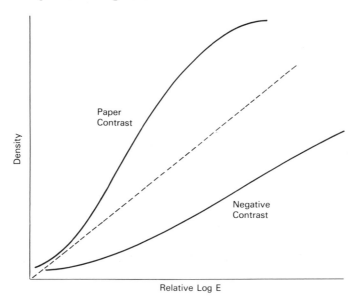

Figure A.14 These curves show an easy way to understand how negative contrast is balanced by paper contrast. The dotted line is the resultant vector from combining the paper and negative curves, with density changes that are proportionate to exposure changes.

Figure A.15 A comparison between the Stouffer Density Scale and its results printed on Fuji Duplicating Film. Gum print criteria were used (bromide paper developer and a supplementary flash exposure). A typical camera negative might range from step 3 to 15 on the Stouffer Scale, and the important concern is to print the highlights to midtones of this negative. Because the gum print paper has a short scale, see on the curve that the average negative has good separation (contrast) in this area to balance the low contrast of the gum emulsion.

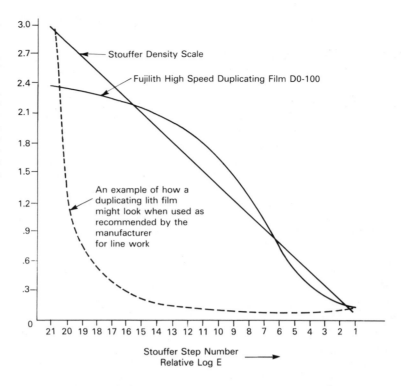

Figure A.16 Characteristic and Contrast Index Curves for Kodak Super-XX Pan Film/4142. *Source: Kodak Professional Black-and-White Films,* Kodak Publication No. F-5, August 1990, p. DS-7. Reprinted courtesy of Eastman Kodak Company. *Note:* These data are accurate to the best of Kodak's current knowledge and are not intended as a standard or specifications published by Kodak. As such, they are subject to change with product improvements and may be affected by your conditions of exposure and processing. The use of these data requires the exercise of your independent business judgment. This technical information is provided without any obligation or liability on the part of Kodak.

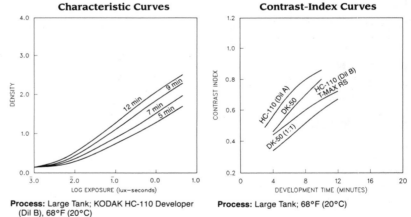

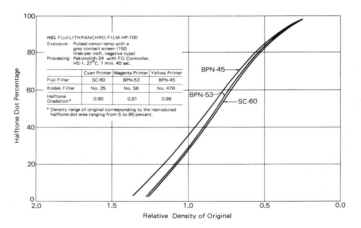

Figure A.17 *Source:* Fuji Film Data Sheet. Reprinted with permission.

PRACTICING SENSITOMETRY
The following examples illustrate a few applications of sensitometry.

Adjusting Negatives to Suit Printing Paper There is only one grade of printing available for gum printing, unlike variable-contrast papers. It is important to know the exposure scale of the emulsion, so that negatives can be developed to correlate. The scale of the paper requires that we render a full range of subject tones with texture in the shadows and highlights.

The scale of a printing paper is known by finding the exposure for the first visible deposit (silver, pigment, etc.), and by comparing this to the exposure required for a complete "black" deposit. Division of the two times gives the scale of the paper. For example, if a 2-second exposure produces a "just visible" density on a white paper, and 24 seconds are required for a "maximum" density, the exposure range is 12 (see Table A.6). This can be applied in two useful ways:

1. We can discover the brightness range of the gum print paper. This provides the density range of the negatives.
2. When the brightness range of the paper is known, we can test to find an equivalent black-and-white paper, which can be used to "proof" negatives for gum printing. This provides a quick visual check on negative quality.

TABLE A.6 ILFORD MULTIGRADE 3-RESIN COATED PAPER

Filter	Paper*
#1 (low contrast)	Exposure range of 24
#3	Exposure range of 12
#5 (high contrast)	Exposure range of 6

*at f/16 with 2 minutes development in Dektol at 1:2.

A printing paper "requires" a negative with a density range equivalent to the log of the scale of the paper. Here, the term "requires" means that the negative density can print details from highlights to shadows on the paper. We can calculate from the information of Ilford filters that:

Filters*	Exposure Range	Suited Negative Range
#1	24	1.4
#3	12	1.10
#5	6	0.80

An alternate method for the same test is to contact-print a transmission gray scale with both the gum print emulsion and variable contrast paper (using different filters). Expose to get a maximum density on the gum print at the thinnest end of the gray scale and do the same with each filter for the variable-contrast paper. Once these tests are completed,

*The density range of a variable contrast paper is lower than graded paper of equal numerical value.

Figure A.18 Calculate an exposure change by marking actual and required density points (e.g., 9 and 1.4, and read the corresponding exposure change from the exposure scale).

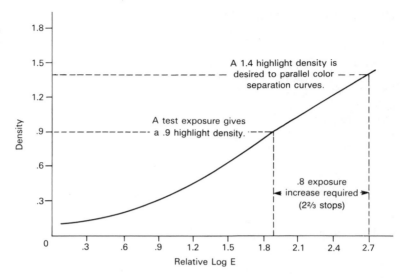

check the gum print to see how many more steps are visible until separation from the white paper is lost. Then, find the test from the variable-contrast paper that shows the same number of steps. Note which filter is used. Calculate the exposure range and negative density range from these results, as previously shown.

The gum print was previously referred to as a "short-scale process," which means that it has an exposure range of about 10. This translates into a useful negative contrast range of 1.0 (.9 to 1.1 is better). From the explained test, we require close to filter #3½.

Exposure Corrections Mark the position on the curve, figure out the preference, and drop perpendiculars down to the exposure scale for the required exposure change (see Figure A.18).

Determining Exposure for Color Separation
Exposures for the different separation negatives can be found sensitometrically (see Figure A.19). Use the gray scale densities as follows:

Highlight Readings

- green negative 1.42
- red negative 1.47
- blue negative 1.39

Determine the density differences from the test negative (e.g., green is used as the first test):

red 1.47 – green 1.42 = .05

The difference is .05. Look up the antilog for .05, which is 1.12. If the green negative required a 20-second exposure, the red negative would be:

1.12 × 20 = 22.5 seconds

For the blue negative, use:

green 1.42 – blue 1.39 = .03

The difference is .03. This has the antilog of 1.07. Since the blue negative has a lower density, the exposure is divided and would be:

20 ÷ 1.07 = 18.7 seconds.

Sensitometry, A Summary

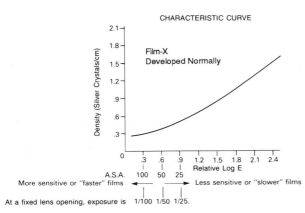

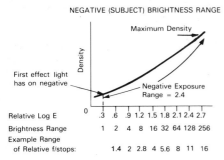

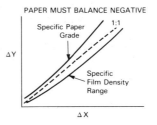

A change in 8 stops represents a brightness range of 256 and an exposure range of 2.4.

Figure A.19 Sensitometry, a summary.

NOTES

1. Jack Eggleston, *Sensitometry for Photographers* (London: Focal Press, 1984).

2. Eastman Kodak Co., *Advanced Black-and-White Photography* (Rochester, NY: Eastman Kodak Co., 1985), pp. 48–61.

3. Jack Eggleston, *Sensitometry for Photographers,* pp. 203–205.

4. William Crawford, *The Keepers of Light* (Dobbs Ferry, NY: Morgan & Morgan, 1979), p. 118.

5. D. A. Spencer, *Colour Photography in Practice* (London: Focal Press, 1969), p. 286.

6. Eastman Kodak Co. *Basic Photographic Sensitometry Workbook* (Rochester, NY: Eastman Kodak Co., Data Book Z-22-ED, 1981), pp. 15–16.

7. Refer to Eastman Kodak Co., *Basic Photographic Sensitometry,* pp. 17–20.

APPENDIX B
Contrast Control

FLASHING

There are occasions when the contrast of the enlarged negative is too great to obtain the print quality desired. A number of sophisticated methods can be used to reduce contrast, but flashing usually works well. It involves exposing the enlarged negative to white light prior to making the actual image exposure. The same technique applies to any film (e.g., duplicating, ortho, pan, lith, etc.). If you want to use flashing, use the following guidelines:

1. To figure out the correct flash exposure, remove the original negative from the enlarger negative carrier and position your film in the easel.
2. Make a test strip, exposing the film to the white light of the enlarger.
3. Establish the inertia point (minimum exposure for the first visible density) (see Figure B.1).
4. Use the inertia time to calculate a flash time for testing. If the inertia time is 10 seconds at f/11, reduce the time by 10% to 9 seconds for the test time.
5. Expose a piece of film at the estimated flash time. Replace the negative in the carrier and test expose on the flashed film with a main exposure.
6. The final result combines the correct flash and main exposures.

SILVER MASKING
FOR CONTRAST AND COLOR CONTROL

The contrast range of black-and-white negatives can be controlled by making a silver or "shadow" mask on film. Color systems also can use contrast and color correction masks (contrast masks for transparencies are called "highlight" masks). The masks can be created from the transparency through specific filters or, sometimes, the masks for color

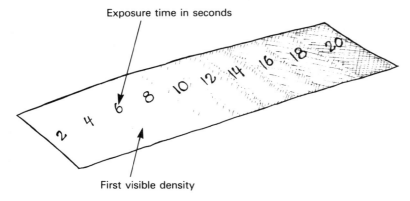

Figure B.1 Find the inertia point of film by testing for the first visible density without a negative.

103

separation are made from the separation negatives and incorporated at
the time of printing. (In this text, the terms highlight and shadow masks
refer to continuous tone contrast reduction masks, not to "drop-out"
masks that are usually high-contrast masks with one specific density.)

The need for masking in color separation occurs because of filter and
process color deficiencies. Blue and green should not register on a
red-filtered negative because a red filter absorbs these colors. But colors
are never pure primaries and since film does not discriminate, there are
crossovers from the other primaries. (The red- and green-filtered sepa-
rations cause the most problem with respect to color "bleeding." The
blue-filtered separation gives the purist pure primaries.)

The principles for black-and-white negatives and color transparencies
are much the same and can be done simply. They involve making an
unsharp mask of low contrast and low density and registering it in contact
with the master during printing. To gain familiarity with masking, begin
with a black-and-white mask produced from a 35mm negative. Later, the
process also can be applied to contact print methods for enlarged nega-
tives. The following covers basic procedures for negative and trans-
parency masking.

Negative Masking for Contrast Control To apply the
technique of masking, you need:

1. Masking film such as Kodak Pan Masking Film 4570. This film is
 panchromatic and can be used for masks from black-and-white or
 color films. (Panchromatic films require absolute darkness.) If mask-
 ing is only used with black-and-white films, an ortho (or blue sensi-
 tive) masking film can be used.
2. Low-contrast developer such as DK-50 or HC-110.

Once you have the materials, follow these guidelines. (For color
transparencies, substitute "transparency" for negative. Interpret the
mask as a negative mask for highlight control in lieu of a positive mask for
shadow control):

1. Attach the negative to a strip of acetate using pressure-sensitive
 tape. The acetate provides a surface to punch-register the negative
 and must be large enough to use with your system (see Figure B.2).
2. Punch-register the acetate and secure registration pins to the base-
 board of the enlarger or contact frame.
3. Place a diffusion sheet between the negative and masking film. A
 degree of softness is wanted in the mask, and although Kodak Pan
 Masking Film has built-in diffusion, this increases the effect. The
 unsharp mask reduces the edge definition when registered with the
 negative to obtain increased sharpness in the print. Sharpness also
 can be reduced if you put the mask into contact with the negative
 emulsion side up (see Figure B.3). (Also, note that sharpness is
 increased in the end result with a diffused mask. The sharp density
 differences of the original remain and can be reproduced—density
 differences in a film are precisely what create sharpness.
4. Punch-register the masking film to correspond to the negative. If
 your masking film is panchromatic, code-notch any sheets that are
 cut to maintain the correct emulsion orientation. Layout the negative
 and masking film as illustrated.

Figure B.2 A simple registration system for masking 35mm film.

Tape hinge the film to an
acetate strip for punch registration.

5. If the D_{max} and D_{min} of the negative are known, testing can be controlled. Otherwise, regulate the exposure and processing time for the masks by testing (begin processing at 3 minutes in DK-50, 1 part developer to 1 part of water). Expose and process the mask to a low D_{max}, approximately between .3 and .5. A greater increase in density may produce a mask that is too dense, resulting in a flat print. Aim for a combined mask and negative with a density range suitable for gum printing, approximately 1.0.
6. Dry the mask and register it with the original negative. Secure the films with tape and position the assembly in a glass carrier for enlarging.
7. Print the combined negative and positive sandwich normally. There is a reduction of shadow contrast in the final print.

Transparency Masking for Color and Contrast Control After you have experience with highlight or shadow masking, you may become interested in learning how color corrective masking is used. The following list provides some information:[1]

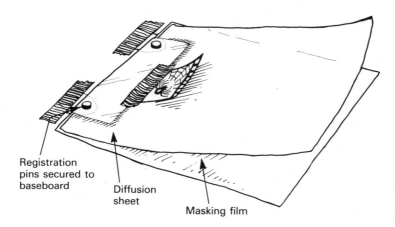

Registration
pins secured to
baseboard
Diffusion
sheet
Masking film

Figure B.3 Diffuse the mask with a diffusion sheet between the image and masking film.

1. Color correction masking is important for commercial applications since comparisons are made with the original "side by side." When the color photograph is not compared with the original subject, mental comparison is less accurate. A highlight contrast mask is often all that is required. Using a color-correcting mask can be deferred unless your results are unsatisfactory.

2. As Current stated, color-correction masks can be produced in either of two ways: "(1) exposing the masking film through the color transparency with red or green light to produce negative masks that are bound in register with the transparency when exposing the separation negatives, and (2) exposing through the separation negatives to form positive masks that are bound in register with the negatives when printing the matrices."[2]

3. If a highlight mask is required to maintain detail, it is produced the same way as a negative shadow mask, but it has a second purpose: it is used in register with the transparency to produce both the color-correction masks and the principle separations. The contrast effect of the mask can be tested by making a Cibachrome print. (Bear in mind that in the "single-mask system," used for most masking, the highlight mask can be created by using a colored light. The mask, when registered with the transparency, has the effect of lightening (in the final print) the complementary color of the filter used. For example, a red-filtered mask will lighten the cyan effect on other colors.)

4. Color-correction masks are exposed by using colored light to alter the complement of that color (see Table B.1).

Table B.1 illustrates the standard "double-mask" system. The masks are developed to a density range that would correct the unwanted absorption (a guideline for testing purposes is 20% to 30% of the density range of the master negative).

Creating the mask makes it possible to have a negative image possessing the printing qualities of the complementary color. When used with the transparency, it cancels the respective color effects on other filtered negatives.

**TABLE B.1 SELECTING MASK FILTERS
FOR SEPARATION NEGATIVES**

Color of Filter for Separation Negative	Filter Number	Use Mask Made with Filter to Print Separation Negative
Red	29	29 – Red*
Green	61	29 – Red
Blue	47B	61 – Green

*The red-filter mask should be used for the red separation in order to bring the contrast into line with the other separations. (See Color Plate 6.)

NEGATIVE MASKING USING STRIPPING FILMS

Accurate methods of dodging and burning-in negatives are possible with the use of a different type of masking film, a "light-safe" stripping film,

Figure B.4 Hinge masking film over the negative.

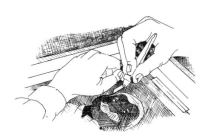

Figure B.5 Cut the emulsion of the mask with a swivel knife.

Figure B.6 Peel off the cut masking film in the exposure area.

coated on a polyester backing sheet, such as that made by Ulano in New York. Excellent precision is possible, which is helpful with the low sensitivity of the gum emulsion.

Ulano products are available in art or screen-process supply stores. The film is available in red or yellow, depending on the degree of protection necessary (it may also be used as inexpensive filter substitutes for safelights). You will also need to get a swivel knife from the same supplier for cutting the film. Then, use the following procedure:

1. Mark the front of the film (it is a thin, removable colored skin, easily cut; the backing is a medium-weight polyester).
2. Using tape, hinge a piece of the film to the border of the negative. The piece should be large enough to cover the entire image. The backing (shiny side) of the stripping film contacts the negative.
3. Working on a light box, cut the stripping film, outlining the areas for masking. Only light pressure can be used—too much force will cut into the polyester backing. Gently peel off the stripping film where cut, leaving the desired areas open for additional exposure (see Figures B.4, B.5, and B.6).

NEGATIVE REDUCTION

The benefit of an effective reduction technique provides an efficient, inexpensive method for correcting density problems in enlarged negatives. Lists of formulas on reduction are available in such titles as *Photographic Facts and Formulas,* by E. J. Wall and Franklin I. Jordan, revised by John S. Carroll (Garden City, NY: Amphoto, 1975), pp. 177–189. The three principle categories are:

1. Subtractive reducers: these reducers remove equal quantities from the full density range of the negative. Because shadow areas are cleared, an illusion is created that contrast is increased, which is not so.
2. Proportionate reducers: formulas can remove density proportionate to the original density in the negative; highlights are affected more than shadows, which makes this type of reducer useful for over-development.

3. Superproportionate reducers: the results provided are similar to those obtained with proportionate reducers, only more exaggerated; highlights are affected more than shadows, but in a greater proportion than in the actual density range.

Permanganate reducer seems to be the best formula for these purposes. A distinct advantage besides its basic qualities as a "proportionate" reducer is its speed. Permanganate reducer is very effective on enlarged negatives and saves time, compared to other formulas. The process is as follows (see Table B.2):

<div align="center">

TABLE B.2 PERMANGANATE REDUCER*

</div>

	Product	*Quantity*
Stock solution A:	Water	1 liter
	Potassium permanganate[†]	52.5g
Stock solution B:	Water	1 liter
	Sulfuric acid[†]	32.0cc

*Eastman Kodak refers to this as Kodak Reducer R-2 in early texts.
[†]Note on safety: Always add the sulfuric acid to the water slowly, stirring constantly, **never add water to acid.** Wear a vapor mask. Do not inhale fumes. Protect eyes and skin. With permanganate, keep container closed and do not contaminate with other product, as various contact may cause explosion. Avoid contact with combustible surfaces. Wear gloves, eye protection, and particle mask.
Source: Eastman Kodak Co., *Formulas and Processing* (Rochester, NY: 1946), p. 58; and Ernest M. Pittaro, ed., *Photo Lab Index,* Lifetime Ed. (Dobbs Ferry, NY: Morgan & Morgan, 1971), supplement 125, sec. 3, p. 247; and E. J. Wall and Franklin Jordan, *Photographic Facts and Formulas* (Boston: American Photographic Publishing Co., 1940), p. 131.

1. Prepare the solution A by dissolving the permanganate crystals in a small volume of hot water at 80°C, then dilute to volume with cold water.
2. Thoroughly fix and wash the negative to remove all traces of hypo before reducing.
3. When using, take 1 part of solution A, 2 parts of solution B and 64 parts of water. If reduction is too fast or slow, modify the volume of water.
4. Reach the point of adequate reduction and place the negative in a fresh fix bath for a few minutes to remove yellow staining.
5. Wash thoroughly.

If the surface of the reducing negative is muddy (reddish), this indicates that the negative required more washing to be clear of hypo. If stains are not eliminated in fixing, try a 1% solution of potassium metabisulphite, followed with the wash. The separate solutions will keep well, but should not be combined until immediately before use.

DYE DODGING WITH CROCEIN SCARLET

The use of crocein scarlet (neo-coccine) as a dodging agent is definitely not new. However, in spite of its simplicity and adaptability, this technique is not prevalent.

The methods involve the application of a red dye (available from Kodak) to the negative.[3] The density and strength of the dye determine the extent to which the negative will be lightened in the resulting print. As one enthusiastic writer states,

> At our command it will act as a dodger, reducer, intensifier or an opaque. In portraiture, it will make blondes out of brunettes, and high-key prints from low-key negatives. In commercial work, it will remove the shadows from interiors, brighten up dark pieces of machinery and lighten up or remove entirely distracting backgrounds. In pictorial work, it will eliminate the harsh contrasts between foreground and sky and it is indispensable in the handling of winter scenes where we have dark rocks and trees against brilliant snow. As I have often told the students, New Coccine puts that certain 'latitude' in negative emulsions which the manufacturer so fondly hopes for.[4]

The advantages of crocein dodging for the gum printer are as follows:

1. The requirement for large negatives in the contact process permits considerable accuracy in the use of the methods. (It also can be used with small-format negatives.)
2. The expense and effort required in the production of enlarged negatives entail salvaging many images that might otherwise be abandoned.
3. Applications made to the negative are not permanent; density can be built in successive layers or strengths or, if excessive, can be removed entirely with water.

You can find more details on the process in many books (1940–1960), specializing in photographic print quality, enlarging, and retouching—the methods are the same in contemporary work. The following summarizes the directions that are typically found:

1. The dye is diluted in various strengths with water and stored in bottles. Start with a main stock solution containing a heavier concentration than suggested by label directions. This works better for "blockout" effects. The stock dilution can then be measured into other strengths for a range of densities and tested.
2. Add a few drops of wetting agent to each concentrate, for a smoother penetration of dye into the negative.
3. Use ammonia (as strong as 28%) for a quick reduction of crocein. Household strength ammonia is also adequate or plain water can be used if there is sufficient time. (Follow safety precautions when handling ammonia.)
4. The dye can be applied to either side of the negative but responds best to the "tooth" of the emulsion. Use any method of application (brush, "Q-tips," etc.). Proper technique can eliminate the problem of forming uneven densities. If any discarded sheets of clear film stock are available, they can be hinged to the negative and used as the dye surface. (A sheet can be fixed expressly for this purpose.)
5. Build up dye in layers. A blue filter can be used to check the density, which converts the red dye color on the negative to a monochrome balance. If in doubt, make a proof on black-and-white paper.

6. If an excess of dye has been built up, the film can be soaked in water. Ultimately the crocein will dissolve. Use a solution of potassium metabisulphite (1%) to speed this process, followed with a wash.

NOTES

1. For additional information, see Ira Current, *Photographic Color Printing* (Boston: Focal Press, 1987), pp. 151–164, 182, 222; Philip Zimmermann, ed., *Options for Color Separation* (Rochester, NY: Visual Studies Workshop, 1980), pp. 35–38; and Eastman Kodak Co., *Silver Masking of Transparencies with Three-Aim Point Control* (Rochester, NY: Eastman Kodak Co., 1974), *Color Separation and Masking* (Rochester, NY: Eastman Kodak Co., Data Book E-64, 1959), and *Fundamental Techniques of Direct-Screen Color Separation* (Rochester, NY: Eastman Kodak Co., Data Book Q-10, 1975). Unfortunately, Kodak has discontinued many good technical publications. You can try to find some of these publications in photographic school libraries or from club sales of photographica.

2. Current, *Photographic Color Printing,* p. 158.

3. Ralph Hattersley states in *Photographic Printing* (Englewood Cliffs, NJ: Prentice-Hall, 1977), p. 209, that a "red food dye" will work.

4. Ghislain J. Lootens, *Lootens on Photographic Enlarging and Print Quality* (Baltimore, MD: The Camera, 1946), pp. 146.

APPENDIX C
Working with Halftones

EQUIPMENT AND MATERIALS

Review the list of supplies and information as described under Step 13. The following lists modifications and additions required for halftone work.

Film For halftone work, good film choices are Fujilith Panchro Film HP-100, or Kodak Kodalith, MPII Pan Film, SO-479 (MP stands for machine processes, but this product is suitable for tray processing, with the MPII or Super RT developer).

The market in separation films is specialized. Anticipate some difficulty in the availability of products and minimum amount of purchase. Contact a variety of suppliers for alternatives. It also may be advisable to visit some local commercial printers; they may be interested in helping you in your project by selling some of their stock.

The films suggested have applications other than for color separation work. They are excellent for the *tone line process,* a line effect with full cancellation of tones without shadows. A few more guidelines can help you achieve the best results:

1. Color separation panchromatic films should be handled in absolute darkness. If any sheets require cutting, make code notches to help with emulsion orientation.
2. *Autoscreen film* is good for halftones from black-and-white negatives, but is orthochromatic and cannot work for color separations.
3. Orthochromatic film may be required for separations when continuous tone separations are made first and the halftones are a second generation. This is a common commercial method, with advantages for process cameras and masking. Another consideration favoring preliminary continuous tone separations is the availability of lith films for halftones. This eliminates the need for finding panchromatic separation lith film. The transparency can be projected onto continuous tone separation film and a halftone contacted on duplicating film.

Developer Lith films use a two-part developer labeled solution A and B. They have a short working life when prepared and so should be mixed just prior to use. Check such variables as time, temperature, and agitation carefully for repeatable results. (Kodalith Super RT has proven to offer significant improvement over many lith developers. Because of an excellent tray life, testing is reduced and less frequent changing is necessary. If not using it, begin with the manufacturer's suggested product.) Precautions should be taken to prevent streaks and staining: add a few drops of photo-flo to the rinse water.

The author gratefully acknowledges the assistance of Herzig Somerville Printing, Toronto, for specific information on tricolor gum printing and sensitometric data using halftone techniques.

HALFTONE SCREEN

There are several types and characteristics of halftone screens. The two more common screens are the *gray screen* and the *magenta contact screen*. The gray film screen is necessary for separation from color transparencies or copy.

The magenta screen has a dye (rather than a silver) dot pattern. The dye pattern makes it possible to control halftone contrast by using color filters (e.g., a yellow filter extends the range of the screen, a magenta filter compresses it).

The use of a gray screen is recommended. Consider the following in selecting one:

1. The gray screen is available with either a square or elliptical dot. The typical halftone screen produces a square dot, which creates a "checkerboard" pattern in the midtones because it breaks up the image to a coarse dot. The use of an elliptical dot screen produces a midtone dot that is football-shaped, connecting at the ends, and creates a softer effect. Printers prefer to use the elliptical screen for a smoother reproduction but either can work well (see Figure C.1).
2. Halftone screens are available in different rulings, designated by the number of lines per inch. The selection ranges from 65 to 300 lines per inch, depending on the purpose, quality of print desired, and printing process. It can be erroneous to assume that the larger the numerical value of a screen, the better the print quality. In processes such as serigraphy, using a fine screen is not possible. An 80-line screen is standard; a finer dot could be lost in the screen mesh.
3. There are miscellaneous factors in selecting a "correct" screen ruling. A major one is paper quality and how the paper responds to the process. Rough paper with poor sizing absorbs much pigment, forming dots that spread. Gum printing on this paper causes the dots to plug up, with a resulting loss of detail.

 For gum printing, a screen of 100 lines is recommended, with an acceptable variation from 85 to 135 lines. This is similar to newspaper printing. Commercial printers sometimes purchase screens that are "preangled," to reduce the risk of moiré. This luxury does not improve the results.

Other than the conventional contact screen, there is a range of possibilities for obtaining "dot" patterns in photography. These can be somewhat simple[1] (e.g., non-glare glass, diffusion screens) or more involved such as the *random dot* method that requires Fine-Line Developer, and an emulsion suited to the technique. Many alternate methods are not satisfactory as they tend to diffuse the image excessively. Gum printing is inherently soft. With increased image diffusion, printing becomes difficult, if not impossible.

TECHNIQUES FOR HALFTONE NEGATIVES

The procedure for monochrome halftones is the same as for tricolor halftones, except in the following cases:

1. An ortho lith film is used (unless a monochrome halftone is made from a color film).

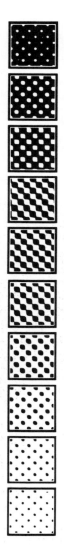

Figure C.1 The elliptical effect is most visible in the midtone area.

2. The ortho film can be processed by inspection or timing. If pan lith film is used, timing is required.
3. Since only one screen is used for monochrome (save special methods), moiré is not a concern.

Guidelines for Monochrome and Tricolor Separation

For transparencies, prefer the image characteristics described in Step 14. For negatives, refer to Step 1. Then the following guidelines can be used.

1. Follow preparation for a film jig (holding mask) and setup explained in items 1, 2, and 3 of the Guidelines for Continuous Tone Separations section of Step 14.
2. Select a panchromatic lith film and place it in contact with the screen, emulsion to emulsion (dull side to dull side).
3. The halftone screen must get the closest possible contact during exposure. A vacuum table, manufactured or handcrafted, gives the best registration. If none is available, a contact frame or heavy glass plate is acceptable.
4. To prevent moiré, a guide for altering the direction of the halftone screen must be established (see Figure C.2). (Any method for panchromatic halftones must be applied in total darkness.) The need for screen rotation necessitates a large screen. Select a screen at least one size larger than the film, otherwise rotation is not possible. The angles can vary subject to the type of screen (i.e., elliptical or square dot). Use the following arrangement:

Elliptical Dot Screen	*Square Dot Screen*
105°: red (cyan)	75°: red (cyan)
75°: green (magenta)	45°: green (magenta)
45°: blue (yellow)	15°: blue (yellow)
——————————— 0°	——————————— 0°
baseline	baseline

There are variables in finding the correct screen angles. Some visible moiré does not print, particularly that of the blue separation filter.
5. Follow exposure tests from guidelines for item 4 of the Continuous Tone Separations Section of Step 14. If continuous tone separations were made previously, the filter factors used are *not* an equal ratio for halftone separation.
6. For halftones, one exposure cannot form dots with a sufficient density range to fit the average negative or transparency. Several exposures are required to make the negative. Study the results by examining distinct image areas:

Main exposure: use the main exposure to get the correct highlight and midtone (main) exposure.
Flash exposure: give a flash exposure besides the main exposure, to add dots (detail) to the shadow areas. Make the flash exposure without an image. Use an alternate light source of approximately 7 to 15 watts, at a distance of about 1.5 meters. A safelight is a good source. Use a red filter to flash a pan film or an amber flash for ortho

Figure C.2 Moiré. *Source: Photographic Printmaking Techniques,* Deli Sacilotto. (New York: Watson-Guptil), 1982, p. 54. Reprinted with permission.

film. Do not change the screen and film contact. The highlight and midtone dots change very little compared with the shadows in proportion to the flash exposure. (Determine the flash exposure using the same method outlined in Appendix B. The only difference is that the halftone screen remains on the film during the flash exposure. An approximate time using the suggested bulb and distance is 10 seconds.)

Bump exposure: sometimes, if dots in the highlights are too small, a third exposure known as the bump exposure is required. Carefully remove the screen without disturbing the film, and make an exposure of the photograph in the enlarger. This exposure is about 10 to 15% of the main screen exposure. Bumping is seldom needed for gum print negatives, but is mentioned here should the need arise.

7. Inspect the test results as follows:

Dots should be present in the entire density range (highlights to shadows).

If the highlights of the negative are solid black, the main exposure was too long.

If the clear dots in the highlights are too large, that is, greater than 10%, the main exposure was too short.

If highlights are satisfactory but shadows are clear, more flash is required.

If highlights are satisfactory, but shadows are too large, that is, greater than 10%, less flash exposure is needed.

SENSITOMETRIC MEASUREMENT OF HALFTONES

Similar to measurement of continuous tone materials, density measurements of halftones are common practice. Formal measurement provides the basis for proper communication with the industry and for establishing standards until visual measurements are adequate.

Density readings are interpreted in percent dot areas. Figure C.3 displays halftone densities, and their respective *percent dot areas.* For conversion of density readings to percent dot areas, see Table C.1.

The percent dot and density readings are guided by the "integrated halftone density." This refers to the measurement of the combined dense and clear area of the halftone. The ability of a densitometer to calculate this reading is contingent on its aperture opening, often adjustable to an acceptable dimension.* An aperture of 4mm is considered adequate for most screens. Smaller apertures can be used if the screen is 133 lines or finer, but no aperture smaller than 2.5mm. Because of the requirement for a large aperture, a homecrafted densitometer is useful for halftone measurement.

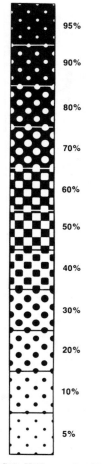

Figure C.3 Halftone densities are read in percent dots. *Source: Fundamental Techniques of Direct-Screen Color Reproduction.* (Rochester, NY: Eastman Kodak Company), 1975, p. 28. Reprinted courtesy of Eastman Kodak Company.

*Note on densitometer set up for halftones: Zeroing the densitometer will vary slightly from the continuous tone setting. The industrial standard for printing from a *first-generation halftone* is balance on a density just prior to a non-printing dot. This is too heavy for the gum print process—a better zero measurement is about a 2% dot. This is a change of about 0.1 above the base plus fog level. Again, the measurement need not be absolute; the flexibility of the process must be maintained.

TABLE C.1 CONVERSION FROM DENSITY TO PERCENT DOT AREAS

Integrated Halftone Density	Percent Dot Areas	Integrated Halftone Density	Percent Dot Areas	Integrated Halftone Density	Percent Dot Areas
.004	1	.181	34	.482	67
.009	2	.187	35	.495	68
.013	3	.194	36	.509	69
.018	4	.201	37	.523	70
.022	5	.208	38	.538	71
.027	6	.215	39	.553	72
.032	7	.222	40	.569	73
.036	8	.229	41	.585	74
.041	9	.237	42	.602	75
.046	10	.244	43	.620	76
.051	11	.252	44	.638	77
.056	12	.260	45	.658	78
.061	13	.268	46	.678	79
.066	14	.276	47	.699	80
.071	15	.284	48	.721	81
.076	16	.292	49	.745	82
.081	17	.301	50	.770	83
.086	18	.310	51	.796	84
.092	19	.319	52	.824	85
.097	20	.328	53	.854	86
.102	21	.337	54	.886	87
.108	22	.347	55	.921	88
.114	23	.357	56	.959	89
.119	24	.366	57	1.000	90
.125	25	.377	58	1.046	91
.131	26	.387	59	1.097	92
.137	27	.398	60	1.155	93
.143	28	.409	61	1.222	94
.149	29	.420	62	1.301	95
.155	30	.432	63	1.398	96
.161	31	.444	64	1.522	97
.168	32	.456	65	1.699	98
.174	33	.468	66	2.000	99

Note: Readings are given to three decimal places only for interpolation purposes.
Source: Kodak Publication, *Fundamental Techniques of Direct-Screen Color Reproduction* (Rochester, NY: Eastman Kodak Co., 1975), p. 28. Reprinted courtesy of Eastman Kodak Company.

Figure C.4 (see page 116) illustrates the "correct" percent dot areas for the gum print tricolor separation produced on an electronic scanner. The readings are difficult to reach precisely in each 3-point control (unless separations are produced commercially). The rule is to "place" accuracy in the highlight/midtone sections and let the shadows "fall."

PRINTING

Observe that halftone negatives require less exposure than continuous tone negatives. This is due to the "all-or-nothing" effect of halftone. Apply the use of halftones to techniques for both single and multiple printing.

Figure C.4 Conversion from a color transparency to halftone separation negatives. The data was obtained from a scanner specifically for the qualities of tricolor gum printing. The red filter negative will print heavier to maintain a gray balance and eliminate the black printer. Courtesy of Herzig Somerville Printers.

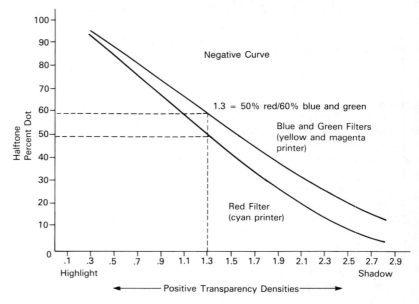

NOTE

1. See Suda House, *Artistic Photographic Processes* (New York: Amphoto, 1981), p. 134. Directions are given for crafting a halftone screen by applying adhesive transfer dots (from an art store) to a piece of acetate. This writer has not tested this method, but the possiblity is attractive with a minimum of expense.

APPENDIX D
Print Editioning

Set up an organized system of print editioning by keeping records of negatives and prints. Any arrangement that provides some history and an index for your work is beneficial. Begin this promptly, as it can help raise the monetary value and appeal of your prints to galleries, museums, and collectors. The terms and tradition for photography are the same as for fine art printmaking.

The Print Council of America is a group of scholars who meet occasionally to read and hear scholarly papers on prints. An extension of their activities is an excellent book (unfortunately out of print), by C. Zigrosser and C. Gaehde, titled: *A Guide to the Collecting and Care of Original Prints.* It states:

> An original print is a work of art, the general requirements of which are:
> 1. The artist alone has created the master image in or upon the plate, stone, wood block or other material, for the purpose of creating the print.
> 2. The print is made from the said material, by the artist or pursuant to his directions.
> 3. The finished print is approved by the artist. These requirements define the original print of today and do not in all cases apply to prints made before 1930.[1]

(Note that it is not imperative for the artist to do the printing for an original print, although standards must be maintained. Sometimes, the letters *imp* follow the artist's signature on the print and collector's documentation. This stands for *impressit,* meaning "has printed it" and testifies the artist printed the work.

Zigrosser and Gaehde discuss photography with considerable depth:

> Although photomechanical methods of reproduction have been discussed in this booklet, nothing has been said about photography itself as a form of printmaking. For photography is a form of printmaking, and, like the other print mediums, is capable of both utilitarian and aesthetic use. In the early nineteenth century the researches of Louis Daguerre, Nicéphore Niepce, William Talbot, and others brought about the perfection of the photographic process—a device for fixing an image on paper or glass plate, and later on film, by purely optical and chemical means, and then printing from that negative. The daguerreotype, being a unique positive, cannot be classed as a print. The camera can objectively and impersonally translate whatever appears before it in terms of light and dark upon the plate. The subjective factor is the selective eye of the photographer. If nature, or any object, is to be copied, photography can do it more quickly and cheaply than any artist can. And seemingly more accurately, because the copyist's personality is not obvious. It must be remembered, however, that photography is really only another pictorial convention and that the camera's eye also has a kind of personality or idiosyncrasy, since its diverse-angled lenses and monocular vision (as opposed to human binocular or stereoscopic vision)

produce not only variations but also distortion from 'reality.' But photography is so universally used and accepted that we have adoped its conventions as the last word in accuracy or realism.

Today, photography is the great documentary medium. Although most of its applications have been utilitarian and documentary, the medium has been employed to create original and conscious works of art—in other words, original prints. Witness the prints of such master photographers as Alfred Stieglitz or Edward Weston, to name but two. It has been said that photography could not be an art medium because all its operations are mechanical. All the print mediums have mechanical elements, which the artist has learned to manipulate and control. There are enough variations in the steps of the photographic process to give the artist a wide repertory of expressive devices: lighting and arrangement of materials, choice of lenses, changes of focus, variations in development and printing, including solarization. There is no logical reason, then, why a photograph cannot be a work of art if it is made by a conscious artist. The subject is vast and complex and could easily fill a book. It is introduced here briefly for the sake of completeness.[2]

PRINT EDITIONING

Much can be learnt from reading on print editioning. The following covers some useful aspects.

Types of Printmaking
There are four principle types of printmaking: *relief, planographic, intaglio,* and *stencil.* Gum prints predominantly resemble images produced by lithography, but also have unique characteristics (e.g., gum prints are not produced in a press). Still, whether a gum print specifically fits into one main graphic art medium is not important, as experienced collectors and dealers agree on their value. Some print galleries may show photographic gum prints and disregard conventional silver prints. Any knowledge that a photographer can gain on collecting prints from books, galleries, and so forth is vital to their success. Become confident in this area, and dealers will take more notice of your work.

Editions
A multiple is an original work that exists in duplicated examples, called an *edition.* As with many print forms, gum bichromates may exist as multiples, although it is unlikely that prints are exactly alike. Therefore, gum printing can be compared with etching, where effects are dependent on the wiping and heat of the plate, and the amount of oil or ink used. Still, expert copper plate printers can print uniform impressions, so gum workers should be equally successful, with some effort.

The term "artist's proof," originates from the French "bon à tirer," which means the first print to meet the artist's approval. The print is reserved for the artist's personal use, outside of the edition. It can still exist in multiples of equal quality, but limited to 10% of the total. It has a special value because it has an added personal association with the artist. Also, since gum printing is so adaptable to making unique prints (like *monotypes*), the term is used as a label for printers showing that their prints vary (see Color Plate 7).

Numbering Your Edition
Many artists only sign prints and mark them as "artist's proof," despite the number produced. They feel numbering is insignificant, except for marketing, and protects only the

dealer and collector. Still, editioning requires record keeping, and for that reason individual print numbers are functional as serial numbers. The printmaker can choose to keep a worksheet, which classifies the print by name and number, production dates, and a full description of colors, sequence, techniques, and dimensions of the image. The size of an edition may range from ten or twenty to several thousand. Well-known artists sometimes prefer small editions to ensure their value, but only the experts can speculate. Editions today are smaller than they were in the past, perhaps because many artists do their own printing, and are reluctant to spend too much time doing so. If it is claimed that an edition is limited, it must in fact be limited. Each print should bear an indication of the maximum size of the edition.

The numbering sequence sometimes shows the order in which the prints were produced. With gum prints, as with serigraphs (stencil printing), each consecutively numbered print is of equal value, since the techniques are nondestructive to the quality of each progressive print. In drypoint etching (intaglio printing), this is not so. Each pull of the press weakens the bite of the zinc or copper plate, until the loss of quality becomes significant.

Working Proofs Besides the edition and "artist's proof," there is another category of prints known as the trial or "working proof." For example, to develop a suitable gum print, the artist can experiment with several different color combinations, brush work and masking. These prints represents tests and unfinished states of an "artist's proof," which may be interesting and attractive. Select examples are marked "working proof," and numbered in the sequence printed. They are not considered part of the finished edition.

When printing is complete, the edition must be canceled. Sometimes, to prevent the production of unauthorized prints, the negative or plate may be destroyed or defaced.

PREPARING A PRINT HISTORY

Now that the rudiments of printmaking have been reviewed, start your own framework. With each finished print, follow the correct method to layout your "signature."

1. Using a medium pencil, place the print number and edition size, or the words "artist's proof," (abbreviated AP) on the lower left side.
2. Write the title in the center.
3. Your signature goes on the lower right and, if desired, followed with the year of production.

Keep track of your "collectors," giving them authorized receipts following purchase. To begin, try to follow a personally devised set of print identification rules. Set these up based on professional standards. Find a suitable plan in a book on art sales. The following typifies a print catalog raison d'être:

Have your name, address, and the titles of your print catalogue commercially printed. Select a quality paper that could be letter size or smaller to stick on the back of a framed work (e.g., 10 × 15cm), depending on the scale of the information you want to provide. Prepare an index of information from the following:

- Print title: maintain this even if you do not title your work, in which case you can designate "untitled."
- Negative catalogue number: this is the accession number for each negative. A negative file also must be subindexed, since processes may create variations on the master negative (e.g., several enlarged versions).
- Negative production date: negatives are "sketches," selected for printing at some later date. Use this date to mark the processing of the *original* negative. Also enter the date of any variations on the master negative.
- Print catalogue number: prints may be multiples or monotypes, so each must have its own reference number.
- Production date: many gum prints are simultaneously produced over a period of time. Enter the date of completion.
- Process/technique: include specifics of interest to clarify appreciation of the work.
- Image size/paper size: since the paper is usually larger than the actual image, both should be recorded.
- Edition size: enter data previously explained in this section.
- Copyright: unless this permission has been granted, note "artist," and you own the copyright. (This does not confer status, but some protection is available if a problem arises.)
- Collection: enter the name of the original purchaser.
- Curatorial notes: include relevant information, such as archival aspects, reproduction catalogues, significant exhibits, instructions for hanging, and so forth.

Do *not* list the purchase price.

NOTES

1. Carl Zigrosser and Christa M. Gaehde, *A Guide to the Collecting and Care of Original Prints* (New York: Print Council of America, 1985), p. 98. Reprinted by permission of Crown Publishers, Inc.

2. Zigrosser and Gaehde, *A Guide to the Collecting and Care of Original Prints,* pp. 68–69. Reprinted by permission.

APPENDIX E
Questions and Answers

Q: I am beginning my first attempts at gum printing. Are there any typical difficulties that I might anticipate?

A: The most frequent problems are related to "staining." Stains may be apparent in the highlights or unexposed areas following development. They may also be irregular in other image areas, which can make their source difficult to locate. Consider the following potential causes:

1. Low-quality pigments
2. Overexposure or light source overheating the emulsion
3. Impurities in low-quality printing paper, reacting with emulsion chemicals
4. Poor chemical grades
5. Inadequate or uneven sizing
6. Impure water
7. Improper proportions in the emulsion (e.g., too much or too little gum, sensitizer, or pigment)

Q: I have explored sources for the chemicals, but cannot purchase small quantities.

A: Contact The Photographers' Formulary.* They have been specializing in providing mail-order chemicals for photography since 1977. Also, check the list of suppliers listed in *The New Photography*[1] and *The Keepers of Light.*[2]

Further, contact colleges and universities offering photography and art classes. They may have a workshop that specializes in or includes gum printing. This school can provide information on sources and frequently will sell chemicals to students.

Q. Is there a common tendency, when printing, that can be easily corrected?

A. Avoid the desire to prematurely manipulate the print during development. Consider your prints "hands off" until processed in a still bath for a *minimum* of 10 minutes.

Simple, basic techniques also cause many problems. For example, when printing enlarged negatives, don't use a dodging material that is transparent to light, such as a contact sheet. Advice of this type cannot be included in a book specializing in gum printing.

Also, be aware of the visual characteristics of gum printing and strive to exploit them. The fact that gum printing is not a sharp medium should be turned to advantage. Use the character of brush strokes, instead of trying to achieve an uncommonly smooth finish.

*The Photographers' Formulary: P.O. Box 5105, Missoula, Montana. Tel.: 1-800-777-7158 or 1-406-543-4534.

Q. I would like to try printing on some watercolor papers. I've been told by the merchant that they're suitable, but your specifications call for "artist's intaglio papers." What are the differences?

A. Paper used for intaglio or *etching* can also be used for watercolor. Yet the reverse is not true. Watercolor papers are *not* suitable for etching (unless used for relief printing). They cannot withstand the pressure of the press, which embosses them, or other treatments common to the etching process.

If watercolor papers can withstand pressure without tearing, and so on, they are not "true" watercolor papers. Because of this overlap in character, some of these papers work well for gum printing. Always select the best paper since production of prints is limited.

Q: Does the quality of bulb influence color separation negatives or the flash exposures for color separated halftones?

A: Data provided with separation films specify that the film is designed for enlarger use, equiped with tungsten lamps. Tungsten is the standard enlarging bulb. Any light can be used for the flash exposure.

Q: Why are filter factors unspecified for color separation?

A: Filters change their factor subject to the variables in the process. Every enlarger, transparency film, separation film, and so on affects the filters. There are too many variables that are not standard for a recommendation (see Step 14).

NOTES

1. Catharine Reeve and Marilyn Sward, *The New Photography* (Englewood Cliffs, NJ: Prentice-Hall, 1984), pp. 217–221.

2. William Crawford, *The Keepers of Light* (Dobbs Ferry, NY: Morgan & Morgan, 1979), pp. 311–314.

APPENDIX F
Chemical Formulas
and Preparation

Most chemicals and materials needed can be found in photographic and graphic arts dealers stores, drugstores, chemical supply houses, science shops, and art supply stores.

Many chemicals for photography are only available in high-purity grades. In other instances, you can select a specific "photo grade." Chemicals branded this way are supplied expressly for photographic use. Manufacturers use analytical and photographic tests to ensure that a satisfactory and standard product is offered at a fair price. They also distinguish between impurities that are harmless and those that are undesirable, so that you often need to choose from different categories. Use the following guideline to become familiar with proper classification:

- Analytical reagent (AR): This is a general term used as the standard commercial designation to describe the highest purity (and the highest cost). This degree of purification is not usually necessary for photographic purposes. The methods of testing in different countries can vary, but the specifications for refining the grade are standard. In North America, the AR grade includes:
 American Chemical Specification (ACS)
 Great Britain and Commonwealth Countries (ANALAR)
- Pharmaceutical: This is a medium standard and the best alternative when a photographic grade is unavailable. This grade is suitable for gum printing. If there is any problem obtaining good results or should you suspect an impurity in the chemical (sediment, etc.), try an analytical reagent. Pharmaceutical grade also can have different labels:
 United States Pharmacopeia (USP)
 United States National Formulary (NF)
 British Pharmacopeia (BP)
- Commercial, technical, and unbranded: These grades present an element of risk. There are no guarantees against variation or against impurities. Test for suitability by comparison.

PERCENT SOLUTIONS AND CALCULATING DILUTIONS

Percent Solutions A percent solution is an ambiguous term that must be applied in the manner intended. A percent solution may correspond to volume per volume (v/v), weight per volume (w/v), or weight per weight (w/w). In each case it is expressed in parts per 100, but each case results in different amounts. This text uses the common system for photographic purposes, weight per volume. The percentage strength will

therefore indicate how many grams of a chemical are dissolved in 100ml of the final solution. For example, to make a 10% solution of potassium bromide, dissolve 10g of potassium bromide in some water, then add water to make 100ml.

Note that many chemicals have a greater specific gravity (i.e., they are heavier) than the liquid. Mix them by adding only small amounts at a time. Otherwise, the bottom of the liquid can become a saturated solution, the top remaining pure water. When mixing more than one chemical, pay attention to the order in which the ingredients are mixed. Follow the order of the formula.

Calculating Dilutions An easy method to find a desired dilution is illustrated below.

A		**C**
	%	
B		**D**

A = Percentage of the solution that will be diluted
B = Percentage of the solution that will be used for diluting A (if this is water, it uses 0%)
% = The desired percent for the resulting solution
C = % minus B
D = A minus %

For the solution at the required percentage, mix C parts of A with D parts of B. For example, with a 5% clearing bath of potassium metabisulphite, to get a 1% solution, by adding water we would write the values as:

5		**1**
	1%	
0% (water)		**4**

Therefore, to get a 1% solution from a 5% solution, you would mix 1 part of the 5% solution with 4 parts of water.

The following contains some information about chemicals used for gum printing. Photographers and laboratory workers frequently wish to know how to substitute one chemical for another. There is little to be gained by substitution of chemicals in formulas. So, the information provided in this section on substitutions are suggestions to use only if the need arises. (See Table F.1 for metric conversions.)

Albumen
- Organic compound, at one time used in photography for making albumenized paper—an early type of daylight printing paper, prepared from egg white, which is almost pure albumen.

Ammonia NH_4OH
- Synonyms: ammonium hydroxide, ammonia solution
- Characteristics: colorless aqueous solution of ammonia gas; strong alkaline reaction; caustic; tends to enlarge grain structure of negatives; hypersensitizes film.
- Warning: use in well-ventilated room or with fume hood to avoid fumes. Wear vapor mask and gloves.

TABLE F.1 METRIC CONVERSION
Approximate Conversions to Metric Measurements

Length		
inch	2.5	centimeters (cm)
foot	0.3	meter (m)
yard	0.9	meter (m)
mile	1.6	kilometers (km)

Weight		
ounce	28	grams (g)
pound	0.45	kilogram (kg)

Liquids		
fluid ounce	28	milliliters (ml)
pint	0.57	liter (l)
quart	1.14	liters (l)
gallon	4.5	liters (l)

Temperature (exact)

$$°C = °F - 32 \times \tfrac{5}{9} \qquad °F = °C \times \tfrac{9}{5} + 32$$
$$20°C = 68°F \qquad\qquad 80°F = 27°C$$
$$52°C = 125°F \qquad\qquad 32°F = 0°C$$

To convert nonmetric units into metric units, multiply quantities to be converted by the figures in second column. To convert from metric to nonmetric, divide quantities by the same figures listed in second column.

Ammonium Dichromate $(NH_4)_2Cr_2O_7$

• Synonym: ammonium bichromate
• Characteristics: used as a sensitizer for the carbon, carbro, gum bichromate, and other photomechanical processes; freely soluble in water at room temperature; orange crystals; has a stronger sensitizing power (approximately twice) and is more soluble than potassium. When in contact with a colloid, it is decomposed by light and renders the colloid insoluble.
• Substitutions: for every 100 parts, substitute 117 parts of potassium or sodium dichromate.
• Warning: chromates are highly poisonous and are readily absorbed by the skin. When mixing, do so in open air using a particle mask; wear gloves and eye protection; wash dust away immediately afterwards.

Arrowroot

• Synonym: maranta (West Indian)
• Characteristics: A prepared pure starch from various plants, the finest being West Indian. English arrowroot is starch obtained from potatoes. Arrowroot forms an almost clear solution when melted. It can be used for sizing papers before sensitizing in about a 2% or 3% solution and also as a mountant.

Chrome Alum CrK $(SO_4)_2 12H_2O$

• Synonyms: chromic potassium sulphate, potassium chromium sulphate

- Characteristics: red-violet to black crystals forming a purplish solution. When heated or in the presence of sulphite, the solution gradually turns greenish and loses its hardening properties within about 24 hours. It is used as a hardener in stop and fixing baths and with gelatin size in gum bichromate work; fairly soluble in water at room temperature. Its tanning action is greater than that of ordinary white alum and is capable in favorable circumstances of raising the melting point of gelatin to over 93°C.
- Warning: *See* potassium alum.

Formaldehyde HCHO

- Synonyms: formalin, formic aldehyde, formol
- Characteristics: pure formaldehyde is a gas but is supplied commercially as a colorless 37% aqueous solution with about 9% methanol as a stabilizer; has a pungent odor; used for hardening gelatin films in contemporary work and as a hardening agent for paper size with gum printing. Its action on the gelatin is not the same as the alum hardeners. It is used more where hardening in a neutral or alkaline solution is required since the alum is totally ineffective in that case.
- Warning: poisonous; vapors attack eyes, nose, and throat, causing intense irritation. Use in well-ventilated room or with fume hood, wear vapor mask and gloves.

Gelatin

- Characteristics: a product obtained by boiling animal skins, tendons, bones, ligaments, hooves, and so on, it is not a definite chemical compound and a given sample will contain various molecular weights. As a naturally occurring protein it has both acid and basic properties. It contains carbon, hydrogen, nitrogen, and oxygen, with a small portion of sulphur. It is insoluble in cold water, which it absorbs and then swells up to a slimy mass; it is soluble in all proportions in hot water but insoluble in alcohol and ether.

Glycerol $(CH_2OH)_2$ CHOH

- Synonym: glycerin
- Characteristics: heavy liquid with oily properties that is soluble with water in all proportions; chemically neutral; classified as an alcohol

Gum Arabic

- Characteristics: gummy substance obtained from the stem of the acacia. Also occurs in the fruits of certain other plants native to Africa. It is soluble in water but becomes insoluble when treated with certain bichromates and exposed to light. Used in mountants, for sizing paper before sensitizing for certain processes, and as the colloid in the gum bichromate process. Pure pharmaceutical grade acacia is white, from Kordefan in Sudan and is sunbleached. Solutions may be almost clear to slightly yellow.
- Substitutions: although many other gums exist, there are none that dissolve in water as readily. Should a shortage occur, check with your suppliers for their recommendation.

Mercuric Chloride $HgCl_2$

- Synonyms: perchloride, bichloride of mercury, corrosive sublimate
- Characteristics: made commercially by dissolving mercury in hot hydrochloric acid; easily soluble in water at room temperature.

- Warning: extremely poisonous and dangerous to use. Vapor mask and gloves must be worn. Wash dust away immediately after mixing.

Potassium Alum $AlK(SO_4)_2 12H_2O$

- Synonyms: aluminum potassium sulphate, potash alum
- Characteristics: this is the common alum; used as a hardener in fixing baths, colorless crystals or crystalline powder; fairly soluble in water at room temperature; may raise the melting point of gelatin to about 70°C; keeps its hardening properties much better than chrome alum in solution.
- Warning: all chromium compounds are extremely dangerous. When mixing, wear a vapor mask, gloves, and eye protection. Wash dust away immediately afterwards.

Potassium Dichromate $K_2CR_2O_7$

- Synonym: potassium bichromate
- Characteristics: used in chromium intensifier and sensitizer for carbro, carbon, gum bichromate, and other photomechanical processes; large orange-red crystals obtained from chrome iron ore. When in contact with a colloid, it is decomposed by light and renders the colloid insoluble; fairly soluble in water at room temperature, freely soluble in hot water.
- Substitutions: for every 100 parts, substitute an equal amount of sodium dichromate or 85 parts of ammonium dichromate.
- Warning: refer to ammonium dichromate.

Potassium Metabisulphite $K_2S_2O_5$

- Synonyms: metabisulphite of potash, potassium pyrosulphite
- Characteristics: white crystals smelling of sulphurous acid gas, used as acidifying agent in acid fixers and stop baths, as preservative in developers; highly soluble in water at room temperature; highly effective when used as clearing agent or preservative for removing yellow dichromate stain from gum bichromate prints.
- Substitutions: for every 100 parts substitute 94 parts of sodium bisulphite or 86 parts of sodium metabisulphite.
- Warning: wear vapor mask and gloves. Handle in well-ventilated room or with fume hood.

Potassium Permanganate $KMnO_4$

- Synonyms: permanganate of potash
- Characteristics: odorless, dark purple crystals, with a blue metallic sheen. Aqueous solutions are intense, dark purple; powerful oxidizing agent; may cause fire if in contact with organic materials.
- Warning: keep container closed and do not contaminate as certain contact may produce explosion. Wear rubber gloves, particle mask, and eye protection.

Sodium Bisulphite $NaHSO_3$

- Synonyms: acid sodium sulphite, leucogen
- Characteristics: white crystal powder with faint sulphurous odor; used for acidifying fixing baths and solutions of sodium sulphite and for preserving stock solutions of developer; may be used as clearing bath for gum prints; fairly soluble in water.
- Substitutions; for every 100 parts, substitute 106 parts of potassium metabisulphite or 91 parts of sodium metabisulphite.
- Warning: *See* potassium metabisulphite.

Sodium Carbonate (Anhydrous) Na_2CO_3
- Synonyms: carbonate of soda, soda ash, washing soda
- Characteristics: colorless crystals freely soluble in water, principle alkali, or accelerator used in development.

Sodium Dichromate $Na_2Cr_2O_7 2H_2O$
- Synonym: sodium bichromate
- Characteristics: used in intensifiers, bleaching baths and carbon, carbro, gum bichromate, and other photomechanical processes in place of potassium or ammonium dichromate without marked advantages—its deliquescence is a disadvantage. It consists of red deliquescent crystalline fragments, obtained in a manner similar to the potassium salt and used for the same purposes. Highly soluble in water.
- Substitutions: for every 100 parts, substitute an equal amount of potassium dichromate or 85 parts of ammonium dichromate.
- Warning: *See* ammonium dichromate.

Sodium Metabisulphite $Na_2S_2O_5$
- Synonym: sodium pyrosulphite
- Characteristics: white crystals used in acid fixing baths and stop baths and as a preservative in developers; fairly soluble in water; may be used as clearing bath for gum prints.
- Substitutions: for every 100 parts, substitute 116 parts of potassium metabisulphite or 110 parts of sodium bisulphite.

Sulfuric Acid H_2SO_4
- Synonyms: oil of vitriol, oleum, fuming sulfuric acid
- Characteristics: colorless, odorless, oily corrosive liquid available in many concentrations, possible ignition on contact with other substances.
- Warning: do not breath gas. High concentration may cause ignition of combustibles. Attacks most metals involving explosive hydrogen. Protect eyes, skin, respiratory system, and clothing.

GLOSSARY

Actinometer Chemical meter introduced in 1888 by Ferdinand Hurter and Charles Driffield for use with silver-bromide plates and used until 1940. *See* Chapter 4, Step 9.

Additive primary light A system for creating a full-color image by blending black and white separation positives. The positives are projected through primary filters and superimposed.

Adjacency effect The effect created by local exhaustion of a developer when a small area, such as a control patch of the transparency guide, is surrounded by a large, fully developed area. The effect can be eliminated by constructing a neutral density "holder" to surround the transparency and control patches while exposing. The density of the holder is equivalent to the average density (about 0.7 to 1.0) of the transparency.

Agglutinate Tendency that viscous substances such as glue have to adhere or unite.

Autoscreen film Autoscreen film is handled like other films, but produces a halftone negative automatically because the dot pattern is built right into the emulsion, eliminating the need for a contact screen. Its advantages compared with conventional halftones are enhanced sharpness and shorter exposure times.

Baumé hydrometer *See* Degree Baumé.

Bichromated colloid Various substances, such as albumen, gelatin, and gum arabic, that dissolve in water but will not diffuse through parchment membrane. Classified as colloids, they can be sensitized with the chromium salts of potassium, ammonium, or sodium, and have a light-hardening effect in the bichromate processes.

Blue sensitive Applies to film materials that are sensitive to the blue and near ultraviolet light inherent in every silver halide emulsion. They are often used in specialized work such as masking or halftone duplication. Their advantage is a high tolerance to safelight illumination.

Bracket exposures Even with the aid of modern sophisticated exposure calculators, there are occasions when exact exposure is difficult. If the photograph is important, "bracketing" is used, making a series of separate exposures. It would be best to make three exposures, one at the most likely value and the other two on either side.

Bromide (developer or paper) Bromide is the most popular type of development or paper for enlargements. The sensitive salt for the paper coating is silver bromide, usually with a small silver iodide content, in gelatin.

Bump exposure This exposure is used to extend middle and highlight areas of a film. It follows the main exposure and is made without a screen with a brief exposure to the copy.

Carbon arc lamp Carbon arc lamps are employed in the photomechanical trade when high intensity is required. The lamps can be subclassified as low-intensity and high-intensity. They range is color temperature from 3,800°K to 10,000°K. High-intensity lamps sometimes allow control of the spectral distribution of light.

Cibachrome A modern, popular, direct reversal color print process for transparencies. Its advantages from other reversal papers are improvements of color and permanence.

Clearing bath Any bath used in the processing of a negative or print to remove stains. Sometimes, it can also neutralize chemicals left by a previous treatment.

Colloid *See* bichromated colloid.

Color temperature *See* Kelvin scale.

Color separation The methods applied to isolating specific color wavelengths into film records. These are used for image reproduction with different color processes. Making color separation prints can vary in structure depending on whether you work from the original subject, transparencies, negatives, or other surfaces.

Continuous tone image A positive or negative print or transparency composed of a range of densities from black through gray to white. The densities are formed by varying amount of silver, dye, or pigment. This differs from a "line reproduction," which is composed of only two tones, black (or a color) and white.

Contrast Refers to the visual or sensitometric differences in the brilliance between two parts of an image (e.g., the range of brightness between the highlights and the midtones as rendered in a negative or print). The contrast range is determined by subject brightness range, emulsion, and development (*see* Density range).

Crocein scarlet (neo-coccine) dye Crocein scarlet is used on negatives as a dodging dye for masking large areas or to lighten shadows, highlights, and so on. Because the process requires applying red dye in varying densities, the area being retouched can be easily controlled.

Crystallization If a saturated solution cools, or is further concentrated by evaporation, it becomes supersaturated. Some dissolved chemicals will precipitate as crystals. *See* Saturated solution.

Cyanotype process An early negative contact printing process, producing an insoluble prussian blue image. It is still used by architects for reproducing technical drawings and is sometimes called the blueprint process.

Daylight balanced For accurate color evaluation of prints and transparencies, viewing should be performed under controlled artificial lights referred to as "daylight balanced." In commercial standards, an international standard is preferred, most frequently the Macbeth (Kollmorgen Corp., Baltimore).

Degree Baumé A degree Baumé measures the specific gravity of a liquid or a solid in weight per volume compared to the weight of an equal volume of water. An easy method for determining the specific gravity of a liquid is to use a hydrometer. It is a slender sealed glass tube weighted at the bottom and bearing graduated marks. To provide more accurate readings, hydrometers are made with a small range suitable for one type of liquid. It is customary to use hydrometers marked with the Baumé scale, although another scale, the specific gravity scale, also is available.

Deliquescent Refers to the property of a substance that absorbs so much moisture from the atmosphere that it will eventually dissolve.

D/Log E curve A sensitometric curve is often called different names, the most common abbreviation being the D/Log E curve. The curve shows the way a photographic material is effected by exposure and development.

Density range The visual or sensitometric difference between the brightest, nonspecular white highlight and the darkest shadow in which details must be preserved in the print, transparency, or negative. The density range is dependent on the subject's brightness range, on the emulsion used, and on development. Understanding the density range offers many advantages in photography (*see* Contrast).

Diffusion sheets Diffusion sheets such as those manufactured by Kodak are useful for controlling contrast. The diffusion sheet is positioned in a contact printing frame, above the emulsion of the film during exposure. The contrast is lowered by the refraction of light through the diffusion sheet to the film. A small reduction in image sharpness may be expected.

Duplicating film A special film that gives a duplicate negative by exposing it to the original negative through an enlarger. It may either be a prefogged emulsion that produces a reversed image by the destruction of the latent image by exposure to yellow or orange light (Herschel effect), or it may be film with a diazotype (dyeline) layer that directly yields a negative image from a negative (*see* Lith film).

Dye transfer process Separation negatives are used to make positives on separate sheets of matrix film. The matrix can absorb dye in proportion to the density, which is passed on to a paper support. This classic printing process maintains a commercial market owing to its beauty and permanence.

Edition A work of art that exists in duplicated examples. It applies to any print medium (e.g., photography, etching, etc.). Besides the prints comprising the edition, there may be further duplicates, which are other categories of the edition (e.g., studio proofs, etc.).

Electronic flash A light source that uses a short-duration flash of light, produced by passing a voltage charge through a gas-filled tube.

Emulsion Usually termed the light-sensitive coating or "working" surface of photographic materials, the emulsion is coated on a base.

Etching See Ingtalio *and* Relief.

Exposure latitude In sensitometric terms, it is possible to have over and underexposure and still obtain a result that is usable.

Fine grain positive film A low-speed, blue-sensitive film for making positive transparencies from continuous tone or line negatives. This film features extremely fine grain, high resolving power, and excellent definition, even with a high degree of magnification.

First-generation halftone A halftone obtained directly from the negative, transparency, or print, is a first-generation halftone. Because many processes require reversal of the positive or negative, the contacted halftone becomes a "second generation." The second generation produces a harder and sharper dot. The first generation is softer, with a distinct fringing or irradiation.

Flashing A method of varying the contrast of a photographic material, it uses a brief auxiliary "fogging" exposure besides the printing exposure. A high proportion of flash compared to basic printing exposure gives a softer result. The flash can be applied prior to, simultaneously, or after the image exposure.

Fluorescent lamp Fluorescent lights are a soft, low-intensity, diffused light source. Their efficient design gives off more light per unit of electrical power consumed than any comparable lamp. They maintain a cool temperature that makes them suitable for photography. Made in long tubes filled with mercury

vapor that produces an even glow throughout their length, they can have different color temperatures, including daylight or a special color-match tube for color correcting. The term blacklight sometimes applied to them originated from the ultraviolet illumination used to make objects visible in the dark. This special light is different from "standard" blacklights. Consult the distributor before purchase.

Format (camera and enlarger) The film size used in a camera determines its format. A 35mm camera is called a small-format camera while a 20 × 25cm or 28 × 35cm camera are examples of a large-format camera.

Gouache color Watercolor pigments tempered with white that are opaque. Traditional watercolor is used without white and is transparent.

Gray balance Gray balance for tricolor printing permits the elimination of the fourth printing negative, or "black printer." Since colors in a reproduction are created by the overlap of pigments, the individual strength of these pigments becomes just as important as their separate hues. Grayed color is seriously affected by pigment strength, becuase it is formed by at least three inks. Improper strength of any one of the three pigments can shift the hue to an entirely different color.

Gray screen This is the conventional color separation screen, made on a film base and having a graded dot pattern.

Gray scale (transparency or reflection) In color photography, gray reflects equal amounts of red, green, and blue light. The scale increases in density in regularly spaced steps. It is used to provide a scale of brightness for measurement with sensitometric data. If separation negatives transmit equal grays, then colors are in equal proportion.

Halftone image Photomechanical reproductions produce the illusion of tone by different sizes of dots of printed ink, called halftones. The reproduction simulates a continuous tone image when viewed at the correct distance, with tones that appear to be the result of varying densities.

Hardener A chemcial used to toughen the gelatin emulsion, or in gum printing, the gelatin size. Examples of hardeners are potash alum, chrome alum, or formaline. Hardening protects from physical damage and, in gum printing, raises the melting point of the gelatin.

Hydrometer *See* Degree Baumé.

Incident light meter Meter that measures the intensity of light falling on a subject (not that reflected from it). The incident light meter is fitted with a diffusing cover over the photoelectric cell.

Intaglio The intaglio process is known as etching or photogravure, depending on whether hand or photographic methods are used. The procedure involves incising an image into metal. The non-printing areas are left in relief. The image is inked, the surface wiped clean, and a print is taken from the remaining ink in the recessed areas (*see* Relief).

Irradiation Irradiation is the effect created by an image spread caused by internal reflections with the emulsion layer.

Kelvin scale (color temperature) The color temperature, expressed in degrees Kelvin (°K), is the temperature on the absolute scale (°C + 273). The Kelvin scale is used to measure energy distribution (color quality) over the spectral range. A light source measured with a continuous spectrum provides an easy method for specifying the "whiteness" of illuminants in color photography.

Kwik-Print Originally called "Kwik-Proof," this process uses ingredients and systems similar to gum printing. It is commonly called "the modern version of gum printing," likely owing to the revival and popularity of the gum process.

Latent image The image made by light on a photographic film or print prior to development.

Lith film A film with the potential for images of extreme contrast when exposed and developed according to the manufacturer's directions. By modified processing, lith film is useful for continuous tone negatives. Lith films are usually orthochromatic, but other categories exist, such as duplicating film, pan lith, and so on.

Lithographic See Planographic.

Logarithms Condensed numbers for simplified calculations. The system is arranged so consecutive numbers stand for constant increases. In the base ten logs used in sensitometry, log 0 = 1; log 1 = 10; log 2 = 100; intermediate numbers are given decimally—log 150 is 2.18.

Magenta contact screen The magenta screen has a dye, not a silver, dot pattern. The dye pattern makes it possible to control halftone contrast by using color filters.

Masking This applies to systems where a registration of images of different quality, form corrective procedures in contrast and color. The "mask" is a correcting image, which neutralizes imbalances with the master negative or transparency.

Meniscus The correct level at which to read a liquid volume. In a graduate, this corresponds to the bottom of the liquid's curved surface, or the lowest level of liquid in the middle of the graduate. With opaque solutions, the bottom of the meniscus has to be estimated.

Minimal art The concept of an art process existing without purpose in which the artist's concern is not with the visible subject, but more with the idea, intended to "shock" the spectator.

Moiré When regular patterns of halftone screens overlap, moiré patterns are formed. These create a visual interference is correct viewing of the resulting print.

Monotype A monotype is a unique print, exclusive of multi-original printmaking, more like a drawing with printed features. It is frequently made by painting on a sheet of metal or glass with oil-based inks or paints. The plate is then printed on paper by a press or hand rubbing, to transfer the image.

Multi-coated lens Some light passing into a lens is non-image forming, but reflected from other objects and causes lens flare. Flare reduces film quality, and can be reduced by anti-reflection coatings on a lens.

Multiple printing (registration) When making gum prints, single-color layers are built up by some accurate method of registration. In sophisticated color printing machines, automatic registration is used but gum prints still are registered by hand and registration marks are required. The most common method uses pins to punch holes showing points for realignment.

Newton's rings Visible, irregular interference pattern formed when two glossy transparent surfaces are in uneven contact. They are common in photography

when the film backing comes into contact with glass. The matte texture of the emulsion does not create Newton's rings.

Opaque A paste recommended for blocking out areas on film.

Orthochromatic Refers to black-and-white emulsions that are sensitive to ultraviolet, violet, blue, green, and in certain instances, yellow light. No ortho materials respond to the orange and red wavelengths beyond about 5,900°K. They are particularly good for work in the darkroom since the film can be handled under a red safelight.

Panchromatic Refers to black-and-white emulsions that respond to all colors of the visible spectrum, from ultraviolet to red. They are used in photography requiring tonal reproduction from full-color subjects. They can be handled under a dark olive-green safelight, although this method is impractical.

Percent solution A method for measuring the strength of a chemical in solution. The system for calculation can vary and result in different amounts if not understood.

Percent dot areas Halftone dot structures are measured in terms of percentages. For example, a 10% dot structure to 90% dot structure represents the area of shadows to highlights of a negative. Any reference to a percent dot always indicates the black area of exposure and development. It must be clear whether a negative or positive is referred to.

Pinhole camera A homecrafted camera, often called a "shoebox camera." A hole produced by a needle in metal or tinfoil replaces the lens. Pinhole photographs have a special softness that is very pleasing.

Pinhole registration A simple method that can be used for multiple printing techniques. The system uses pinholes in corresponding positions on the negative and paper, which allows the repositioning of the negative in a repeatable manner (*see* Multiple printing).

Planographic The planographic process is known as lithography or photolithography. An image is made by hand or photography, on limestone or aluminum plates. The image is flat, yet, can be printed due to ink being accepted in the image and rejected in other areas. Gum prints resemble lithographs.

Plasticizer A substance that can be used to improve the smoothness, solubility, and brushing qualities of powder pigments. Plasticizers are nonvolatile and permanent. Glycerol, syrup, and wetting agent are frequently used for this purpose.

Pop art An art movement, primarily in American art. It can be interpreted in two ways, as art that is meant to be popular, or art that derives images from popular or common things in the real world.

Preshrinking Paper shrinks about 15% the first time it has been watersoaked and dried. To avoid any registration problems when printing, a preliminary soaking and drying should be given prior to printing.

Process camera This is a graphic arts camera that is a giant version of a monorail view camera. Its advantage is enlarged copy for the printing and arts industries.

Ramdom dot Kodak's Fine-Line developer, used with specific films, can produce a dot that can be substituted for a halftone in several printing processes, but it is not sufficiently sharp for gum printing.

Reciprocity failure The result of long exposure times, greater than 1/10 sec. in color films or 1 second in black-and-white films. The effect reduces emulsion speed. Some manufacturers provide exposure corrections.

Reduction Sometimes the result of processing a film is not satisfactory. There are modifications possible and reduction is useful for negatives that are objectionably dense. A variety of formulas exist that can effect changes to the original exposure or development in the preferred ways.

Registration *See* Multiple printing.

Relief For example, a woodcut, lino cut, or wood engraving. A light-sensitive coating can be added to the surface to obtain images photographically. A photo-mechanically prepared plate is usually printed as a relief image. The result is more textural and softer than an image printed by intaglio (*see* Relief).

Reticulation An irregular grain that forms from a physical change in film gelatin. One cause is sudden swelling or contraction caused, for example, by temperature change.

Saturated solution Any chemical solution that cannot absorb more substance. One disadvantage to using saturated solutions is the fact that they change with temperature (solubility increases in hot liquids). They should be avoided as much as possible. If used, they should always be prepared according to the same formula. To obtain a saturated solution, prepare more than you need and at a higher temperature than required. When it has cooled down to the desired temperature, you will find crystals at the bottom. Use the top part of the solution and store for future use.

Scanning The application of computer technology in assessing and producing images in various processes. Its main advantages are the accuracy, speed, and elimination of masking.

Sensitometry The scientific study of light-sensitive materials.

Size Raw papers need to be sized before sensitizing to fill up the pores and keep the image on the surface. The sizes most used are arrowroot, starch, and gelatin. Paper can be soaked in a size or the size can be brushed on it.

Stencil The stencil process is silk screen or serigraphy, the former a commercial term, the latter a fine art term. A suitable woven material is stretched across a frame. The parts of the stencil not meant to be printed are filled with a block-out material, by hand or photographic methods. The screen is laid on the paper and ink is squeezeed across through the open areas.

Subtractive color process The color principles of producing prints on paper are different from the projected additive process. It forms the "subtractive synthesis" of color printing. The reflective white piece of paper is covered with complementary dyes or pigment that absorb or "subtract" some colors from white light, while reflecting the remainder (e.g., yellow is "minus blue").

Three-point density control Control of tone reproduction can be based on two density aim points, highlights and shadows. A third aim point, at midtone density, improves control of the reproduction. It is sometimes an advantage to emphasize the midtone and highlight densities, as opposed to shadow densities, or vice versa.

Tonal scale Refers to a range of densities (usually for positive prints). The print tonal scale is rendered by the negative density range. The negative density range depends on subject brightness range. Photographic printing papers with a low contrast such as grade 1 possess a long tonal scale for printing a wide density range negative (subject).

Tone line process A high-contrast process using negative and positive lith films in contact. A "line drawing" of the image can be seen in the relief areas when a

light is positioned at 45° to the film's surface. The line drawing is exposed on a third lith film, while the contact assembly revolves at 45° to the light.

Van Dyke process Two versions of the process exist. The most popular one is a silver nitrate contact process, producing a magnificent brown print. The appearance accounts for its designation as the Van Dyke process. It is sometimes mistaken for a platinum print. The earlier Van Dyke (Vandyke) process, was a lithographic process invented by F. Vandyke and used for map printing. The technique required zinc plates, inking, and press printing.

White light An ambiguous way to describe light that is not noticeably deficient in any particular color. The quality of light from artificial sources is different from daylight and artificial sources can vary among themselves. For gum printing, the differences are not important compared with the precise requirements for contemporary color work.

Zone system A system for control in photography initially based entirely on the light meter and visual methodology, which contributed to its success. The subject is "previsualized" with the light meter in tones, and interpreted into the photograph. It can be used as an alternative to sensitometry although contemporary views often integrate a scientific approach. Early leading exponents included Minor White and Ansel Adams.

☙ BIBLIOGRAPHY ☙

BOOKS

General Books on Photography

Abbott, Henry G.
MODERN PRINTING PROCESSES
(Chicago: Geo. K. Hazlitt Co., 1900, pp. 5–39)

Anderson, A. J.
THE ABC'S OF ARTISTIC PHOTOGRAPHY
Special Printing Processes
(Toronto: Dent Publishing, 1913)

Beede, Mindy
DYE TRANSFER MADE EASY
(New York: Amphoto, 1981, pp. 11–16, 33–70, 145–148)

Blacklow, Laura
NEW DIMENSIONS IN PHOTO IMAGING
(London: Focal Press, 1989, pp. 34–47, 93–100, 108–116)

Clerc, L. P.
PHOTOGRAPHY THEORY AND PRACTICE
(London: Focal Press, 1970, vol. 1, pp. 1–18)

Coote, Jack H.
COLOUR PRINTS
(London: Focal Press, 1968, pp. 22–58, 115–121)
MAKING COLOUR PRINTS
(London: Focal Press, 1944, pp. 7–48, 120–124)

Crawford, William
THE KEEPERS OF LIGHT
(Dobbs Ferry, NY: Morgan & Morgan, 1979, pp. 85–95, 117–127, 199–212, 227–223)

Current, Ira
PHOTOGRAPHIC COLOR PRINTING
(London: Focal Press, 1987)

Demachy, Robert
THE MODERN WAY IN PICTURE MAKING
(*The Gum Bichromate Process,*
Rochester, NY: Eastman Kodak Co., 1905, pp. 185–190)

Eastman Kodak Co.
BASIC PHOTOGRAPHY FOR THE GRAPHIC ARTS
(Rochester, NY: Data Book Q1, 1972)
COLOR SEPARATION AND MASKING
(Rochester, NY: Eastman Kodak Co., Data Book E-64, 1959)
**FUNDAMENTAL TECHNIQUES OF DIRECT SCREEN
COLOR REPRODUCTION**
(Rochester, NY: Eastman Kodak Co., Data Book Q-10, 1975)
BASIC PHOTOGRAPHIC SENSITOMETRY WORKBOOK
(Rochester, NY: Eastman Kodak Co., Data Book Z-22-ED, 1981)

Eggleston, Jack
SENSITOMETRY FOR PHOTOGRAPHERS
(London: Focal Press, 1984)

Encyclopedia Britannica
GRAPHIC ARTS
(New York: Garden City Publishing, 1929, pp. 257–266)
Gassan, Arnold
THE COLOR PRINT BOOK
(Rochester, NY: Light Impressions, 1981, pp. 2–7, 17–38, 58–61)
THE HANDBOOK FOR CONTEMPORARY PHOTOGRAPHY
(Athens, OH: Handbook Co., 1972, pp. 91–94, 103–106, 122–123)
Hasluck, Paul N., ed.
THE BOOK OF PHOTOGRAPHY
(London and New York: Cassell, 1907, pp. 199–200)
Henney, Keith, and Dudley, Beverley, eds.
HANDBOOK OF PHOTOGRAPHY
(London: Whittlesey House and McGraw-Hill, 1939, pp. 466–506)
Horder, Alan, ed.
ILFORD MANUAL OF PHOTOGRAPHY
(Essex, England: Ilford Ltd., 1966, pp. 7–42, 293–326)
House, Suda
ARTISTIC PHOTOGRAPHIC PROCESSES
(New York: Amphoto Books, 1981, pp. 59–83)
Howell-Koehler, Nancy
PHOTO ART PROCESSES
(Worcester, MA: Davis Publications, 1980, pp. 87–95)
Jay, Bill
ROBERT DEMACHY
(London: Academy Editions, 1974)
Jones, Bernard E., ed.
ENCYCLOPEDIA OF PHOTOGRAPHY
(New York: Arno Press, 1974, Reprint of *Cassell's Cyclopaedia of Photography*. London and New York: Cassell, 1911)
Kraszna-Krausz, A., ed.
THE FOCAL ENCYCLOPEDIA OF PHOTOGRAPHY
(London: Focal Press, 1965, Vol. 1 and 2)
VICTORIAN PHOTOGRAPHY
(London: Focal Press, 1942)
Lootens, J. Ghislain
LOOTENS ON PHOTOGRAPHIC ENLARGING AND PRINT QUALITY
(Baltimore, MD: The Camera, 1946, pp. 146–164)
Maskell, Alfred, Demachy, Robert, and Bunnell, Peter C., eds.
NONSILVER PRINTING PROCESSES
Photo-Aquatint or the Gum-Bichromate Process, (New York: Arno Press, 1973, Reprint of *Amateur Photographers Library no. 13*, London,: Hazell, Watson, and Viney Ltd., 1898)
McIntosh, J.
THE PHOTOGRAPHIC REFERENCE BOOK
(New York: Tennant and Ward, 1905, pp. 164, 287)
Miller, C.W.
PRINCIPLES OF PHOTOGRAPHIC REPRODUCTION
(New York: Macmillan Co., 1942, pp. 173–180)
Morgan, Willard D., ed.
THE ENCYCLOPEDIA OF PHOTOGRAPHY
(New York: National Educational Alliance, 1949, vol. 11, pp. 823–830 and pp. 867–877)

Nadeau, Luis R.
GUM DICHROMATE
(Fredericton, Canada: Atelier Luis Nadeau, 1987)
Neblette, C.B.
PHOTOGRAPHY PRINCIPLES AND PRACTICE
(New York: Van Nostrand Reinhold, 1942, pp. 669–674)
Pittaro, Ernest M., ed.
PHOTO LAB INDEX
(Dobbs Ferry, NY: Morgan & Morgan, 1979, Lifetime Edition, sup. 139,
sec. 11, pp. 17–20, sup. 153, sec. 3, pp. 626–632)
Reeve, Catherine and Sward, Marilyn
THE NEW PHOTOGRAPHY
(Englewood Cliffs, NJ: Prentice-Hall, 1984, pp. 35–43, 67–71, 88–89, 95–
120)
Richards, J. Cruwys
PRACTICAL GUM BICHROMATE
(London: Iliffe Books, c. 1904, pp. 11–118)
S.D. Warren Co. (Scott Paper)
BLACK HALFTONE PRINTS
(Boston: Bulletin No. 3, 1987)
Sheppard, Julian
PHOTOGRAPHY FOR DESIGNERS
(London: Focal Press, 1971, p. 212)
Sipley, Louis Walton
A HALF CENTURY OF COLOR
(New York: Macmillan Co., 1951)
Sowerby, A.L.M., ed.
DICTIONARY OF PHOTOGRAPHY
(London: Iliffe Books, 1961, pp. 357–362)
Spencer, D.A.
COLOUR PHOTOGRAPHY IN PRACTICE
(London: Focal Press, 1969, pp. 32–33, 184, 232–268, 283–295, 373)
Swedlund, Charles and Elizabeth
KWIK-PRINT
(Rochester, NY: Light Impressions, 1985)
Wade, Kent E.
ALTERNATIVE PHOTOGRAPHIC PROCESSES
(Dobbs Ferry, NY: Morgan & Morgan, 1978, pp. 126–132)
Wall, E.J., revised by A.L.M. Sowerby (16th ed.)
DICTIONARY OF PHOTOGRAPHY
(Boston: American Photographic Publishing Co., 1943, pp. 351–358)
Wall, E.J. and Jordan, Franklin.
PHOTOGRAPHIC FACTS AND FORMULAS
(Boston: American Photographic Publishing Co., 1940, pp. 131, 225–230)
Warren, W.J.
THE GUM BICHROMATE PROCESS
(London: Iliffe Books, c. 1899, pp. 11–118)
Wheeler, Owen
PHOTOGRAPHIC PRINTING PROCESSES
(Boston: American Photographic Publishing Co., 1930, pp. 151–156)
Zimmermann, Philip, ed.
OPTIONS FOR COLOR SEPARATION
(Rochester, NY: Visual Studies Workshop, 1980)

Art and Printmaking Related to Photography

Auvil, Kenneth
SERIGRAPHY
(Englewood Cliffs, NJ: Prentice-Hall., 1965, pp. 139–148)

Berger, John
WAYS OF SEEING
(London: BBC and Penguin, 1972)

Heller, Jules
PRINTMAKING TODAY
(New York and Toronto: Holt, Rinehart, and Winston, 1972)

Kranz, Kurt
ART: THE REVEALING EXPERIENCE
New York: Shorewood Publishers, 1964, pp. 2–3, 14, 222–240)

Mayer, Ralph
THE ARTIST'S HANDBOOK OF MATERIALS AND TECHNIQUES
(New York: Viking Press, and Macmillan Co., 1970, pp. 32–37, 78–79, 293–311, 393, 396, 408–413, 537–546, 571–604, 627–640, 669)

Moholy-Nagy, Laszlo
PAINTING, PHOTOGRAPHY, FILM
(Cambridge, MA: MIT Press, 1973)

Ross, John and Romano, Clare
THE COMPLETE PRINTMAKER
(New York: Free Press, and Macmillan Co., 1972, pp. 73, 194, 247–258, 282–283)

Ross, John, Romano, Clare, and Ross, Tim
THE COMPLETE PRINTMAKER
(New York: Free Press, and Macmillan Co., 1990)

Sacilotto, Deli
PHOTOGRAPHIC PRINTMAKING TECHNIQUES
(New York: Watson-Guptill, 1982, pp. 47–61)

Zigrosser, Carl, and Gaehde, Christa M.
A GUIDE TO THE COLLECTING AND CARE OF ORIGINAL PRINTS
(New York: Crown Publishers, Inc./Print Council of America, 1985, pp. 68–69, 98)

Growth of Photographic Processes

Bernard, Bruce
PHOTO DISCOVERY, MASTERWORKS OF PHOTOGRAPHY, 1840–1940
(New York: Harry N. Abrams Inc., 1980, pp. 251–261)

Davenport, Alma
HISTORY OF PHOTOGRAPHY: AN OVERVIEW
(Boston: Focal Press, 1991)

Thomas, David Bowen
FIRST NEGATIVES: AN ACCOUNT OF THE DISCOVERY AND EARLY USE OF THE NEGATIVE-POSITIVE PHOTOGRAPHIC PROCESS
(London: Her Majesty's Stationery Office, 1964)

Wills, Camfield and Diere
HISTORY OF PHOTOGRAPHY, TECHNIQUES AND EQUIPMENT
(New York: The Hamlyn Publishing Group, 1980)

Coe, Brian
COLOUR PHOTOGRAPHY, THE FIRST 100 YEARS: 1840–1940
(London: Ash and Grant Ltd., 1978)

Garrett, Albert Edward
ADVANCE OF PHOTOGRAPHY: ITS HISTORY AND MODERN APPLICATIONS
(London: K. Paul, Trench, and Trubner, 1911)
Gassan, Arnold
A CHRONOLOGY OF PHOTOGRAPHY
(Athens, OH: Handbook Co., 1972, pp. 125, 126)
Gernsheim, Helmut
HISTORY OF PHOTOGRAPHY FROM THE CAMERA OBSCURA TO THE BEGINNING OF THE MODERN AGE
(New York: McGraw-Hill, 1969)
Goldsmith, Arthur
THE CAMERA AND ITS IMAGES
(Italy: The Ridge Press Inc. and Newsweek Inc., 1979)
Newhall, Beaumont
THE HISTORY OF PHOTOGRAPHY
(New York: Museum of Modern Art, 1982)
LATENT IMAGE, THE DISCOVERY OF PHOTOGRAPHY, 2d ed.
(Santa Fe, NM: University of New Mexico Press, 1983)
Reilly, James
CARE AND IDENTIFICATION OF 19TH CENTURY PHOTO-GRAPHIC PRINTS
(Rochester, NY: Eastman Kodak Co., Publication G-2S, 1986)
Rosenblum, Naomi
A WORLD HISTORY OF PHOTOGRAPHY
(New York: Abbeville Press, 1984)

MISCELLANEOUS PERIODICALS

General Articles

Adams, William J.
"Gum Printing: The Non-Silver Photography"
(*Petersen's PhotoGraphics:* April 1981, pp. 46–54)
Brooks, David
"Kwiken Your Step"
(*Petersen's PhotoGraphics:* December 1978, pp. 42–43)
Cyr, Don
"Kids & Kameras"
(*Popular Photography:* August 1979, pp. 16, 135, 137)
Davis, William S.
"Gum-Pigment Printing"
(*The Camera,* vol. 26: 1922, p. 549)
Freytag, Heinrich
"Photographic Art Printing Processes"
(*Camera:* December 1970, pp. 35, 36, 52)
Gimbel Brothers
"A German Gum Bichromate Process"
(*Photo Talks:* October 1907)
Horenstein, Henry
"Gumming Up Their Works"
(*American Photographer:* mimeograph, about 1981, pp. 66–74, 92–93)
Lindley, Thomas
"Bichromate Printing"
(*Popular Photography,* vol. 73: 1973, pp. 124–125, 150)

Martinez, R.
 "Pictorialism In Europe"
 (*Camera:* December 1970, pp. 8–26)
Porter, Allan, ed.
 "Robert Demachy 1859–1936"
 (*Camera:* partial reprint from *Camera Work* December 1974, pp. 3–46)
 "Pictorialism"
 (*Camera:* December 1970, pp. 6, 26, 49–51)
W.W.M.M.
 "Gum Bichromate Printing Made Easy"
 (*American Photography,* vol. 23: May 1929, p. 5)
Warren, W.J.
 "Mr. W.J. Warren on the Gum Bichromate Process"
 (*The Photo-Beacon,* vol. 2: September 1899, pp. 244, 245)

Articles from *Camera Notes*

Carlin, W.R.
 "The Gum Bichromate Process"
 (vol. 3: October 1899, pp. 66–72)
Commentaries on Herr Watzek and Prof. R. Namias
 "Gum Bichromate Process" and **"New Bichromate Process"**
 (vol. 4: April 1900, pp. 239–240)
Stevens, Chas. W.
 "Improved Gum-Bichromate Process"
 (vol. 4: October 1900, p. 102)

Articles from the *British Journal of Photography*

Bennett, Henry W.
 "The Gum-Bichromate Process"
 (vol. XLV: January 7, 1898, pp. 4–15)
Commentary on D. Clarke
 "The Gum-Bichromate Process"
 (vol. XLIV: December 3, 1897, pp. 776, 777)
Commentary on G. Hanmer Croughton
 "The Gum-Bichromate Process in America"
 (vol. XLV: August 26, 1898, pp. 554, 555)
Commentary on Herr Watzek
 "The Gum-Bichromate Process"
 (vol. XLVI: February 3, 1899, p. 68)
Commentary on J. Gaedicke
 "The Gum-Bichromate Process"
 (vol. XLV: July 8, 1898, pp. 437, 438)
Commentary on James Packham and John Pouncy
 "The Gum-Bichromate Process"
 (vol. XLIV: December 10, 1897, pp. 786, 787)
Commentary on Dr. P.H. Emerson
 (vol. XLV: September 16, 1898, pp. 594, 595)
Commentary on Ritter Von Scholler
 "The Gum-Bichromate Process in Three Colours"
 (vol. XLIV: April 30, 1897, p. 281)
Commentary on Robert Demachy
 "Gum-Bichromate Process"
 (vol. XLV: March 25, 1898, p. 190)

Commentary on W.J. Ramsey
 "Enlarged Negatives"
 (vol. XLV: May 13, 1898)
Commentary on:
 "Gum-Bichromate Portraiture"
 (vol. XLVI: August 4, 1899, p. 487)
 "Modified Gum-Bichromate Process"
 (vol. XLV: December 16, 1898, p. 804)
 "Pictorial Photography"
 (vol. XLVI: November 17, 1899, pp. 722, 723)
 "The Gum-Bichromate Process and Its Alleged Uncertainty"
 (vol. XLV: April 1, 1898, p. 194, 195)
 "The Gum-Bichromate Process"
 (vol. XLV: June 24, 1898, p. 409)
Eddington, A.
 "Gum Bichromate Paper"
 (vol. XLV: March 25, 1898, pp. 188, 189)
Emerson, P.H.
 "Naturalistic Photography"
 (vol. XL: April 7 and April 14, 1893, pp. 211, 213, 231, 232)
Ewing, Geo.
 "The Bichromated Gum Process"
 (vol. XLIV: March 19, 1897, p. 181–182)
Lewis, Joseph
 "The Last Word upon the Gum-Bichromate Process"
 (vol. XLV: February 4, 1898, pp. 78, 79)
Maskell, Alfred
 "The Exhibition of the Paris Photo Club, with Some Remarks upon the Position of Pictorial Photography in France"
 (vol. XLII: May 31, 1895 and June 14, 1895, pp. 341, 342, 374, 375)
 "The Antique Paper Velours and Direct Pigment Processes"
 (vol. XLII: December 13, 1895, pp. 786–790)
Mumery, J.C.S.
 "Gum-Bichromate Process"
 (vol. XLV: April 8, 1898, p. 223)
Packham, James
 "The Gum-Bichromate Process,"
 (vol. XLIV: December 10, 1897, pp. 789, 791)
Pouncy, W.
 "The Gum-Bichromate Process"
 (vol. XLV: January 14, 1898, pp. 29, 30)
Pretz, A.D.
 "The Bichromated Gum Process"
 (vol. XLIV: March 19, 1897, pp. 183, 184)
Tulloch, M.B.
 "The Gum-Bichromate Process"
 (vol. XLV: May 20, 1898, pp. 327, 328)

Articles from *The Beacon*

Commentary on:
 "Pigment Printing"
 (vol. IV: May 1892/June 1892, pp. 139–141, 173–174)
Brown, Joseph B.
 "A New Printing Process"
 (vol. II: March 1890, pp. 53, 54)

EXHIBIT CATALOGUES

Naef, Weston, and Boorsch, Suzanne
"The Painterly Photograph 1890–1914"
(New York: Metropolitan Museum of Art, 1973)
Sutnik, Maia-Mari
"Pictorial Expressions in Landscape and Portrait"
(Toronto: Art Gallery of Ontario, 1989)

UNPUBLISHED MANUSCRIPTS

Whipple, Leyland
"The Gum Bichromate Printing Process"
(Rochester, NY: International Museum of Photography at George Eastman House, Archives: Cat. 81.4 W574 #9998, 1964)
Ravell, Henry
"Gum Bichromate Process"
(Rochester, NY: International Museum of Photography at George Eastman House, handwritten manuscript, accession number unavailable)
Macnamara, Charles
"Gum Bichromate Printing"
(Toronto: Art Gallery of Ontario, handwritten manuscript, c. 1905)

INDEX